NICOLAS BOURRIAUD IS GULBENKIAN CURATOR OF CONTEMPORARY ART AT TATE BRITAIN AND FORMER CO-DIRECTOR OF THE PALAIS DE TOKYO IN PARIS. HIS PREVIOUS BOOKS INCLUDE *RELATIONAL AESTHETICS* (LES PRESSES DU RÉEL, 1998, ENGLISH VERSION 2002), *POSTPRODUCTION* (LUKAS & STERNBERG, 2002), AND *FORMES DE VIE: L'ART MODERNE ET L'INVENTION DE SOI* (ÉDITIONS DENOËL, 1999).

NICOLAS BOURRIAUD
THE RADICANT

LUKAS & STERNBERG, NEW YORK

Nicolas Bourriaud

The Radicant

Publisher: Lukas & Sternberg, New York

© 2009 Nicolas Bourriaud, Lukas & Sternberg

All rights reserved, including the right of reproduction in whole or in part in any form.

Translation: James Gussen, Lili Porten

Copy Editors: Tatjana Günthner, Jake Hooker, Kari Rittenbach

Design: Miriam Rech, Markus Weisbeck, Surface, Berlin / Frankfurt am Main

Printing and binding: Brandenburgische Universitätsdruckerei Potsdam

ISBN 978-1-933128-42-9

Lukas & Sternberg is an imprint of Sternberg Press.

Sternberg Press

Caroline Schneider

Karl-Marx-Allee 78, D-10243 Berlin

1182 Broadway #1602, New York, NY 10001

www.sternberg-press.com

CONTENTS

PREFACE 07
INTRODUCTION 11

ALTERMODERNITY 25
ROOTS: A CRITIQUE OF POSTMODERN REASON 25
RADICALS AND RADICANTS 44
VICTOR SEGALEN AND THE TWENTY-FIRST-CENTURY CREOLE 60

RADICANT AESTHETICS 79
AESTHETIC PRECARIOUSNESS AND WANDERING FORMS 79
JOURNEY-FORMS 106
TRANSFERS 131

TREATISE ON NAVIGATION 143
UNDER THE CULTURAL RAIN (LOUIS ALTHUSSER,
MARCEL DUCHAMP, AND THE USE OF ARTISTIC FORMS) 143
ARTISTIC COLLECTIVISM AND THE PRODUCTION
OF PATHWAYS 158

POST-POST, OR ALTERMODERN TIMES 177

PREFACE

This book was written between 2005 and 2007 in the places to which circumstances brought me: Paris, Venice, Kiev, Madrid, Havana, New York, Moscow, Turin, and finally London. Cities and places, rather than countries. Nations are abstractions I distrust, for reasons that will become apparent.

Indeed, it is a way of life that inspires this theoretical reflection on contemporary art, a reflection that responds less to existing texts than to lived experience. Too often have I had occasion to deplore the absence of a vital link between critics and works—not to underscore the fact that this theoretical reflection is born of my nomadic life—in the course of which I have crossed paths with most of the artists whose work will be discussed here. The ideas expressed in this book arise, for the most part, from my contact with these artists and from assiduous observation of their work.

Multiculturalism; postmodernism; cultural globalization. Such are the key words around which this essay is organized: words that refer to unresolved questions. As is well known, certain generic notions, far from grappling with the cluster of problems they designate, settle for simply naming them. Thus, a nagging question constitutes the point of departure for this theoretical work: why is it that globalization has so often been discussed from sociological, political, and economic points of view, but almost never from an aesthetic perspective? How does this phenomenon affect the life of *form*?

In reflecting on the important role of the journey and on the iconography of mobility in contemporary art, I remembered a text I had published in 1990 in the journal *New Art International*, titled "Notes on Radicantity." The present text simply develops and deepens this youthful intuition, which at the time was supported by only a few examples. Aside from a couple of chapters in Part Three, however, *The Radicant* is entirely new. "Under the Cultural Rain" was published in the Pompidou Center's

exhibition catalogue *Sonic Process*; a revised version appeared in *Hz*, on the occasion of an exhibition at the Schirn Kunsthalle in Frankfurt. "Artistic Collectivism and the Production of Pathways" served as the introduction to the exhibition *Playlist*, which I organized at the Palais de Tokyo in 2005.

An image, an idea: such is the rhythm I have sought to reproduce in this essay. My readings of Walter Benjamin and Georges Bataille have taught me that the exposition of an idea through fragments, through a roving and disconnected type of writing, can sometimes better circumscribe its object than can a more linear approach. Moreover, this method corresponds to the subject I propose to treat. I have thus conceived this book as a kind of "PowerPoint presentation": an image, an orientation. Or again: as a necklace whose elements are linked to each other by the prehensile power of an *idée fixe*, as a conceptual archipelago, which also corresponds to the central image of this essay.

At the same time, *The Radicant* is composed of three distinct parts: the first approaches the subject in a theoretical manner; the second consists of an aesthetic reflection based on recent works of art; the third extends radicant thought first to modes of cultural production, then to modes of consumption and use.

Finally, during the writing of this book, I have tried never to lose sight of an avid obsession: to look at the world through that optical tool that is art, in order to sketch a worldly and worldwide art criticism in which works are in dialogue with the contexts in which they are produced.

INTRODUCTION

On November 9, 1989, the Berlin Wall fell.

Six months earlier—on May 18 to be precise—the exhibition *Magicians of the Earth* opened, bearing the subtitle *First World Exhibition of Contemporary Art* because it brought together visual artists from every continent: an American conceptual artist rubbed shoulders with a Haitian voodoo priest, and a sign painter from Kinshasa exhibited alongside great names of European art.[01] To the great mixer that was *Magicians of the Earth*, we can date the official entry of art into a globalized world shorn of master narratives, a world that is henceforth our own. This sudden emergence into the contemporary arena of individuals from countries then considered "peripheral" corresponds to the advent of that stage of globally integrated capitalism which, twenty years later, was to acquire the name *globalization*.

If this exhibition blurred the lines separating the figures of artist, priest, and artisan, it goes without saying that the virulent polemics the show provoked were not unconnected to the collapse of the symbolic alternative represented by the communist world. For with the end of US-Soviet bipolarity came the end of history. That at least is what American philosopher Francis Fukuyama claimed, in a text published shortly after the opening of the Iron Curtain, which created a considerable stir. Go back to sleep, subjects of the new world order... At any rate, it became evident that history was no longer the supreme measure by which to classify and rank artistic signs. Up until that time, the history of twentieth-century art was conceived as a succession of formal inventions, a procession of individual and collective experiments, each bearing a new vision of art. But that era had ended, and postmodern thought, which had appeared during the preceding decade, could finally triumph.

01 ORGANIZED BY JEAN-HUBERT MARTIN AT THE CENTRE POMPIDOU AND AT THE GRANDE HALLE DE LA VILLETTE, PARIS, 1989.

We were becoming part of "post-history": an era of conquests for the capitalist economy, henceforth sovereign, and of the establishment of a culture free of the ostensible "terror" propagated by the avant-garde. Modernism? A thing of the past, with its outdated humanism and universalism, the colonial machinery of the West. The entire world was to become contemporary: as the Asian economic boom was demonstrating, it was just a matter of waiting for the countries that were behind to follow the recommendations of the International Monetary Fund to the letter and link their "complex old cultures" up to the capitalist matrix. The development of urban culture was facilitating this movement. The worldwide explosion of megacities, from Mexico City to Shanghai, contributed to the emergence of a global formal vocabulary, to the point that one could describe the art of our era as an art of the *metapolis*—though there is something paradoxical about this art's propensity to turn the desert expanse or virgin forest into pillars of its imaginary universe. Are we to suppose that the end of history is to take the teeming form of the globalized, standardized city? Are we indeed so very far removed from utopian ideas, from radicality, from the avant-garde movements that marked the twentieth century? While "everyone said the end of communism signified the death of utopianism and that now we were entering the world of the real and of economy," Slavoj Žižek ironically remarks, nonetheless everything suggests, to the contrary, that the nineties "amounted to a veritable explosion of utopianism, a liberal capitalist utopianism that was expected to resolve all problems. Since September 11, however, we have known that the divisions are in fact still very much there."[02]

For post-history is a hollow concept—just like postmodernity, a term whose meaning is purely circumstantial, simply a placeholder to mark the period after modernism. The prefix "post-" with its exquisite

02 AUDE LANCELIN, "LE NOUVEAU PHILOSOPHE," INTERVIEW WITH SLAVOJ ŽIŽEK, *NOUVEL OBSERVATEUR*, NOVEMBER 11, 2004.

ambiguity, has ultimately served simply to lump together multiple versions of that *after*, ranging from the critical theory of poststructuralism to some patently reactionary options.[03] As for the famed idea of cultural hybridization, a typically postmodern notion, it has proved to be a machine for dissolving any genuine singularity beneath the mask of a "multiculturalist" ideology, a machine for erasing the origins of the "typical" and "authentic" elements that it propagates on the trunk of the Western technosphere. So-called cultural diversity, preserved under the bell jar of humanity's patrimony, turns out to be the inverted reflection of the general standardization of imaginations and forms. The more that contemporary art integrates heterogeneous artistic vocabularies deriving from multiple non-Western visual traditions, the more clearly there emerge the distinctive characteristics of a single global culture. Is it not the case that the idea of a "dialogue of cultures," a notion dear to official discourse, stems from a conception of the world as a series of cultural preserves—indeed, from that *animal humanism* that Alain Badiou defines as a humanism without any goal, except that of preserving existing ecosystems? "We must live in our 'global village,'" he writes, "let nature do its work, affirm its natural rights everywhere. For things have a nature that must be respected… The market economy, for example, must find its balance, between some unfortunately inevitable millionaires and the unfortunately innumerable poor, just as we should respect the balance between hedgehogs and snails."[04] Cultural differences, fossilized in a syrup of compassion, will thus be safeguarded in the global village—no doubt in order to enrich the theme parks that cultural tourists will delight in.

Should we mourn the demise of a modernist universalism? Not at all. It is pointless to recall here the colonialism (unconscious or otherwise)

03 SEE HAL FOSTER, "WHO'S AFRAID OF THE NEO-AVANT-GARDE," IN *THE RETURN OF THE REAL: ART AND THEORY AT THE END OF THE CENTURY* (CAMBRIDGE, MA: MIT PRESS, 1996).

04 ALAIN BADIOU, *THE CENTURY*, TRANS. ALBERTO TOSCANO (CAMBRIDGE, UK: POLITY PRESS, 2007), 176–77.

from which it is inseparable, its propensity to treat differences as attachments to the past and to impose its own norms everywhere, its own historical narrative and concepts, which it takes for natural, and thus capable of being spontaneously embraced by all. In the modernist model, explains Thomas McEvilley, history is nothing but "a single line moving forward across the page of time, with the vast ahistorical blank spaces of nature and the undeveloped world around it."[05] And non-Western cultures? Non-historical, hence irrelevant. What about Baule fetish figures? Authorless, the product of an obscure tribe, mere kindling for the furnace of progress.

Since the 1980s, numerous critics have devoted themselves to deconstructing this discourse. The theme of liberating alienated minorities has come to supplant the persuasive rhetoric of modernism, but in the process it has made every utterance the object of a major suspicion: the modernist universal, according to this logic, was nothing but a mask for the dominant white male voice. The theory of deconstruction, incarnated by Jacques Derrida, enables its practitioners to detect unspoken traces of homophobia, racism, phallocentrism, or sexism beneath the surface of the founding texts of political, philosophical, and aesthetic modernism. Through a kind of double negation or reverse deafness, the postmodern scene endlessly reenacts the rift between colonizer and colonized, master and slave, keeping to the frontier—its object of study—and thereby preserving it as such. Between modern universalism and postmodern relativism, it is said, we have no choice.

Postcolonial deconstruction has thus facilitated the substitution of one language for another, the new one contenting itself with subtitling the old one, without ever getting started on the process of translation that would establish a possible dialogue between past and present, the

05 THOMAS MCEVILLEY, *ART & OTHERNESS: CRISIS IN CULTURAL IDENTITY* (KINGSTON, NY: DOCUMENTEXT / MCPHERSON, 1992), 135.

universal and the world of differences. Postmodern thought presents itself as a decolonizing methodology, the core tool of which, deconstruction (more as it is practiced in cultural studies than as Derrida understood it), serves to weaken and delegitimate the master's language in favor of an impotent cacophony. Emancipation, resistance, alienation: these concepts born of Enlightenment philosophy, concepts that were criticized but at the same time legitimated by the anticolonial struggles and then by postcolonial studies, have become conceptual fetters from which we must free ourselves in order to rethink the relationship of contemporary works to power and politics.

The time seems ripe to reconstruct the "modern" for the present moment, to reconfigure it for the specific context in which we are living. For there is a modern eon, an intellectual spirit of modernity that traverses time, a mode of thought that assumes the shape that circumstances impress upon it and accommodates itself to the particular contours of the obstacle it confronts in a given epoch. Today this adversary has a thousand names, among them the aforementioned *animal humanism*, various strains of nostalgia for the old order, and above all the homogenization of the planet now underway in the guise of economic globalization. Although this spirit, this modern fluid, has not yet congealed in an original and identifiable form, we can nevertheless already perceive without difficulty what obstacles it must today exert itself against. Thus, we can assert, in these early years of the century, that it is possible to reclaim the concept of modernity without for an instant feeling that it's a throwback and without ignoring salutary criticisms of the totalitarian temptations and colonialist claims of the modernism of the last century. Avant-garde, universalism, progress, radicality: all these notions are linked to that modernism of the past, and it is by no means necessary to embrace them again in order to lay claim to modernity—that is, in order to take a step beyond postmodern borderlines, boundaries born of an aesthetic Yalta that no longer delimits anything but regions dominated by the most banal convention.

A number of authors and artists have already taken this step, though the novel space in which they are feeling their way has yet to be named. But at the heart of their practices are crucial principles on the basis of which a modernity could be reconstituted. Principles that may be enumerated: a focus on the present, experimentation, the relative, the fluid. The present, because the modern ("what belongs to its time," for such is its historical definition) is a passion for the current, for today understood as seed and beginning—against conservative ideologies that would embalm it, against reactionary movements whose ideal is the restoration of this or that time past, but also, in a manner that distinguishes our modernity from preceding ones, against futurist prescriptions, teleological notions of all sorts, and the radicality that accompanies them. Experimentation, because being modern means daring to seize the occasion, the *kairos*. It means *venturing*, not resting contentedly with tradition, with existing formulas and categories; but seeking to clear new paths, to become a test pilot. To be equal to this risk, it is also necessary to call into question the solidity of things, to practice a generalized relativism, a critical comparatism unsparing of the most tenacious certainties, to perceive the institutional and ideological structures that surround us as circumstantial, historical, and changeable at will. "There are no facts," wrote Nietzsche, "only inter-pretations."[06] This is why the modern favors the event over monumental order, the ephemeral over an eternity writ in stone; it is a defense of fluidity against omnipresent reification.[07]

If, at the beginning of this century, it is important to "rethink the modern" (which thus means moving beyond the historical period defined by

06 FRIEDRICH NIETZSCHE, *THE WILL TO POWER*, TRANS. WALTER KAUFMANN (NEW YORK: VINTAGE BOOKS, 1968), 267 (481); TRANSLATION MODIFIED.

07 FOR A TRANSHISTORICAL ACCOUNT OF MODERNITY THAT EXPLORES THE IMPERATIVE TO "MAKE YOUR LIFE A WORK OF ART," SEE THE AUTHOR'S *FORMES DE VIE: L'ART MODERNE ET L'INVENTION DE SOI* (PARIS: ÉDITIONS DENOËL, 1999).

the postmodern), it is necessary first to tackle globalization, understood in its economic, political, and cultural aspects. Still more important, it is necessary to grapple with a blindingly obvious fact: if twentieth-century modernism was a purely Western cultural phenomenon, later picked up and inflected by artists the world over, today there remains the task of envisaging its global equivalent, that is, the task of inventing innovative modes of thought and artistic practices that would this time be directly informed by Africa, Latin America, or Asia and would integrate ways of thinking and acting current in, say, Nunavut, Lagos, or Bulgaria. This time around, to have an impact, African tradition won't have to influence new Dadaists in a future Zurich, nor will Japanese print art have to rely on inspiring tomorrow's Manets. Today's artists, whatever latitudes they live in, have the task of envisaging what would be the first truly worldwide culture. But there is a paradox bound up with this historic mission, which will have to be undertaken not in the wake of, but in resistance against, that political pressure to conform known as globalization. In order for this emergent culture, born of differences and singularities, to come into being, instead of conforming to the ongoing standardization, it will have to develop a specific imagination, relying on a logic unlike that which presides over capitalist globalization.

In the nineteenth century, in Europe, modernity crystallized around the phenomenon of industrialization. In these early years of the twenty-first century, our ways of seeing and acting have been transformed in a similarly brutal way by economic globalization. Globalization is our "barbarism," to use the term by which Nietzsche named the gamut of forces that was exploding the old frontiers and reconfiguring the space of "farmers."[08] According to the *2002 International Migration Report* of the United Nations, the number of migrants has doubled

08 FRIEDRICH NIETZSCHE, *THE GAY SCIENCE*, ED. BERNARD WILLIAMS, TRANS. JOSEFINE NAUCKHOFF, POEMS TRANS. ADRIAN DEL CARO (CAMBRIDGE, UK: CAMBRIDGE UNIVERSITY PRESS, 2001), 32.

since the 1970s. About 175 million people are living outside their native countries, a number that continues to rise and is doubtless under-estimated. The escalating flow of money and migrants, the fact that expatriation has become commonplace, the mushrooming of transport networks, and the explosion of mass tourism are fashioning new transnational cultures—which in turn are triggering angry retreats into ethnic or national identity. For if there are approximately 6,000 languages in the world, a mere 4% of these languages are used by 96% of the global population. Moreover, half of these 6,000 dialects are headed for extinction.

Since my first travels to India in the 1980s, I have been able to witness the extraordinary spread of Western norms within a culture that is nonetheless highly self-sufficient. American pop stars now fill the celebrity pages of national dailies, shopping malls are flourishing, and a new generation of artists is deftly employing the codes of contemporary international art. This trend toward standardization goes hand in hand with the imagined shrinking of the planet, which is accompanied by technical improvements in representing it. Thus, satellite images have made it possible to fill in the last empty spaces on the map of the world; there are no longer any unknown lands. We are living in the era of Google Earth, which allows us to zoom in on any point on the planet from our computers. Across this divided-up planet, a globalized cultural stratum is developing with stunning rapidity, nourished by the Internet and the networking of major media outlets, while local or national particularisms find themselves sentenced to "protected" status, like those Tanzanian rhinoceroses on the path to extinction.

In 1955, in *Tristes Tropiques*, Claude Lévi-Strauss was already expressing concern about this disastrous "monoculture" that is exhausting the imagination and ways of life on Earth. During a trip to the West Indies, the French ethnologist visited several rum distilleries. In Martinique, where manufacturing processes had remained the same

since the eighteenth century, he had been able to sample a "mellow and scented" concoction, while the modern plants of Puerto Rico, "a display of white enamel tanks and chromium piping," produced only a rough, unrefined alcohol. This contrast, according to the ethnologist, illustrated "the paradox of civilization: its charms are due essentially to the various residues it carries along with it, although this does not absolve us of the obligation to purify the stream."[09] Lévi-Strauss's rum perfectly exemplifies this generic modernity, henceforth synonymous with technical progress and standardization. In ordinary language, "modernizing" has come to mean reducing cultural and social reality to Western formats. And today, modernism amounts to a form of complicity with colonialism and Eurocentrism. Let us bet on a modernity which, far from absurdly duplicating that of the last century, would be specific to our epoch and would echo its problematics: an *altermodernity*, if we dare coin the term, whose defining issues and features this book seeks to sketch out.

For thirty years, the global cultural landscape has been shaped, on the one hand, by the pressure of the overproduction of objects and information, and, on the other, by the rampant standardization of cultures and languages. The dense chaos of cultural objects and works within which we are evolving encompasses both present production and that of the past, since the museum of the imagination henceforth extends to every civilization and continent, which was not the case in the past. "For Baudelaire, sculpture began with Donatello," recalled Malraux. For an amateur at the beginning of the twenty-first century, the domain of sculpture includes Taino art as much as Paul McCarthy's mechanical stuffed animals, Donald Judd's installation in Texas as well as the temples of Angkor. The Internet is the privileged medium of this proliferation of information, the material symbol of this atomization of

09 CLAUDE LÉVI-STRAUSS, *TRISTES TROPIQUES*, TRANS. JOHN AND DOREEN WEIGHTMAN (NEW YORK: PENGUIN, 1974), 386.

knowledge into multiple specialized and interdependent niches.

What postmodernism calls hybridization involves grafting onto the trunk of a popular culture that which has become uniform markers of "specificity"—features, usually caricatured, of a distinctive ethnic, national, or other cultural identity—just as mass-produced candies are infused with different synthetic flavors. Today only two cultural models, themselves contradictory, seem to resist these tendencies: on the one hand, the withdrawal into national, ethnic, or cultural identity [*repli identitaire*], the resurgence of traditional and local aesthetic values; on the other hand, what is called, after the Caribbean model, *creolization*, a process involving acclimatization and crossbreeding of heterogeneous influences. "The world is becoming creolized," explains West Indian writer Édouard Glissant; "that is to say that the cultures of the world are furiously and knowingly coming into contact with each other, changing by exchanging, through irremediable collisions and ruthless wars—but also through breakthroughs of moral conscience and hope."[10]

In a world growing ever more uniform with each passing day, we can defend diversity only by raising it to the level of a cherished value, one that exceeds the immediate attraction of the exotic and knee-jerk instincts of conservation—that is to say, only by establishing it as a conceptual category. Otherwise, what is the case for diversity? Why would it be preferable to a globalized cultural Esperanto, which would after all represent the fulfillment of the old fantasy of a worldwide culture? The texts of Victor Segalen, the prodigious French writer and traveler who died in 1919, provide striking matter for reflection. His *Essay on Exoticism*, flying in the face of all modernist analyses, is a plea for the diverse against the generalized flattening of differences whose disastrous consequences Segalen already perceived at the

10 ÉDOUARD GLISSANT, *INTRODUCTION À UNE POÉTIQUE DU DIVERS* (PARIS: GALLIMARD, 1996), 15.

beginning of the twentieth century. In *Essay on Exoticism*, a new figure emerges, for whom Segalen coins the term *exote*. The figure of the *exote* helps us better appreciate today's art, which is haunted by figures of travel, expedition, and global dislocation.

As we have said, the most common defensive reaction consists of exalting difference as substance. If I am Ukrainian, Egyptian, or Italian, I should therefore resist the forces of uprooting—ill winds blowing from who knows where—and conform to those national historical traditions that allow me to structure my presence in the world as a mode of identity. Born into a specific context, I am called upon to perpetuate the old ways that distinguish me from others. But who are those *others*? It is surprising to note that the question of identity is most pressing for immigrant communities in the most globalized countries: the satellite dishes in ethnic ghettos, isolation within customs that cannot be adapted to the host country, grafts that do not take. It is *roots* that make individuals suffer; in our globalized world, they persist like phantom limbs after amputation, causing pain impossible to treat, since they affect something that no longer exists. Rather than set one fixed root against another, a mythologized "origin" against an integrating and homogenizing "soil," wouldn't it make more sense to assign them to other conceptual categories, ones suggested by a global imagination in the process of mutation? 175 million people on the planet living in more or less voluntary exile; about 10 million more every year; professional nomadism increasingly commonplace; unprecedented circulation of goods and services; the formation of transnational political entities—couldn't this novel situation give rise to a new way of conceptualizing cultural identity?

Let's talk botany. The contemporary world, by orchestrating the material conditions of movement, facilitates our transplantations. Flowerpots, nurseries, greenhouses, open country. Is it only coincidence that modernism was from start to finish a tribute to the root? It was radical.

In the course of the twentieth century, artistic (and political) manifestos appealed for a return to the origin of art or of society, to their purification, with the aim of rediscovering their essence. It was a matter of cutting off useless branches, subtracting, eliminating, rebooting the world from a single master principle that was presented as the foundation of a liberating new language.

Let us wager that our own century's modernity will be invented precisely in opposition to all radicalism, dismissing both the bad solution of re-enrooting in identities as well as the standardization of imaginations decreed by economic globalization. For contemporary creators are already laying the foundations for a radicant art—*radicant* being a term designating an organism that grows its roots and adds new ones as it advances. To be radicant means setting one's roots in motion, staging them in heterogeneous contexts and formats, denying them the power to completely define one's identity, translating ideas, transcoding images, transplanting behaviors, exchanging rather than imposing. What if twenty-first-century culture were invented with those works that set themselves the task of effacing their origin in favor of a multitude of simultaneous or successive enrootings? This process of obliteration is part of the condition of the wanderer, a central figure of our precarious era, who is insistently emerging at the heart of con-temporary artistic creation. This figure is accompanied by a domain of forms—the domain of the journey-form—as well as by an ethical mode: translation, whose modalities this book seeks to enumerate and whose cardinal role in contemporary culture it seeks to demon-strate.

ALTERMODERNITY

ROOTS: A CRITIQUE OF POSTMODERN REASON

In contemporary aesthetic thought, the "critical dimension" of art represents the most common criterion of judgment. Reading art catalogues and journals that mechanically echo this ideology of suspicion and turn the "critical" coefficient of works into a touchstone able to differentiate good from evil, the interesting from the insignificant, how can one escape the impression that works are no longer evaluated so much as sorted and graded like eggs on a production line? Such pigeonholing is well attested; it was already the dominant approach at the end of the nineteenth century, another era in which academicism privileged the subject (which must not be confused with the content) over form (which is not simply a matter of visual pleasure). In postmodern times, we are once again seeing works that flaunt edifying sentiments in the guise of a critical dimension, images that are able to win acceptance despite their formal poverty by foregrounding their militant or minority status, and aesthetic discourses that exalt difference and multiculturalism without really knowing why.

The numerous aesthetic theories born of the nebulous alliance of cultural postcolonialism have failed to elaborate a critique of modernist ideology that does not lead to an absolute relativism or to a piling up of "essentialisms." In their most dogmatic form, these theories go so far as to obliterate any possibility of dialogue among individuals who do not share the same history or cultural identity. The threat should not be minimized: through the pressure of caricature, the comparatist ideology underlying postcolonial studies is paving the way for a complete atomization of references and criteria of aesthetic judgment. If I am a Western white man, for instance, how can I exercise critical judgment on the work of a black Cameroonian woman without running the risk of inadvertently imposing on it an outlook corrupted by Eurocentrism? How can a heterosexual critique the work of a gay artist without relaying a dominant perspective? But even if the suspicion of Eurocentrism or phallocentrism were to be established as critical

norms, the problem of the periphery would remain intact: the center is designated, with Enlightenment philosophy in the defendant's seat. But what is the charge? Homi Bhabha presents postcolonial theory as an active refusal of the "binary and hierarchical" vision that characterizes Western universalism.[11] Gayatri Spivak, an important figure in "subaltern studies," wants to *dewesternize* the very concepts through which alienation is thought. These projects have had salutary consequences, but it is their perverse effects that I am focusing on here, effects which transform the modern outlook that grew out of the Enlightenment into something unrecognizable, something both omnipresent and reviled, ceaselessly deconstructed yet untouchable. Jacques Lacan would accord it the status of an *objet petit a*, which is to say an object existing only as shadow, an empty center, visible only indirectly, in the form of its anamorphoses. This modernist totem thus offers a strange analogy with capital, denounced and despised but at the same time considered untouchable, endlessly deconstructed yet left intact.

"Postmodernism," write Antonio Negri and Michael Hardt, "is indeed the logic by which global capital operates," for it constitutes "an excellent description of the ideal capitalist schemes of commodity consumption" through notions such as difference, cultural multiplicity, mixture, and diversity.[12] Postmodern theories, they go on to say, can thus be understood as the homologous counterparts of religious fundamentalisms, the former attracting the "winners" of globalization, the latter its "losers." Once again we rediscover that binarism (hip uprootedness versus enrootedness in identity) from which it is increasingly urgent that we extricate ourselves by using the resources of modern culture. The work of reconstituting a new modernity—whose strategic task would be to strive for the dissolution of postmodernism— entails first of all inventing a theoretical tool with which to combat

11 HOMI BHABHA, *THE LOCATION OF CULTURE* (LONDON: ROUTLEDGE, 1994).

12 MICHAEL HARDT AND ANTONIO NEGRI, *EMPIRE* (CAMBRIDGE, MA: HARVARD UNIVERSITY PRESS, 2001), 152.

everything in postmodern thought that in practice supports the trend toward standardization inherent in globalization. It is a matter of identifying what is valuable and extracting it from the binary and hierarchical schemes of yesterday's modernism as well as from regressive fundamentalisms of all sorts. It is a matter of opening up an aesthetic and intellectual region in which contemporary works might be judged according to the same criteria—in brief, a space for discussion.

In the meantime, we are witnessing the emergence of a kind of postmodern aesthetic *courtesy*, an attitude that consists of refusing to pass critical judgment for fear of ruffling the sensitivity of the other. Granted, this overblown version of multiculturalism is based on well-meaning sentiments, that is to say, desire for recognition of the other as *other* (Charles Taylor). But the perverse effect of this courtesy is that it implicitly leads us to view non-Western artists as guests to be treated with politeness, and not as full-fledged actors on the cultural scene in their own right. For what could be more insulting and paternalistic than discourses that dismiss out of hand the possibility that a Congolese or Laotian artist could be pitted against Jasper Johns or Mike Kelley in a shared theoretical space and made the object of the same criteria of aesthetic evaluation? In postmodern discourse, "recognition of the other" too often amounts to pasting the other's image into a catalogue of differences. *Animal humanism*? This so-called "respect for the other," at any rate, generates a kind of reverse colonialism, as courteous and seemingly benevolent as its predecessor was brutal and nullifying. In *Welcome to the Desert of the Real*, Slavoj Žižek cites an interview with Alain Badiou in which the latter recalls that the concept of respect for the other would be meaningless, for example, to a resister engaged in the struggle against the Nazis in 1942, or even "when one must judge the works of a mediocre artist."[13] Thus, this notion of respect or recognition of the other in no way represents "the most basic of ethical principles," as one might be led to believe from reading Charles Taylor. We must move beyond the

peaceful and sterile coexistence of reified cultures (multiculturalism) to a state of cooperation among cultures that are equally critical of their own identity—that is to say, we must reach the stage of translation.

The stakes are immense. It is a question of rewriting "official" history in favor of plural accounts, and in the process working out the possibility of dialogue among these different versions of history. Without this, the trend toward cultural standardization will only escalate, reassuringly masked by the idea of "recognizing the other," where the other is conceived as a species to be preserved. Gayatri Spivak defends the idea of a "strategic essentialism," in which minority individuals or groups lay claim to the cultural substance on which they found their identity, which permits these "subalterns" to gain a voice in the context of globalized imperialism. Spivak is known to view all cultural identity as potentially susceptible to deconstruction, but she proposes this detour "in a scrupulously visible political interest."[14] Is this tactic truly efficacious? An "essence," the dictionary tells us, is "what makes something what it is"; essentialism thus refers to what is stable and immutable in a system or concept. That the origin thus takes precedence over the destination in the life of forms and ideas turns out to be the dominant postmodern motif.

Why should Patagonian, Chinese, or Iranian artists be required to produce their cultural difference in their works, while American or German artists find themselves judged on their critiques of patterns of thought, or on their resistance to authority and the dictates of convention? Lacking a common cultural space since the collapse of modernist universalism, Western individuals have felt obliged to

13 CHRISTOPHER COX AND MOLLY WHALEN, "ON EVIL: AN INTERVIEW WITH ALAIN BADIOU," *CABINET*, NO. 5 (WINTER 2001): 72, QUOTED IN SLAVOJ ŽIŽEK, *WELCOME TO THE DESERT OF THE REAL* (LONDON: VERSO PRESS, 2002), 67.

14 GAYATRI SPIVAK, *IN OTHER WORLDS: ESSAYS IN CULTURAL POLITICS* (NEW YORK: ROUTLEDGE, 1988), 205.

regard the other as a representative of the true, and to do so from a locus of enunciation by which a narrow barrier separates them from the other. Commenting both on *Magicians of the Earth* and on *Sharing Exoticisms*, the exhibition that he organized for the Lyon Biennial in 2001, Jean-Hubert Martin explains that "the great change marking this *fin de siècle* is that now it is possible for every artist in the world, whether his inspiration is religious, magical, or otherwise, to achieve global fame in accord with the codes and references of his own culture."[15] Thus, we find ourselves confronting an aporia: although we know that the universal master narrative of modernism is obsolete, the idea of judging each work according to the codes of its author's local culture implies the existence of viewers who have mastered each culture's referential field, which seems difficult to say the least. But after all, why not imagine an ideal viewer with the properties of a universal decoder? Or why not accept the idea that judgment must be suspended indefinitely? In a sort of Faustian pact with an other fantasized as the keeper of political and historical truth, art criticism willingly views itself as a kind of neo-anthropology that aspires to be the quintessential science of otherness.[16]

One cannot help but be struck, however, by the dichotomy between this humanist proposition (judge each artist "in accord with" his own culture) and the real movement of social production: in an era in which ancient particularities are being eradicated in the name of economic efficiency, aesthetic multiculturalism urges us to examine with particular care cultural codes that are on the path to extinction, and in doing so makes contemporary art into a conservatory of traditions and identities that are in reality being wiped out by globalization. One might speak of a productive tension here, but I see a contradiction, even a trap. But the crux of the matter lies in the expression used by Jean-Hubert

15 *PARTAGES D'EXOTISMES*, CATALOGUE OF THE LYON BIENNIAL, 2001, 124.

16 HAL FOSTER, *THE RETURN OF THE REAL* (CAMBRIDGE, MA: MIT PRESS, 1996).

Martin—"in accord with." Not "by conforming to or following their codes and references," which would indicate something exclusive, but by harmonizing their codes with other codes, by making their singularity resonate with a history and with problems born of other cultures. In short, by an act of translation. Indeed, today translation may represent that "basic ethical effort" that has been mistakenly associated with recognition of the other as such. For translation always implies adapting the meaning of a proposition, enabling it to pass from one code to another, which implies a mastery of both languages but also implies that neither is self-evident. The gesture of translation in no way prevents criticism or even opposition; in any case, it implies a presentation. In performing it, one denies neither the unspeakable nor possible opacities of meaning, since every translation is inevitably incomplete and leaves behind an irreducible remainder.

It is worth noting that within the crypto-humanist discourses born of cultural studies and postcolonial studies, the sole element that has been bequeathed without argument is the sphere of technology. Thus, in art, video is becoming *a lingua franca* thanks to which artists, whatever their nationality, can legitimately show off their cultural differences, which are then inscribed in the new context constituted by the technological apparatus, a context that is universalist by default.

Yet video is by no means a neutral technology or discipline; the proliferation of the documentary genre that has taken place since the beginning of the 1990s responds to a dual need for information and thorough reexamination. The need for information stems from the fact that certain former functions of cinema—functions that Roberto Rossellini and the French New Wave exalted in their time (recall the concept of "ontological realism," which makes of each fiction a documentary of the time and place it is recorded)—are increasingly being abandoned to contemporary art by a film industry that is no

longer interested in the external world as anything but a storehouse of settings and plots. For Hollywood films no longer bear witness to the way people live. Giving news of the world, registering changes in our environments, showing how individuals move around in or form part of those environments: most so-called auteur films fulfilled these tasks, some more diligently than others. In the past, that is, cinema brought us information about the world around us; now, it seems, this role is for the most part entrusted to contemporary art. The proliferation of long viewing sessions at biennial exhibitions and the increasing artistic legitimacy of the documentary genre indicate above all that this type of object is no longer commercially viable outside the art circuit, and also that the simple need for news of the world is today more often satisfied in art galleries than in movie theaters. This reversal of the roles of art and cinema also extends to the aesthetic domain, with the invasion of cinema by what Serge Daney calls "the visual" (the application to the cinematic image of the principles of advertising) and the problematic character of the image in art. To make a long story short, while film has been moving more and more toward the image (to the detriment of the shot), art has been going in the opposite direction, fleeing the symbol to confront the real through the documentary form. Certainly this phenomenon is in part the effect of a productive encounter between art and film, but it is also, alas, an effect of the law of profit, which transfers unprofitable products to a less costly system of production.

The documentary form has the immediate virtue of reconnecting signs to real referents. In the videos of Jennifer Allora and Guillermo Calzadilla, Kutluğ Ataman, Shirin Neshat, Francis Alÿs, Darren Almond, and Anri Sala, the "exotic" context plays a significant role, and one that goes beyond the subject at hand. Instinctively, viewers seek news of the planet in these videos, information about elsewhere, about the other. Here it is not the manner in which the world is represented that turns out to be other, but the reality these artists are framing with their

camera; the audience is hungry for information. "I come from there," the artist could say, "but I am showing you images of my universe using the format that is most familiar to you, the televised image."

Kutluğ Ataman plays with this familiarity in his imposing installation *Kuba*. In a dimly lit space, a horde of television sets of various origins are installed in a rectangular formation on precarious tables and desks, each broadcasting the image and letting us hear the monologue of a different inhabitant of Kuba, a slum in the suburbs of Istanbul. More than the chaotic compositions of Nam June Paik, which this assemblage of televisions might call to mind, Ataman's work combines the formal design of the electronics store with that of the classroom. Whether gathering the voices of transvestites or those of refugees, Ataman belongs to the tradition of a Pasolini filming in the Roman suburb a local piece of the Third World. It may be demagogic, paternalistic, simplistic, like most of this sort of production, yet the televisual frame that the artist imposes on his models, whose words are lost in a forest of sounds and images coming from a multitude of outmoded monitors, more adequately represents the contemporary tragedy than does a charity benefit show. We must get closer to hear a particular voice; we must pay attention, as would a casual visitor.

What does it mean today to be American, French, Chilean, Thai? Already these words do not have the same meaning for those who live in their native country and those who have emigrated. What it means to be Mexican in Germany has little to do with what it means to be Mexican in Mexico. With the standardizing tide of globalization traversing virtually all nation states, the portable dimension of national identities has become more important than their local reality. Jean-Paul Sartre, in *War Diaries: Notebooks from a Phony War*, recounts that in fall 1939, under the Nazi threat, the French government organized the exodus of entire villages from Alsace to Limousin, which was then

a very backward area. The fact that these Alsatians were transplanted village by village induced among them a fixation on their rites, customs, and collective representations, but in a context in which these particularities no longer signified anything, since they were no longer reflected in the climate or architecture that had previously given them a material basis: "Not surprisingly, the more that social ritualism comes to lack real foundations," explains Sartre, "the more exacerbated and frenetic it becomes. It is now a kind of landless society, dreaming its spirituality instead of apprehending it through the thousand and one tasks of everyday life. This spurs pride as a defensive reaction, and an unhealthy tightening of social bonds. The result is a frenetic, upside-down society."[17] What better image could there be for the French *banlieues** or for American neighborhoods in which immigrant communities cluster? Still more remarkable, however, is the fact that this account of villages relocated during World War II also describes the cultural condition today of an average European with the advent of globalization. The "ground" is giving way; we are told to compromise our rituals, our culture, and our history, now confined to standardized urban contexts that no longer reflect any image of us, except in locations reserved for that purpose: museums, monuments, historic districts. Our environments no longer reflect history; rather, they transform it into a spectacle or reduce it to the limits of a memorial. Where can it be rediscovered? In portable practices. It is in the domain of everyday lifestyles—images, clothing, cuisine, and rituals—that immigrants tinker, far from the gaze of the masters of the soil, piecing together a fragile and deracinated culture whose essential quality is that it is detachable. These portable forms are arranged and one way or another

17 JEAN-PAUL SARTRE, *WAR DIARIES: NOTEBOOKS FROM A PHONY WAR* (LONDON: VERSO, 1999), 43.

***** TRANSLATOR'S NOTE: WHILE THE WORD *BANLIEUE* MAY LITERALLY BE TRANSLATED AS SUBURB, IN FRANCE THE *BANLIEUES* CONJURE IMAGES OF POVERTY, VIOLENCE, AND DECAY; THEY ARE ASSOCIATED WITH HOUSING PROJECTS AND IMMIGRANT COMMUNITIES. THUS, THE WORD *BANLIEUE* HAS CONNOTATIONS CLOSER TO THOSE OF "INNER CITY" OR "SLUM" OR "GHETTO" THAN TO THOSE OF "THE SUBURBS."

installed on a cultural landscape that did not anticipate them. They grow like wildflowers, sometimes provoking violent rejection. Thus, culture today essentially constitutes a mobile entity, unconnected to any soil, while the phenomena of diaspora are still reflexively conceptualized in the outdated terms of enrootedness and integration.

Postmodern multiculturalism has failed to invent an alternative to modernist universalism, for everywhere it has been applied it has recreated cultural anchorages or ethnic enrootedness. For just like classical Western thought, postmodern multiculturalism operates on a logic of membership. A work of art is thus inevitably explained by the "condition," "status," or "origin" of its author. The work of a black, gay or lesbian, Cameroonian, or second-generation Mexican immigrant artist will thus mechanically be read through the prism of this biopolitical framework that is, however, every bit as normative as the others. Thus, everyone is located, registered, nailed to a locus of enunciation, locked into the tradition in which he or she was born. "Where do you speak from?" critics ask, as if human beings must always stand in the same place and in one place only, and as if they could have at their disposal only a single tone of voice and a single language with which to express themselves. This is the blind spot of postcolonial theory when applied to art: it conceives the individual as definitively assigned to his or her cultural, ethnic, or geographic roots. In doing so, it plays into the hands of the powers that be, which profoundly desire subjects who enounce their own identity, thereby facilitating their statistical classification. Similarly, what the art market wishes is to have simple categories and recognizable images at its disposal so as to facilitate its distribution of products. Multiculturalist theories have thus merely reinforced the powers that be, for they have fallen into the trap that was laid for them: struggling against oppression and alienation through an act of symbolic house arrest—that of essentialist theme parks. And yet, as Claude

Lévi-Strauss wrote: "The one real calamity, the one fatal flaw which can afflict a human group and prevent it from achieving fulfillment is to be alone."[18]

This idea of territorial assignment has its source in a modernist ideology that it claims to refute, but which the radical left sustains on life support by borrowing ways of thinking used by anticolonial struggles throughout the twentieth century, concepts through which we perceive every fight for liberty: emancipation, resistance, alienation. Postmodern discourse takes up these conceptual categories and applies them as they are (without modification) to other social or historical objects.

In his famous essay *The Wretched of the Earth*, Frantz Fanon explains that the ultimate weapon of the colonizer is his ability to impose his image over that of the colonized people. It proved necessary to destroy those intrusive images in order to rediscover, beneath the layer that was obscuring them, those of the peoples struggling for their independence. Indeed, how could anyone fail to notice that today more than ever, the political struggle is a struggle over representations? According to Fanon's contemporary disciples, it is thus essential to replace a history dominated by "dead white males" with what they rightly call "a genuine historical pluralism," that is, by integrating the voices of the defeated into the monophonic narrative of history. Yet the repressive and totalitarian destiny of the bulk of African countries that attained independence ought to have taught us a few things: once emancipation has been obtained, anticolonialism is not a substitute for political thought; by extension, it can by no means provide the basis for a viable aesthetic and cultural project. The anticolonial model, which permeates cultural studies and discourses on art, undermines the foundations of modernism without, however, replacing them with anything other than that very gesture of hollowing out; that is to say, with emptiness. And in

18 CLAUDE LÉVI-STRAUSS, *RACE AND HISTORY* (UNESCO, 1958), 43.

that tireless deconstruction of the Western white male voice, we scarcely hear anything anymore but the soft voice of an aimless negativity.

Today this postcolonial discourse appears hegemonic, for it is perfectly inscribed within postmodern identitarian ideology. If one were to caricature it, one could do so thus: the works of the past were merely the products of the historical conditions in which they appeared, and we should interpret them from an ethno-sociological perspective, whereas contemporary works can be explained by their birth in the universal megalopolis from which they draw their spontaneous meaning. The city, the city, the city. Postmodernism has thus replaced the abstract and theoretical universalism of modernism with another form of totalization, at once symbolic and empirical: that of an infinite urban environment that would be the arena for an identity struggle between immigrants and natives, and for territorial conflict between public space and private property. Thus becomes visible the primitive scene of postmodern ideology: the construction of a gigantic film set, before which rises the scaffold whereon what was once the modern event is to be liquidated—dissected and pulverized in an identitarian multiculturalism. The concept of the event, theorized by Alain Badiou, allows us to consider the question of modernity in a different way: to what are we faithful? To what historical fact are we binding our action? The theoretical stake of this essay could be said to boil down to the philosophical decision to remain faithful to the program opened up by modernism qua event in the realm of ideas (while picking and choosing among its parts), without, however, perpetuating it as form, for it is neither a matter of embracing the fetishization of modernist principles fashionable in art today, nor of relegating to the past the spirit that animated it.

A clever and widespread strategy is to assign modernism to the beginning of the twentieth century by tying it to the radical political ideologies that formed its historical backdrop and by pinning it

once and for all to the map of revolutionary "terror." But such a strategy entails reducing the modern event to an outgrowth of history, limiting it to being merely the product of its time. The works of Kazimir Malevich and Marcel Duchamp cannot, however, be considered simple products of history and of the sociopolitical circumstances that saw their birth. They are not merely the logical result of a series of determinisms, but they also constitute events that generate effects and influence their epoch—in short, produce history. If postmodern critical thought insists so forcefully on a one-way relation of influence between art and history, it is because such a relation is at the heart of the politics of assignment, of the ideology of belonging (to a place, to a moment) that underlies its core discourse. Postmodern thought thus arises as the negation of those powers of decentering, of setting in motion, of unsticking, of de-incrustation; powers that are the foundation of the emerging culture that I term here *altermodern*.

Feminist thought and recent political theories of sexuality inspired by the works of Michel Foucault and Jacques Lacan analyze the post-identitarian regime into which contemporary individuals have entered, affirming that we are no more definitively assigned to our culture or to our country than to a gender. Judith Butler considers it a given that "there is no self-identical subject."[19] As concerns sexuality, the notion of identity has been supplanted by that of actions performed, by the concept of staging the Self, which implies the perpetual mobility of the subject. Sexual identity, Butler explains, is nothing but a game of codes, an articulation of signs that an individual takes on without subscribing to them, merely citing sexual norms rather than identifying irrevocably with any one of them. Thus, we are all potentially queer: not only sexual assignment but all elements of our identity are a product of such gestures, moves that can be played on the chessboard of culture. Cultural life is thus formed of tensions between the reification,

19 JUDITH BUTLER, *BODIES THAT MATTER* (LONDON: ROUTLEDGE, 1993), 230.

pure and simple, presupposed by self-assignment to a readymade category (such as being an amateur opera-lover, a teenage goth, a reader of historical fiction) and the idea of activating or risking identities, which implies a struggle against all attachments and the assertion that consumption of cultural signs does not imply any durable connotation of identity. By definition, we are not what we wear. In 1977, English punks wore Nazi and communist buttons side by side on their leather jackets. Displayed together, those swastikas and sickles above all signified hatred of any logic of ideological assignment: against conclusive evidence (the notion that people must represent the signs they wear, rather than the reverse), the punks chose floating paradox. The only things pinned to their jackets were signs emptied of meaning by the shock of their coexistence. Membership in an identitarian community depends on this logic of political buttons. Wrapped in signs whose coherence is certified by a tradition, in aesthetic and intellectual clothing that is thought to form a "natural body," the contemporary nationalist turns out to be an unwitting drag queen.

I asserted above that it should be possible for a Congolese or Laotian artist to be pitted against a Jasper Johns or a Mike Kelley in the same theoretical space and assessed according to the same set of aesthetic criteria. Against this proposition, the postmodernist reflex consists of denouncing the attempt to bring Congolese or Laotian identity into alignment with a single aesthetic system, since such a system must be suspected of universalism. Yet the identitarian compartmentalization on which the postmodern ethic is based is the foundation for a form of discrimination that is all the more subtle, and maintains Western cultural domination all the better for being practiced under the mask of generosity worn by an ideology of "recognizing the other." But if it is really "in accord with the codes and references of [their] own culture"—to use once again Jean-Hubert Martin's terms—that the works of Barthélémy Toguo, Kim Soo-Ja, and Chris Ofili can be interpreted, these cultural codes and identitarian references

would be nothing more than folkloric elements if they were not connected to that construction plan formed by the system of art, a foundation that historically depends—at least to a large extent—on Western culture. Is its Western origin sufficient grounds for disqualifying this construction plan? Yes, if one believes that the future of art depends on the simple coexistence of identities whose autonomy is to be preserved. No, if one thinks that each of these specificities can participate in the emergence of a modernity specific to the twenty-first century, a modernity to be constructed on a global scale, through cooperation among a multitude of cultural *semes* and through ongoing translation of singularities: an altermodernity.

This system of art, this construction plan, cannot function without a knowledge of its history. That history, however, is not self-enclosed but continuously enriched—thus, today we can make discoveries about the past, like that of the Crystalist movement in Ethiopia in the 1970s, or that of the tradition of tantric monochromatic paintings in seventeenth-century India. It is up to artists of all countries to appropriate this history for themselves in every sense. To take a recent example, the manner in which Rirkrit Tiravanija has forged connections between the Buddhist tradition and Conceptual art is an exemplary model of formal and historical transcoding. Conversely, Tsuyoshi Ozawa's gesture of renewing objects from traditional Japanese culture by introducing practices born of the Fluxus movement demonstrates that this transcoding can take original and singular paths. Buddhism augmented by Dan Graham, Fluxus augmented by the popular tradition of Japan: what these artists aim for in their works is not to accumulate heterogeneous elements, but to make meaningful connections in the infinite text of world culture. In a word, to produce itineraries in the landscape of signs by taking on the role of *semionauts*, inventors of pathways within the cultural landscape, nomadic sign gatherers.

But how can we simultaneously defend the existence of cultural singularities yet oppose the idea of judging works by those singularities, that is to say, refuse to judge them only in keeping with their traditions? It is this aporia that is both the basis of postmodern discourse and the cause of its ontological fragility. In other words, postmodernity consists in not responding to the question. For to formulate a response would require choosing between two conflicting options: one must either tacitly acquiesce to tradition, if one thinks that each culture generates its own criteria of judgment and must be evaluated according to these criteria, or else bet on the emergence of a system of thought capable of making connections between disparate cultures without denying each one's singularity. Postmodern discourse, which oscillates between critical deconstruction of modernism and multiculturalist atomization, implicitly favors a perpetual status quo. From this standpoint, it represents a repressive force, insofar as it helps maintain world cultures in a state of pseudo-authenticity, warehousing living signs in a nature park of traditions and modes of thought where they remain available for any merchandizing venture. What, then, threatens to disrupt this ideal reification? What is that studiously repressed object whose contours can be indirectly perceived in this ideological system? A word never to be pronounced: modernity. In other words, a collective project unconnected to any origin, one whose direction would transcend existing cultural codes and sweep their signs up in a nomadic movement.

What I am calling altermodernity thus designates a construction plan that would allow new intercultural connections, the construction of a space of negotiation going beyond postmodern multiculturalism, which is attached to the origin of discourses and forms rather than to their dynamics. It is a matter of replacing the question of origin with that of destination. "Where should we go?" That is the modern question par excellence.

The emergence of this new entity implies the invention of a new *conceptual persona* (in the sense that Deleuze and Guattari gave this term) that would bring about the conjunction of modernism and globalization. In order to define it, we need to reexamine one of the founding texts of twentieth-century thinking about art, "The Work of Art in the Age of Mechanical Reproduction," by Walter Benjamin. While this 1935 essay has usually been read in relation to the production of images, it also contains a code of ethics whose potential remains underappreciated. Benjamin defines the aura of the work of art as its "here and now," that is, "its unique existence at the place where it happens to be,"[20] the uniqueness that founds its authenticity and its history. With the technological reproduction of images, he explains, this notion of authenticity is shattered, but not only in the sphere of art: the new modes of production of the image imply both new relations of work and a redefinition of the subject. Taking cinema as a paradigmatic example of these new relations, he explains that each of us, in the crowd of the big cities, henceforth lives under the gaze of the camera. "The expansion of the field of the testable that the camera brings about for the actor is analogous to the extraordinary expansion of the field of the testable brought about for the individual through economic conditions."[21] The cinematic shot becomes the definitive model for control of human livestock, and it will considerably alter the exercise of political power. With the appearance of cinematic news, Benjamin continues, anyone can be filmed in the street; anyone can find in the emerging media the possibility of making him- or herself heard. Benjamin drew from this the surprising conclusion that "the distinction between author and public is about to lose its basic character. The difference becomes merely functional; it may vary from case to case."[22]

20 WALTER BENJAMIN, "THE WORK OF ART IN THE AGE OF MECHANICAL REPRODUCTION," IN WALTER BENJAMIN, *ILLUMINATIONS: ESSAYS AND REFLECTIONS*, TRANS. HARRY ZOHN, ED. HANNAH ARENDT (NEW YORK: SCHOCKEN BOOKS, 1968), 220.

21 IBID., 246.

On this particular point, we should take Benjamin at his word and suppose that the era he presaged has managed to produce a new figure of the subject, one rid of that psychological aura that a sacrosanct identity represents. This figure can be discerned in Benjamin's description of the prototype of the new proletarian: the film actor. The latter moves in a fragmented context that he does not master, where he "offers not only his labor but also his whole self, his heart and soul."[23] This section on the actor opens with a long citation from Luigi Pirandello, who essentially explains that "the film actor … feels as if in exile,"[24] that is to say, alienated from the images of himself that the film camera registers. According to Benjamin, "the feeling of strangeness that overcomes the actor before the camera … is basically of the same kind as the estrangement felt before one's own image in the mirror. But now the reflected image has become separable, transportable."[25] A transportable image, a moving mirror: in the world of unlimited reproduction, the destiny of the subject is that of a permanent exile. A century later, we move in a mental universe where each of us lives, every day, the experience of the actor in 1935. It is difficult for us to found our identity on solid ground, and this lack incites us to cling either to a community that provides an identity or else to a pure constructivism. In this world of the inauthentic, policed by the domestic technology of images and surveillance cameras, standardized by the global industry of the imagination, signs circulate more than the forces that animate them. We have no choice but to move in cultures without identifying with them, create singularity without immersing ourselves in it, and surf on forms without penetrating them. No doubt the destiny of man without an aura (thus without background, which here means without origin) is even more difficult to accept for Westerners, who are heirs to a culture

22 IBID., 232.

23 IBID., 231.

24 IBID., 229.

25 IBID., 230–31.

in which values tend toward totality and the universal. Yet this is the destiny we must assume today, unless we wish to opt for the rigid identities whose nationalisms and fundamentalisms offer us protective armor, or for the loose subject-groups proposed by postmodernism.

This dilemma can be expressed in the following way: On the one hand, there is the option of uniting with those who come from the same place, whether it be a nation, a culture, or a community of interests. On the other, there is the option of joining those who are heading toward the same place, even if their destination is hazy and hypothetical. The modern event, in essence, appears as the constitution of a group that cuts across clubs and origins by uprooting them. Whatever their type, their social class, their culture, their geographic or historical origin, and their sexual orientation, that group's participants constitute a troop that is defined by its speed and direction, a nomadic tribe cut off from any prior anchorage, from any fixed identity. To use another image, the modern moment is like an emulsion: the social and cultural liquid is stirred up by movement, producing an alloy that combines, without dissolving them, the separate ingredients that enter into its composition. What I term altermodern is precisely the emergence, at the beginning of the twenty-first century, of an analogous process: a new cultural precipitate, the formation of a mobile population of artists and thinkers choosing to go in the same direction. A start-up, an exodus.

This twenty-first-century modernity, born of global and decentralized negotiations, of multiple discussions among participants from different cultures, of the confrontation of heterogeneous discourses, can only be polyglot. Altermodernity promises to be a translation-oriented modernity, unlike the modern story of the twentieth century, whose progressivism spoke the abstract language of the colonial West. And this search for a productive compromise among singular discourses, this continuous effort at coordination, this constant elaboration of arrangements to enable disparate elements to function together,

constitutes both its engine and its import. The operation that transforms every artist, every author, into a translator of him- or herself implies accepting the idea that no speech bears the seal of any sort of "authenticity": we are entering the era of universal subtitling, of generalized dubbing. An era that valorizes the links that texts and images establish, the paths that artists forge in a multicultural landscape, the passageways they lay out to connect modes of expression and communication.

RADICALS AND RADICANTS

To better understand what is at stake in this process of unsticking identities and signs, it is necessary to reexamine modernism, which was haunted by a passion for radicality. Pruning, purifying, eliminating, subtracting, returning to first principles—this was the common denominator of all of the twentieth century's avant-gardes. The unconscious for Surrealism, the notion of choice for the Duchampian readymade, the lived situation for the Situationist International, the axiom "art = life" for the Fluxus movement, the picture plane for the monochrome: so many principles on the basis of which modern art elaborates a metaphysics of the root, a desire to go back to the beginning, to start again and create a new language, free of its detritus. Alain Badiou compares this passion for "subtraction" to an effort of purification, a word whose sinister political connotations he in no way seeks to efface. In modernism, he writes, there is always a "passion for beginning," a determination to create a vacuum, to wipe the slate clean, as the precondition of a discourse that inaugurates and sows the seeds of the future: the root. If "force is attained through the purging of form,"[26] then Kazimir Malevich's *White Square on a White Background* "is—in the field of painting—the epitome of purification."[27] This perpetual return to the origin on the part of the avant-gardes implies that in the radical system of art, the *new* becomes an aesthetic criterion

26 ALAIN BADIOU, *THE CENTURY*, TRANS. ALBERTO TOSCANO (CAMBRIDGE, UK: POLITY PRESS, 2007), 53.

27 IBID., 55.

in its own right, based on a notion of precedence, on establishing a genealogy that will later give rise to a hierarchy and values. Paradoxically, this "founding father" gesture[28] also formulates a possible end of art. An end and a beginning at the same time, the radical artwork constitutes an epiphany of the present. It opens up a territory from which one can face toward the past as well as the future. Thus, in 1921, when Alexander Rodchenko exhibits a triptych consisting of three monochromatic panels—red, blue, and yellow—he is able to assert that it constitutes the end of painting and that "representation will be no more," and at the same time that it inaugurates a new pictorial tradition. And in 1914, when Marcel Duchamp produces his first true readymade, the bottle rack, it could easily be seen as a gesture whose radicality cannot be surpassed, when in fact it will go on to inform an entire segment of the history of art in the twentieth century.

This Darwinian vision of pictorial modernism can be seen quite clearly in the writings of one of the great theorists of twentieth-century art, Clement Greenberg. It is organized around a radical vision, whose fundamental principle is self-purification. It is on the basis of this quest for "pure opticality" that the New York critic is able to develop a coherent historical narrative of artistic development, equipped with both an origin and an end. Painting progresses toward its specification as a medium, eliminating whatever is not inseparable from and necessary to it. The law of modernism, Greenberg writes, implies that "the conventions not essential to the viability of a medium be discarded as soon as they are recognized."[29] In this narrative, the root is both a mythical origin as well as an ideal goal.

28 THIS ANALOGY BETWEEN RADICALITY AND PATERNALISM HAS NOT BEEN SUFFICIENTLY EXPLORED. THUS, RADICANT THEORY COULD PROVIDE A POWERFUL TOOL FOR AN IN-DEPTH ANALYSIS OF FEMINIST PRACTICES SINCE THE 1970S.

29 CLEMENT GREENBERG, "'AMERICAN-TYPE' PAINTING," IN CLEMENT GREENBERG, *ART AND CULTURE: CRITICAL ESSAYS* (BOSTON: BEACON PRESS, 1961), 208.

Although they are situated at the opposite end of the spectrum in terms of their aesthetic assumptions, the theses of the Situationist International are based on a similar radicality. Between 1957, when it was created at the famous Alba Congress, and 1972, when it was abolished on the orders of Guy Debord, the SI evolved toward an ideological purity that prompted it to eliminate from its ranks, first, all professional artists, and then all members suspected of an accommodating attitude toward artistic activity. The radicalism of the SI harks back to that mythical moment when the division of labor was first introduced into the city. Art as an autonomous practice must be abolished and dissolved into lived situations independent of all professional fields or specific techniques. The "root" of Situationism goes back to the historical period in which art was not yet a separate activity, distinct from other forms of human labor. This rootedness in the past also explains the nostalgic tone of many of its productions, especially the films of Guy Debord, which abound in references to the Middle Ages, particularly François Villon, and the seventeenth century in France, from Cardinal de Retz to Bossuet. Roots, roots…

At the core of postmodern discourse is precisely the effort to undermine radicality and all forms of partisan aesthetic anchoring. From the vogue for *simulationist* art in the 1980s (a simulacrum is a signifier without a signified, a floating sign) to the current exaltation of those identities made of signs, reduced to pure exchange values in the marketplace of exoticisms, all radicality seems to have vanished from art. And if the term is still used to describe certain recent works, it must be confessed that this is the dual effect of laziness and nostalgia. For there can be no true radicality without an urgent desire for a new beginning, nor without a gesture of purification that assumes the status of a program. Formal violence, a certain aesthetic brutality, or simply a refusal to compromise are not enough. Missing are the passion for subtraction and the proselytizing impulse: modernist radicality is binding on everyone, and everyone must embrace it or be consigned

to the camp of the tepid and the collaborators with tradition. Radicality is never lonely. Radical modernism could not have existed without the phenomenon of identification between the artist and the proletarian, regarded as the driving force of history—an extension of Karl Marx's call for a return to the origins of social labor, that is, to a precapitalist condition (supplemented by the notion of collective ownership) of the system of production. The transformation of capitalism at the end of the nineteenth century, followed by its undisputed dominance in the present form of globalization, have completed a process of uprooting that, according to Deleuze and Guattari, is actually its project: the capitalist machine replaces local codes with flows of capital, delocalizes the imagination, and turns individuals into labor power. It strives, in the final analysis, to produce an abstract painting.

Thus, aesthetic postmodernism is distinguished by the creation of an imaginary universe of flotation and fluidity that reflects this vast process of deterritorialization by means of which capitalism accomplishes its goals. Beginning in the late 1970s—with the emergence of artistic practices no longer linked to the idea of radical social change, and in particular with the return of a citational brand of painting that indiscriminately borrowed its forms from various iconographic traditions and historical styles—we start to see signs of a liquid conception of culture, to use a term coined by Zygmunt Bauman.[30] The materials of art history turn out to be freely available, deployable as mere signs, as if they had been sapped of their vitality by being cut off from the ideological significations that justified their appearance at a particular moment in history and constituted responses to specific situations. When cited by postmodern artists, the works of Joseph Beuys or Piet Mondrian become empty forms, their meaning replaced by style, by an eclecticism that amounts to reading only the titles of books and to viewing

30 ZYGMUNT BAUMAN, *LIQUID LIFE* (CAMBRIDGE, UK: POLITY PRESS, 2005).

forms as mere fashion choices. "What is at stake in this caricature of the humanist dream (the atemporal availability of all cultures, past or foreign)," writes Yve-Alain Bois, "is not so much the homogenization of high and low culture that was feared by Greenberg and Adorno as above all the 'antiquarian' devitalization of history, which is henceforth transformed into mere merchandise."[31] And the merchandise that art produces is style. Style, defined as a collection of visual identifying marks that are infinitely manipulable: Piet Mondrian reduced to a motif, Joseph Beuys without the revolution…

If the postmodern aesthetic is born of the extinction of political radicalism, it should not be forgotten that it gathered force in the early 1980s, at the very moment when cultural and media production were entering a period of exponential expansion. It is the great cluttering of our era, which is reflected in the chaotic proliferation of cultural products, images, media, and commentaries, and which has destroyed the very possibility of a *tabula rasa*. Overloaded with signs, buried under a mass of works that is constantly expanding, we no longer have even an imaginary form or concept with which to conceive of a new beginning, much less a rational alternative to the environments in which we live. Thus, the end of modernism coincides with the tacit acceptance of clutter as a way of life among things. According to Jean-François Lyotard, postmodernity is distinguished by the fact that "architecture finds itself condemned to undertake a series of minor modifications in a space inherited from modernity, condemned to abandon a global reconstruction of the space of human habitation."[32] While the Futurists called for Venice to be razed, it is henceforth a matter of exploring its lanes and bridges. Beginning in the early 1980s,

31 YVE-ALAIN BOIS, "HISTORISATION OU INTENTION: LE RETOUR D'UN VIEUX DÉBAT," IN "APRÈS LE MOD-
ERNISME," *LES CAHIERS DU MUSÉE NATIONAL D'ART MODERNE*, NO. 22 (DECEMBER 1987).

32 JEAN-FRANÇOIS LYOTARD, *THE POSTMODERN EXPLAINED TO CHILDREN*, TRANS. DON BARRY ET AL.
(SYDNEY: POWER PUBLICATIONS, 1992), 89.

the problem of clutter is reflected by the heavy presence of images of ruins and debris in theoretical writings and artistic practices. The modernist edifice has crumbled and collapsed, and its signs are floating and adrift, since they are no longer anchored by the weight of history.

In 1980, in a text entitled *The Allegorical Impulse*, Craig Owens describes this fragmentation as the basis of an allegorical language, in contrast to a modernism distinguished by its symbolism.[33] He associates this allegorical language with the "decentering" of language identified by Jacques Derrida as a key figure of postmodernity. Signs are no longer anything more than cultural referents, no longer linked to a reality. It is the decayed ruins of history that, according to Owens, appear in postmodern artworks in the early 1980s. Benjamin Buchloh is not so far removed from this view when he evokes, at the same time, artistic strategies of "fragmentation and dialectical juxtaposition of fragments, and separation of signifier and signified."[34]

The emergence of China, India, and the great countries of Asia and Eastern Europe onto the international scene at the beginning of this century marks the advent of a new era for the economy as well as for the global imagination. Shanghai is rebuilding on the *tabula rasa* principle, but without any ideology to underpin this great leap forward besides that of profit. Thus, modernism reappears in the ghostly guise of progress, which is here assimilated to economic growth. And the Western world looks on with fascination as China eradicates its history without, however, invoking a radicality of any kind, but simply in order to better drift with the powerful currents of the globalized economy.

33 CRAIG OWENS, "THE ALLEGORICAL IMPULSE: TOWARD A THEORY OF POSTMODERNISM" [1980], IN *ART AFTER MODERNISM: RETHINKING REPRESENTATION*, ED. BRIAN WALLIS (BOSTON: GODINE, 1984).

34 BENJAMIN BUCHLOH, "ALLEGORICAL PROCEDURES: APPROPRIATION AND MONTAGE IN CONTEMPORARY ART," *ARTFORUM* (SEPTEMBER 1982): 44.

But what, then, has become of the root, the modernist twentieth century's obsession? At one and the same time origin and regulating principle of an organism's growth, identitarian factor and formal template, affiliation and destiny; the root, paradoxically, becomes the very core of the imaginary universe of globalization at the very moment when its living reality is fading in favor of its symbolic value and artificial character. On the one hand, it is invoked as a principle of assignment and discrimination in reaction to this very process of globalization. Racism and traditionalist ideologies, the exclusion of the other, develop in its name. On the other hand, we see a proliferation of measures that aim at standardization, at effacing the old identities and historical singularities in the name of a necessary uprooting. If for modernism, the "return to the root" meant the possibility of a radical new beginning and the desire for a new humanity, for the postmodern individual it no longer represents anything but the assignment of an identity. That identity may be rejected or mythologized, but in either case it functions as a natural framework. By what connections are individuals bound to their social and political environment? The debates on immigration express the aggravated form of this question, while nationalism and religious fundamentalism are its disturbing caricatures.

"I was quite happy to feel like [an uprooted person]," Marcel Duchamp confessed at the end of his life, "precisely because I was afraid of being influenced by my roots. I wanted to get away from that. When I was in the USA I had no roots at all because I was born in Europe. So it was easy, I was bathing in a calm sea where I could swim freely; you can't swim freely when you get tangled up in roots."[35]

While it is not my intention to conflate identitarian enrootedness (which distinguishes between "us" and "the other" while exalting the

35 JEAN ANTOINE, "LIFE IS A GAME, LIFE IS ART," INTERVIEW WITH MARCEL DUCHAMP [SUMMER 1966], TRANS. SUE ROSE, *THE ART NEWSPAPER* (APRIL 1993): 17.

land and filiation) with modernist radicality (which implicates all of humanity in the fantasy of a new beginning), clearly neither one imagines that a subject—whether individual or collective—could be constituted without some kind of anchor, without a fixed point, without moorings. Or by swimming, as the author of the *Sculptures for Traveling* did all his life.

And yet the immigrant, the exile, the tourist, and the urban wanderer are the dominant figures of contemporary culture. To remain within the vocabulary of the vegetable realm, one might say that the individual of these early years of the twenty-first century resembles those plants that do not depend on a single root for their growth but advance in all directions on whatever surfaces present themselves by attaching multiple hooks to them, as ivy does. Ivy belongs to the botanical family of the *radicants*, which develop their roots as they advance, unlike the *radicals*, whose development is determined by their being anchored in a particular soil. The stem of couch grass is radicant, as are the suckers of the strawberry plant. They grow their secondary roots alongside their primary one. The radicant develops in accord with its host soil. It conforms to the latter's twists and turns and adapts to its surfaces and geological features. It translates itself into the terms of the space in which it moves. With its at once dynamic and dialogical signification, the adjective "radicant" captures this contemporary subject, caught between the need for a connection with its environment and the forces of uprooting, between globalization and singularity, between identity and opening to the other. It defines the subject as an object of negotiation.

Contemporary art provides new models for this individual who is constantly putting down new roots, for it constitutes a laboratory of identities. Thus, today's artists do not so much express the tradition from which they come as the path they take between that tradition and the various contexts they traverse, and they do this by performing

acts of translation. Where modernism proceeded by subtraction in an effort to unearth the root, or principle, contemporary artists proceed by selection, additions, and then acts of multiplication. They do not seek an ideal state of the self or society. Instead, they organize signs in order to multiply one identity by another. Thus, Mike Kelley may tackle his distant Irish origins, or he may just as easily reconstruct a Chinese monument located near his Los Angeles home. The radicant can, without injury, cut itself off from its first roots and reacclimate itself. There is no single origin, but rather successive, simultaneous, or alternating acts of enrooting. While radical artists sought to return to an original place, radicant artists take to the road, and they do so without having any place to return to. Their universe contains neither origin nor end, except for those they decide to establish themselves. One can bring along fragments of identity, provided one transplants them to other soils and accepts the fact of their permanent meta-morphosis—a sort of voluntary metempsychosis that prefers the play of successive guises and precarious shelters to incarnations of any kind. Thus, there are fewer points of contact with the soil, for the artists choose these contacts instead of enduring them. They drill down into the ground at a campsite; they stay at the surface of a habitat—it makes little difference. Henceforth, what counts is the ability to acclimate oneself to various contexts and the products (ideas, forms) that are generated by these temporary acculturations.

On the basis of a sociological and historical reality—the era of migratory flows, global nomadism, and the globalization of financial and com-mercial flows—a style of living and thinking is emerging that allows one to fully inhabit that reality instead of merely enduring it or resisting it by means of inertia. So has global capitalism confiscated flows, speed, and nomadism? Let's be even more mobile than global capitalism. There can be no question of permitting oneself to be backed into a corner and forced to embrace stagnation as an ideal. So the global imagination is dominated by flexibility? Let's invent new meanings for flexibility;

let's inject the long term and extreme slowness into the very heart of speed, instead of confronting it with rigid or nostalgic positions. The force of this emerging style of thought lies in protocols of "setting in motion." It is a matter of elaborating a nomadic type of thought that is organized in terms of circuits and experiments rather than in terms of permanent installations, perpetuation, and built development. Let us confront the increasing precariousness of our experience with a resolutely precarious mode of thought that infiltrates and invades the very networks that stifle and smother us. The fear of mobility, the terror that strikes enlightened public opinion at the mere mention of nomadism and flexibility. Recall the anarchist soldiers of Alfred Jarry: when ordered to turn left, they all turned right. Thus, they always obeyed the dictates of power while openly rebelling against them. These notions aren't bad in themselves, unlike the scenario that commandeers them.

Radicant artists invent pathways among signs. They are semionauts who set forms in motion, using them to generate journeys by which they elaborate themselves as subjects even as the corpus of their work takes shape.[36] They carve out fragments of signification, gathering samples and creating herbaria of forms. Today, on the contrary, it is the gesture of returning to principles that would seem strange. Painting and sculpture are no longer regarded as entities whose elements it would be sufficient simply to explore (unless one merely considered historical segments of these "origins"). Thus, radicant art implies the end of the medium-specific, the abandonment of any tendency to exclude certain fields from the realm of art. For modernist radicality, the goal was the death of artistic activity as such, the transcendence of that activity toward an "end of art" imagined as a historical horizon in

36 SEMIONAUT: FROM *SEMIOS* (SIGN) AND *NAUTOS* (NAVIGATION). SEE THE AUTHOR'S *FORMES DE VIE: L'ART MODERNE ET L'INVENTION DE SOI* (PARIS: ÉDITIONS DENOËL, 1999) AND ALSO *POSTPRODUCTION: CULTURE AS SCREENPLAY. HOW ART REPROGRAMS THE WORLD*, TRANS. JEANINE HERMAN (NEW YORK: LUKAS & STERNBERG, 2002).

which art would dissolve into everyday life—the mythical transcendence of art. Altermodern radicantity is a stranger to such figures of dissolution. Its own spontaneous movement would be to transplant art to heterogeneous territories, to confront it with all available formats. Nothing could be more alien to it than a mode of thought based on disciplines, on the specificity of the medium—a sedentary notion if ever there was one, and one that amounts to cultivating one's field.

Translation is in essence an act of displacement. It causes the meaning of a text to move from one linguistic form to another and puts the associated tremors on display. Transporting the object of which it lays hold, it goes forth to meet the other and presents him with the foreign in a familiar form: *I bring you something that was said in a different language from your own…* The radicant is a mode of thought based on translation: precarious enrooting entails coming into contact with a host soil, a *terra incognita*. Thus, every point of contact that goes to make up the radicant line represents an effort of translation. Art, from this perspective, is not defined as an essence to be perpetuated (in the form of a closed and self-contained disciplinary category) but rather as a gaseous substance capable of filling up the most disparate human activities before once again solidifying in the form that makes it visible as such: the work. The adjective "gaseous" is only frightening for those who see art as identical with its regime of institutional visibility.[37] Just like the word "immaterial," it is only pejorative for those who don't know how to *see*.

The tree's historicity, verticality, and enrootedness were also the foil for the image of the rhizome, which Gilles Deleuze and Félix Guattari developed in their essay *A Thousand Plateaus*. It is an image that was popularized in the 1990s by the emergence of the Internet, for

37 YVES MICHAUD, *L'ART À L'ÉTAT GAZEUX. ESSAI SUR LE TRIOMPHE DE L'ESTHÉTIQUE* (PARIS: ÉDITIONS STOCK, 2003).

which it provides an ideal metaphor with its fluid and non-hierarchical structure and its status as a web of interconnected significations. "Any point of a rhizome can be connected to any other, and must be. This is very different from the tree or root, which plots a point, fixes an order."[38] The radicality of the tree, the multiple simultaneity of the rhizome: what is the specific character of the radicant in relation to these other two models of the growth of living things? Above all, unlike the rhizome, which is defined as a multiplicity that brackets out the question of the subject from the beginning, the radicant takes the form of a trajectory or path; the advance of a singular subject. "A multiplicity," explain Deleuze and Guattari, "has neither subject nor object, only determinations, magnitudes, and dimensions."[39] The radicant, by contrast, implies a subject, but one that is not reducible to a stable, closed, and self-contained identity. It exists exclusively in the dynamic form of its wandering and the contours of the circuit it describes, which are its two modes of visibility. In other words, it is movement that ultimately permits the formation of an identity. By contrast, the concept of the rhizome implies the notion of a subjectification by capture, connection, and opening to the outside. When a wasp pollinates an orchid, a new subjective territory is created by means of branching, and this territory transcends both the animal and vegetable realms.

The figure of the subject defined by the radicant resembles that advanced by queer theory, which views the self as constructed out of borrowings, citations, and proximities, hence as pure constructivism. The radicant differs from the rhizome in its emphasis on the itinerary, the path, as a dialogical or intersubjective narrative that unfolds between the subject and the surfaces it traverses, to which it attaches

38 GILLES DELEUZE AND FÉLIX GUATTARI, *A THOUSAND PLATEAUS: CAPITALISM AND SCHIZOPHRENIA*

[1980], TRANS. BRIAN MASSUMI (MINNEAPOLIS, MN: UNIVERSITY OF MINNESOTA PRESS, 1987), 7.

39 IBID., 9.

its roots to produce what might be termed an installation: one "installs oneself" in a place or situation in a makeshift or precarious way, and the subject's identity is nothing but the temporary result of this encampment, during which acts of translation are performed. Translation of a path into the local language, translation of oneself into a milieu—translation in both directions. Thus, the radicant subject appears as a construction or montage, in other words, as a work born of endless negotiation.

All of which raises a crucial question: can we really free ourselves from our roots? That is, can we achieve a position in which we would no longer be dependent on the cultural determinisms, the visual and mental reflexes of the social group in which we were born, the forms and ways of life that are etched in our memories? Nothing could be less certain. Cultural determinisms leave a powerful stamp on us. We experience them by turns as a nature we are unable to shed, a set of programs we must realize if we wish to become full-fledged members of a community, and values and signs that give worth to our singularity. But must we forget where we come from just because we aspire to travel? Radicant thought is not a defense of voluntary amnesia but of relativism, unsubscription, and departure. Its true adversaries are neither tradition nor local cultures, but confinement within readymade cultural schemata—when habits become forms—and enrootedness, as soon as it becomes a rhetoric of identity. It is not a matter of rejecting one's heritage but rather of learning to squander it, of plotting the line along which one will then carry this baggage in order to scatter and invest its contents. In aesthetic terms, the radicant implies a nomadic bias, whose most fundamental characteristic would be the tendency to inhabit preexisting structures, a willingness to be the tenant of existing forms, even if that means modifying them more or less extensively.[40] It can also mean wandering a calculated path by which the artist

40 I DEVELOP A TYPOLOGY OF THIS MODE OF PRODUCTION IN *POSTPRODUCTION* (NOTE 36).

refuses to become a member of any fixed space-time continuum, refuses to be assigned to any identifiable and irrevocable aesthetic family.

In any case, the subject of globalization is evolving in an era that favors elective and individual diasporas and encourages voluntary or forced immigration. It shatters our very notion of space. In our imaginary universe of dwelling, sedentariness is no longer one option among others. As heralds of this transformation, contemporary artists have recognized that it is just as possible to reside in a circuit as in a stable space, just as possible to construct an identity in motion as through fertilization, and that geography is always also psychogeography. Thus, it is possible to dwell in a movement of round trips between various spaces. Airports, cars, and railroad stations become the new metaphors for the house, just as walking and airplane travel become new modes of drawing. The radicant is the quintessential inhabitant of this imaginary universe of spatial precariousness, a practitioner of the unsticking of affiliations. He thus responds—without confusing himself with them—to the living conditions directly or indirectly brought about by globalization.

It is, above all, our modes of representation that are called into question by globalization. More precisely, globalization is the locus of a complete and total shattering of the relations between representation and abstraction. For it is precisely at the level of the representation of the world that modernism is linked to the capitalist machine—on the plane where our general image of the world is produced, and then the various images created by artists, which may echo, confirm, or invalidate that general image. As the propagating agent of an abstract virus (a "deterritorializing" one, to use a Deleuzian term), globalization substitutes its logos, organization charts, formulas, and recodings for local singularities. Coca-Cola is a logo without a location; by contrast, every bottle of Château Eyquem contains a history based on a particular

territory. That history, however, turns out to be mobile; it comes with the bottle, which is a portable sample of the region. The moment human groups lose all living contact with representation is the abstract moment by which capitalism consolidates its holdings. Thus, globalization carries with it an implicit iconographic project that seeks to replace the representation of lived space-time with an entire apparatus of abstractions, whose function is twofold. First, these abstractions disguise the forced standardization of the world in generic images, like the fence around a construction site. Second, they legitimate this process by imposing against indigenous imaginations an abstract imaginary register that places the historical repertoire of modernist abstraction in the service of an ersatz universalism tinged with "respect for cultures."

But isn't the act of unsticking oneself from one's territory in this manner—freeing oneself from the weight of national traditions—the means to combat that symbolic house arrest that I criticized above? It is necessary to distinguish between the process of setting identities in motion in the context of a nomadic project, and a flexible type of citizenship based on the needs of capital and steeped in a culture unconnected with any soil. On the one hand, we have the creation of a relationship between the subject and the singular territories it traverses; on the other, the industrial production of screen images that make it possible to separate individuals and groups from their environment, to prevent the formation of any vital relationship with a particular place. When the Colombian and Russian miners employed by a Swiss multinational, Glencore, are laid off as a result of moves to new, more profitable locations, what image of power are they confronted with? An abstract one. Interchangeable employees, an unrepresentable power, the administration of an unlocalizable empire. The new powers have no location. They manifest themselves in time. Coca-Cola's power is based on the repetition of its name by advertising, which is the new architecture of power. How can the Bastille be stormed if it is protean and invisible? The political function of contemporary art lies

in this confrontation with a reality that slips away in order to appear in the form of logos and unrepresentable entities—flows, movements of capital, the repetition and distribution of information; so many generic images that seek to escape any visualization not controlled by public relations. The role of art is to become the radar screen on which these furtive forms—spotted and embodied—can finally appear and be named or represented.

The paintings of Sarah Morris represent the sites of power—whether it be the headquarters of a multinational corporation or Chinese urbanism—with the aid of a formal vocabulary borrowed from Minimal art. They bear witness to a renewed relationship between representation and abstraction, a phenomenon that can also be seen in the paintings of Julie Mehretu and Franz Ackermann. Faced with a reality that cannot be grasped by representational pictorial means, the abstract, diagrammatic, statistical, and infographic lexica allow us to cause the furtive forms of command and the structure of our political reality to appear. When Liam Gillick breaks the space of a factory into a series of Minimalist sculptures linked to a narrative, he superimposes the singular on the plural and abstract. When Nathan Coley models all of the religious structures in Edinburgh, he causes the specific history of a city to appear in a blinding image (*The Lamp of Sacrifice*, 2004). When Gerard Byrne reconstructs interviews from the press, with actors in the roles of the interviewed public figures and celebrities, he brings fragments of our history back to life by embodying them. When Kirsten Pieroth explores the biography of Thomas Edison, she personifies something that over time has become an abstract entity. To take abstraction, which has become an ideological instrument, and draw it onto the side of singularity in this way is a plastic operation that possesses a powerful political potential. If the codes of the dominant representation of the world are based in abstraction, that is because abstraction is the very language of inevitability. By presenting the actions of groups and individuals in the guise of a meteorology,

the powers that be are able to perpetuate a system of domination. Thus, the blank spaces that dot the satellite maps of Google Earth correspond to strategic, military, and industrial interests. The function of art is to fill them in through the free play of narrative and diagrams, by using the appropriate tools of representation. The derealizing type of abstraction can only be combated with a different type of abstraction that makes visible what is concealed by the official cartographies and authorized representations.

In the latter half of the nineteenth century, modernity in painting meant the conquest of its autonomy *vis-à-vis* ideological determinations, the valorization of form as possessing a value independent of resemblance and the represented subject, which were the basis of painting's exchange value at the time. This autonomy also involved an implicit categorical imperative: life and the artwork communicate, and they do so through channels chosen by the artist. For its part, contemporary altermodernity is born amid the cultural chaos of globalization and the commodification of the world. Hence it must conquer its autonomy *vis-à-vis* the various modes of identitarian assignment and resist the standardization of the imagination by producing circuits and modes of exchange among signs, forms, and lifestyles.

VICTOR SEGALEN AND THE TWENTY-FIRST-CENTURY CREOLE

After all, why should cultural diversity be preferable to the sharing of a single culture common to all peoples? Hasn't globalization, through American economic power, generated a culture accessible to all, thereby realizing the modernist dream of a united humanity? Andy Warhol brilliantly encapsulated this dream: "the President drinks Coke, Liz Taylor drinks Coke, and just think, you can drink Coke, too."[41] With Pop Art, in the 1960s, there emerges the image of the *serial*

41 ANDY WARHOL, *THE PHILOSOPHY OF ANDY WARHOL (FROM A TO B AND BACK AGAIN)* (N.P.: HARVEST BOOKS, 1977), 100–01.

individual, in synch with the evolution of social production. The material elements that make up his environment are now factory-produced and available all over the planet. Inseparable from this process of industrialization, twentieth-century abstract painting was established as a common language, an Esperanto capable of being read in the same way in New York as in Delhi or Bogotá, reflecting the advance of "progress" and a new production environment.

László Moholy-Nagy was the first, in the 1930s, to produce works via telephone. Thirty years later, Conceptual art brought this mode of production into widespread use. Lawrence Weiner, for example, puts forth verbal proposals that can be executed (or not) by their buyer, exhibited as formulas, scores, or recipes. These two artists, thirty years apart, employ the same manufacturing principle as Nike shoes or Coke: the parameters of their works are rationalized, and so precisely codified that they can be manufactured by anyone, anywhere in the world. But beyond the strong critical dimension of Weiner's work, artistic projects of this type assumed a very different meaning in an epoch in which art had everything to gain by playing mechanization against the ideology of pictorial expertise, a pillar of cultural conservatism. Times have changed, as has the nature of the enemy and the guise in which this enemy exercises its domination. For twentieth-century modernism, in its effort to combat academic tradition, gladly wielded weapons supplied by industry. The artistic modernity of the last century took on the task of struggling on both fronts at once. On the one hand, Seurat adapted the procedures of industry to the composition of paintings: his scientific pointillism introduced the possibility of an art reproducible from a distance, in which the hand would be reduced to the status of a machine executing a preconceived program. On the other hand, Manet and Pissarro, in a gesture of resistance to the process of industrialization, asserted the presence of the hand in painting by emphasizing the brushstroke.

This struggle, which was that of the moderns, seems more topical than ever, for the vise formed by traditionalism and standardization is more powerful today than ever before. And yet the conceptual materials that would enable us to loosen this stranglehold must be sought within modernity itself, which problematized colonization at its apogee, nascent industrialization, and the uprooting of tradition in the name of progress. These issues are explored in an unfinished book, consisting of different versions and preparatory notes spanning the fifteen years between 1904 and 1918: *Essay on Exoticism*, by Victor Segalen.

Through this work, the Symbolist-inspired young poet aspired to theorize an experience still not at all common in his day. Segalen had embarked for Polynesia as a navy medical officer and arrived in the Marquesas Islands in 1903, a little too late to meet Paul Gauguin, who had just died, but on whose easel he found—not yet dry, according to legend—*Breton Village in Snow*. Segalen wrote an admirable text, "Gauguin in his Final Setting," about his visit to the Hiva Oa studio. Inspired by the experience of the painter, whose work in itself con- stituted a tribute to the so-called savages who inhabited these islands and whose modest journal, *The Smile*, spoke out against the colonial administration, Segalen became a defender of the natives. Discovering the Maori civilization at a moment when the process of its extinction was already well underway, he threw himself into the project of becoming its living dictionary. Thus, in 1907 he published a strange book of stories, *A Lapse of Memory*, which portrays the culture of a people debilitated by colonization. From that time forward, Segalen traveled incessantly. Upon returning to Paris, he studied Chinese and decided to participate in an archaeological mission to the "middle kingdom," where he was to make long and frequent stays. His capacity for empathy is such that among some Chinese readers, *Steles*, published in 1912, passes today as a book belonging to their own literary corpus—written in French but on a Chinese wavelength. As if Segalen, infinitely malleable, had acquired the power to connect

his nervous system to cultural spheres as remote as possible from his own, in order to extract from them materials as unmediated as possible by the filter of his European frame of thought.

Over the years, Victor Segalen sought to theorize this relation to the other, this experience of diversity, in the book that he envisaged as his greatest work, but whose fragments were published only after his death under the title *Essay on Exoticism*.The title is ironic: nothing is more foreign to him than what was then commonly called exoticism, with its parade of clichés, which he enumerates with disgust: "palm tree and camel; tropical helmet; black skins and yellow sun."[42] On the contrary, Segalen's point of departure is acknowledgement of the harm done by Western colonization, a position all the more courageous for being still extremely rare at the dawn of the twentieth century, at the height of the so-called civilizing missions conducted by European powers. It is truly an aesthetics of diversity that Segalen means to write, a defense of heterogeneity, of the value of the plurality of worlds, a plurality menaced by the civilizing machine of the West. One of the most surprising facets of this literary project is its precocious diagnosis of the colonial wound and the irremediable harm to be wrought by the westernization of the world. Segalen travels; he reports from the field. He knows that he is moving among images, discourses, and gestures that will soon disappear, but he does not exempt himself, though merely a tourist, from the terrible observations he inventories in describing these ecosystems devastated by missionaries and military might. A century later, one cannot but admire the contemporary relevance of his thought, which declares that the source and driving energy of all beauty is difference, yet never lapses into idealization of the other. Segalen defines the "sensation of Exoticism" as "the notion of difference, the perception of Diversity, the knowledge that something

42 VICTOR SEGALEN, *ESSAY ON EXOTICISM: AN AESTHETICS OF DIVERSITY*, TRANS. AND ED. YAËL RACHEL SCHLICK (DURHAM, NC: DUKE UNIVERSITY PRESS, 2002), 18.

is other than one's self."[43] Exoticism is "the feeling which Diversity stirs in us," indeed the very "manifestation of Diversity."[44] Thus, above all other faculties he esteems the capacity to accept the impenetrable, the incomprehensible, the unreadable, in the form of a "keen and immediate perception."[45]

As seen by Delacroix, the Maghreb (North Africa) appeared as a source of exploitable exotic figures: harems, souks, hetaerae, and caliphs supplied him with raw material to add to the historic and literary scenes that had thus far constituted his iconographic repertoire. Paul Gauguin, Segalen's alter ego, did not exploit the cultural context in which he settled; he translated it. One of his masterpieces, the monumental *Where Do We Come From? What Are We? Where Are We Going?* (1897–1898), does not import indigenous motifs into Western painting, but rather tries to treat pictorially his encounter with Polynesian territory. It does so, first of all, by breaking with the temporal linearity that is dominant in the Western pictorial system: according to a convention that was quite tenacious until the twentieth century, a painting is read like a text, the past represented on the left and the future to the right. If at first sight Gauguin's work appears related to the tradition of the "ages of life," closer observation shows that the painter explodes the rules of classical composition, placing the infant on the right side of the painting, an old woman in the lower left, and in the center, in the foreground, an enigmatic worshipper. *Where Do We Come From…* reveals a universe with neither an origin nor a predetermined end: it is an anti-Christian, anti-eschatological manifesto, setting natural harmony against rational discourses, permanent mystery against allegory, and the immemorial against the linearity of progress. It is not a matter of fading into the landscape one is traversing or of

43 IBID., 19.

44 IBID., 47, 66.

45 IBID., 21.

fusing with the other, which would constitute a new source of deceit and hypocrisy: the "feeling of diversity," Segalen writes, implies the need "to espouse a position." Not hybridization: if the book encourages us to seek to understand foreign cultures, it is so as to better appreciate what establishes our own difference. One cannot become Chinese, but one can attain the ability to articulate Chinese thought; one cannot claim as empathy what is merely a tourist's clear conscience, but one can translate. Translation thus appears as the cornerstone of diversity, as the central ethical act of the "born traveler," capable of perceiving diversity in all its intensity. Segalen gives this figure a name, the *exote*: one who manages to return to himself after having undergone the experience of diversity. It is crucial to recognize the rigor of Segalen's theoretical circumspection; it distinguishes his perspective from that of the adventurers of his day, who were typically caught up in romantic identification with the peoples they rubbed elbows with (as was writer-adventurer T. E. Lawrence), but also from the gaze of the missionary coldly observing the tribal peoples among whom fate has cast him, and from the approach of the ethnologist collecting data among indigenous individuals whom he regards as organisms to be observed. Segalen insists on defining himself as an object alien to the societies he encounters: "While experiencing China profoundly, I have never had the desire to be Chinese. While I have felt the force of the Vedic dawn, I have never really regretted not being born three thousand years earlier and a herdsman. Take off from the real, from what is, from what one is."[46] When a European spends time in Polynesia or in China, two realities are pitted against each other without, however, canceling each other out, for both participate in the same space-time continuum: the exote and the exotic coproduce diversity by elaborating, through negotiation, a relational object in which neither of the two parties is effaced. In these early years of the twenty-first century, contemporary theory encourages us to ponder Segalen's lesson and to ask: is the way in which post-

46 IBID., 49.

colonial thinkers envisage the other, in the often simplistic form of the globalized proletariat, nothing more than the compassionate flip side of colonization?

Serge Daney, one of the most important film theorists of the twentieth century, based his critical work on the idea that putting oneself in the place of the other is both a moral error and an aesthetic crime. To designate this new regime of the image—one in which, according to Daney, the demands of communication (to produce an aesthetically efficacious image) have prevailed over cinematic priorities (to construct a sequence shot)—Daney uses the term "visual," defined as the "sum of substitute images" that are used in order to avoid showing recorded reality. Daney expanded upon this argument at the time of the first Gulf War, in 1991, when television broadcasters around the world continuously replayed a multitude of stock images instead of images of actual combat.[47] No images of dead Americans, of bombed Iraqi civilians or devastated cities. Television viewers had to content themselves with images of military technology and statements by official spokespeople: the visual against the image; communication which dictates, against the documentary, which translates. In film, the ethical imperative that Daney advocates takes the form of the "shot /reverse shot," which conveys the possibility of an opposing point of view. Moreover, this figure could be seen as a definition of the aesthetic of diversity sketched by Segalen: the coexistence of points of view within a multifocal space in which each framing is modified by the one that precedes or follows it. Serge Daney recalled that when traveling, he never took photographs, which he considered acts of predation; instead, he would buy postcards, which viewed the territory through the eyes of the inhabitants themselves. This predilection for postcards raises the question of the origin of the image and the role of that origin in constituting its meaning. Diversity is an aesthetics of the origin,

47 SERGE DANEY, *DEVANT LA RECRUDESCENCE DES VOLS DE SACS À MAIN* (LYON: ALÉAS, 1991), 187.

but it underscores that origin only the better to relativize it, presenting it as a simple point on a flickering, moving line. Not freezing the image, but always inserting it in a chain: thus could one summarize a radicant aesthetic.

This "opposing point of view" is that of the other. But don't the very terms in which this goodwill is expressed—other, otherness—represent a blind spot of the West? Aren't they a natural counterpart of post-modern identitarian thought? In the domain of culture, there is no such thing as otherness, for otherness presupposes an "I," a speaker who would be the measure of what is other. Postmodern cartography, though rewritten in accord with the critique of modernist universalism, always presupposes a North on the basis of which the postcolonial subject is constructed. By thus positing a priori a dialogue between the colonial West and its periphery, it perpetuates the terms of the identitarian discourse by reaffirming their validity.

Segalen's theorem is based on an entirely different principle: there is no other; rather, there are other places, *elsewheres*, none of which is original, still less a standard for comparison. The fundamental requirement of an ethics of diversity is to travel in order to get back to oneself, to start off "from the real, from what is, from what one is," that is to say, the context where happenstance caused you to be born, a context whose value is not absolute but circumstantial.[48] Segalen's topic anticipates Bruno Latour's fundamental idea, that of the need for a "symmetrical anthropology" in which Western society would not benefit from any implicit privilege, as is still the case in the "incomplete relativism" that permeates postmodern thought. The notion of other-ness is questionable because it postulates a common ground, which needless to say is Western. This common ground, Latour explains, is precisely modernist universalism, a cultural wolf disguised as a post-

48 SEGALEN, *ESSAY ON EXOTICISM* (NOTE 42), 49.

modern sheep: "thus, until very recently, the entire planet—including the Chinese, of course—was subsumed under the heading of 'cultures' against the background of an immutable 'nature.'"[49] And yet this "nature" was defined by Westerners as an objective dimension of the world, to which subjects are exterior. This system, Latour adds, makes it possible to classify all cultures in the anthropological museum except our own, for ours plays the role of nature, of the benchmark against which to measure otherness. Latour's thesis is that this implicit great divide between the West and the "others" passes through the intermediary of science, which is born of a desire to model the world mathematically, a desire that implies a radical separation between nature and culture, science and society.

As Segalen saw it, colonization initiated a movement to standardize space-time continuums. At the time, it was a matter of struggling to open trade routes and develop contacts. Global current events prove his point: everywhere, individuals are under house arrest, travel is strictly controlled, and paths of migration are under police surveillance, while merchandise freely circulates in a hyperspace smoothed by the globalized economy. Money, that "general abstract equivalent" (according to Karl Marx's definition), has established a protected zone that contrasts ever more sharply with a political world plagued by incessant problems of translation. Monetary conversion, the transformation of each sign into a market value, represents the exact inverse of this effort of translation. The latter is based on loss—one always loses something in translation—but also on recognition of singularity—one chooses to translate only that which appears unique, outstanding, leaving to software the trouble of converting operating instructions for household appliances into words. Translation is a kind of pass: a deliberate, intentional act that begins with the designation

49 BRUNO LATOUR, *NOUS N'AVONS JAMAIS ÉTÉ MODERNES. ESSAI D'ANTHROPOLOGIE SYMÉTRIQUE* (PARIS: LA DÉCOUVERTE, 1991).

of a singular object and continues with the desire to share this singular object with others.

"I cannot deny that there exists an exoticism of countries and races," writes Segalen, "an exoticism of climates, of fauna and flora; an exoticism that is subject to geography, to the position in latitude and longitude. It is this exoticism, specifically, which is most obvious and which imposed its name, giving to man, who was too inclined to consider himself as identical to himself at the beginning of his terrestrial adventure, the conception of other worlds than his own."[50] Exoticism is thus to be understood as a paradigm: there is an exoticism of history (whose elsewhere would be "bygone days"), one for nature (whose furthest extreme would be the inhuman), for time (whose far point would be science fiction), and especially for individuals. Segalen thus appropriates the formula of Rabelais, who was long ago fascinated by "that other world that is Man." However, his argument in favor of diversity does not reside in a vague humanism, still less in an ideology of preservation that would make his stance akin to contemporary "animal humanism." On the contrary, his plea is materialist, and above all *energetic*. Following the intellectual fashion of his day, he saw it as a matter of thermodynamics: "The exotic Tension of the World is decreasing," he cautions. Further on he adds: "Diversity is in decline. Therein lies the great earthly threat. It is therefore against this decay that we must fight, fight amongst ourselves—perhaps die with beauty." For "exoticism, a source of energy—mental, aesthetic, or physical ... is on the wane."[51] For Segalen, this global form of decay is none other than entropy: the multitude is a source of energy, it kindles ideas and forms, works to produce shocks, friction; just as flints produce fire when struck against each other. The multitude of points of view and ways of doing things represents for him the

50 SEGALEN, *ESSAY ON EXOTICISM* (NOTE 42), 68.

51 IBID., 62–63.

very lifeblood of the human spirit, which would become sluggish and uniform were a platform common to all human communities to prevail, in what would amount to a slow movement toward the "Kingdom of the Lukewarm."[52] Is this realm in fact our own?

Diversity, insists the author of *Steles*, is thus "the source of all energy."[53] But he knows that, if singularities generate exotic energy, they are soon to be exhausted under the onslaught of westernization. And yet it is from the possibility of these singularities coexisting, from their jostling together, from their blending, that art, literature, and all forms of culture are born. To westernize the Chinese or the Polynesians is to starve or mutilate so many versions of human life, to doom so many universes. Which, let us repeat, by no means prevents the Chinese, Polynesians, or British from uprooting themselves from their ecosystem to traverse other cultures and plant their seeds in other soils. Segalen gives a precise and suggestive definition of this cultural entropy: "it is the sum of all internal, nondifferentiated forces, all static forces, all the lowly forces of energy … I imagine Entropy as a yet more terrifying monster than Nothingness. Nothingness is made of ice, of the cold. Entropy is lukewarm … Entropy is pasty. A lukewarm paste."[54] Diversity represents the contrary forces, those of negative entropy: it produces energy through the friction between heterogeneous materials. Segalen's approach is a kind of mental ecology: it sketches an idea for durable cultural development, and anticipates in culture the image of global warming as a global process of waning vitality.

Segalen does not content himself with bringing into relief "the purity and intensity of diversity"; he also suggests means of resisting its collapse and even a method for generating it. In a passage written on April 12,

52 IBID., 57.

53 IBID., 64.

54 IBID., 48.

1912, entitled "Expertise and the Collection," he praises the archive and the collection, exemplary tools of production for a generalized exoticism: "the conglomeration of objects" helps arouse the sense of difference, producing it as value. "Every series, every gradation, every comparison engenders variety, diversity."[55] And "the finer the Difference, the more difficult it is to discern, the greater the awakening and stimulation of the feeling for Diversity."[56] One might intuitively suppose that a collection serves to classify, reify, stiffen, petrify. Segalen sees in it the opposite: the gathering of the nearly-alike in the context of a series has the effect of establishing rarity, or singularity, as distinctive signs of art. One could compare these fragments to the texts that Walter Benjamin would later devote to the subject of his library and his collections.[57]

Segalen's interest in the archive assumes new meaning today, given the numerous works of art produced since the 1960s that have been constructed on the principle of the collection, from Christian Boltanski's museum showcases filled with trifling mementos to the shelves on which Haim Steinbach juxtaposes mass-produced objects or antiquities. What emerges from these heterogeneous approaches, beyond the boost they give to the idea of autobiography and beyond the archival compulsion, is implicit praise of rarity: in an increasingly standardized world, rarity is all the more noteworthy as an instance of breaking free from the general condition of seriality. Thus, in the works of Kelley Walker, mechanical or digital reproduction becomes an infinitely adjustable mechanism for producing the nearly-alike. This is also the case when Carsten Höller divides one of his exhibitions

55 IBID., 51.

56 IBID.

57 WALTER BENJAMIN, "UNPACKING MY LIBRARY," IN *WALTER BENJAMIN: SELECTED WRITINGS*, VOLUME 2, PART 2, TRANS. RODNEY LIVINGSTONE ET AL., ED. MICHAEL JENNINGS, HOWARD EILAND, AND GARY SMITH (CAMBRIDGE, MA: HARVARD UNIVERSITY PRESS, 2005).

into two precisely symmetrical parts, each of whose elements is doubled, from the invitation card to the hanging of the works.[58] A glowing tribute to mental disorientation, Höller's work tries to reestablish human beings' relationship to their immediate environment on a foundation of doubt by systematically undermining any "natural" relationship to it.

In making novelty the criterion by which to judge works of art, modernism relies on the linearity of its historical narrative, a narrative that is entirely consistent both with its radical ideology of returning to principles and with the West's progressive vision. Precursors, precedence… How are we to define singularity in a world that has become multifocal, where henceforth only technology is supposed to "progress"? Originality does not suffice, even if it constitutes a precondition. Victor Segalen relies on the science of his time, notably on the works of Albert Einstein, to describe a "discontinuous" world in which there ceaselessly emerge "new partitions and unforeseen lacunae, a system of very fine filigree striated through the fields that one initially perceived as an unbroken space."[59] What is important, he explains, is to break the monotony of uniformity, to work to discover or construct singularities. They need not be spectacular. To perceive these singularities, one need only change perspective and observe the details of a social formation more attentively. Thus, numerous artists who cull a trivial form from daily life or an anecdote from the past are merely applying Segalen's axiom. A "system of very fine filigree," slender grooves or "striae," a sought-after and valued discontinuity: such is the world that the exote Segalen describes as that of diversity. A grain of sand in the manufacturing engine of the global, singularity depends today neither on precious materials nor on the unique hand of the artist, but on the initiation of an aesthetic event, accomplished through an

58 CARSTEN HÖLLER, *ONE DAY ONE DAY* (FARGFABRIKEN, STOCKHOLM, 2003; MAC MARSEILLE, 2004).

59 SEGALEN, *ESSAY ON EXOTICISM* (NOTE 42), 57–58.

individual's encounter with forms: through the production of a new fold (to borrow Deleuze's term again), which generates an irregularity in the cultural landscape. Singularity is tied to events, and it opens the way for aftershocks and variants; but it also takes up the thread of modernity, for it always constitutes a rupture, a discontinuity in the smooth landscape of the present.

Smooth, and smoother every day, for globalization entails the neutralization of spaces where such meetings can occur. Indeed, contemporary culture is produced in places that would have made Segalen scream: the São Paulo airport, the shopping malls of Bombay, New York's Chinatown–spaces that seem to be similar all over the world (what sociologist Marc Augé would call "non-places"), within which, however, there unfolds a game of differences, in which imported cultures cohabit and jostle together. This displacement explains the importance assumed, in recent years, by the theme of creolization, as a historical phenomenon, as a formula for blending, and as a mode of thought. Thus, the Caribbean represents an original scaled-down model of the contemporary world: the cultures of deported African slaves and those of the European and Asian expatriates have acclimated themselves on neutral soil, forming an artificial, purely circumstantial cultural mix but one that is generative of singularity. "Creoleness is the *interactional or transactional aggregate* of Caribbean, European, African, Asian, and Levantine cultural elements, united on the same soil by the yoke of history … Our Creoleness was, therefore, born from this extraordinary 'migan,' wrongly and hastily reduced to its mere linguistic aspects, or to one single element of its composition."[60]

Migan is a Creole dish that, despite the heterogeneity of the ingredients that compose it, possesses a genuine specificity; making it emblematic

60 JEAN BERNABÉ, PATRICK CHAMOISEAU, AND RAPHAËL CONFIANT, "IN PRAISE OF CREOLENESS," *CALLALOO* 13, NO. 4 (1990): 891–92.

of the process of "becoming minor" of globalized languages: countering obligatory standardization, creolization infinitely ramifies cultural discourses and brews them in a minority crucible, reconstituting them, sometimes unrecognizably, in the form of artifacts henceforth cut off from their origins. Creolization produces objects that express a journey rather than a territory, objects that are the province of both the familiar and the foreign. Thus, in the work of Mike Kelley, parareligious Chinese practices, folk art, and popular culture no longer represent instances of otherness in relation to a dominant culture, but simply elsewheres or other ways, on the same basis as classical Western culture. They are islands of an urban archipelago, which communicate with each other without ever being reduced to the condition of forming a single territory. From this point of view, Mike Kelley's work is elaborated in the non-place of global creolization—in a radicant space.

This neutralized place is represented by Dominique Gonzalez-Foerster as a process of tropicalization. *Park—A Plan for Escape*, presented at the 2002 documenta in Kassel in the middle of the city's immense wooded park, was a space composed of disparate elements from various countries where the artist has spent time (a telephone booth from Rio de Janeiro, roses gathered in India, rock from Mexico); alongside these elements, film excerpts were projected on a modernist-inspired pavilion. Based on an effort to mine lived moments, Gonzalez-Foerster's work responds to the demand for formal translation described by Victor Segalen as "the direct representation of exotic material as conveyed through form."[61] *Park—A Plan for Escape* thus constitutes a radicant mental space born of a diaspora of signs planted on a chance soil. Her work's affirmation of the primacy of the void (the idea, repeatedly affirmed across installations such as *Brasilia Hall* and *Moment Ginza*, that the work both creates a void around itself and is at the same time built on a void) enables Gonzalez-Foerster

61 SEGALEN, *ESSAY ON EXOTICISM* (NOTE 42), 23.

to compose forms by means of encounters: at the heart of this void, cultural phenomena pour forth in parallel to meet in the potential space of the work. Epicurus wrote that the universe was nothing but a rain of atoms before the *clinamen* (spontaneous deviation) caused a pile-up accident, a collision that was the origin of worlds. Before the encounter takes place, the atoms fall like drops of rain, without meeting; their existence, as elements taking part in the encounter, thus proves to be purely abstract. Gonzalez-Foerster's work refers to this vision of the world. It participates in a materialism of signs[62] that is the substrate of that tropicalism under whose aegis she places her work. The Tropics of art: a space where forms and signs, utterly entangled, grow and develop with astonishing speed, in the void.

"Why Japan?" asks Roland Barthes in introducing his *Empire of Signs*. "The Japanese sign is empty: its signified flees; there is no God, no truth, no morality within these signifiers that reign without compensation. And above all, this sign's superior quality, the nobility of its assertion and the erotic grace of its lines, are attached to everything, the most trivial objects and behaviors, those that we usually dismiss as insignificant or vulgar."[63] In other words, the signs that structure Japanese culture stand out against an empty background, in a pure organization of signifiers installed on nothingness. Its forms are mobile and distinct because they are cut off from all pathos, all original meaning. It is from this perspective that we can approach *Riyo* (2004), a video by Gonzalez-Foerster which consists of a long tracking shot on the river that passes through the center of Kyoto, while the soundtrack reproduces a banal conversation, tinged with seduction, between two Japanese teenagers who have run into each other at a party. In the film, the gap between image and sound, which proves a gulf, offers

62 FOR A FULLER ANALYSIS OF THIS ALEATORY MATERIALISM, SEE PART 3, CHAPTER 1: "UNDER THE CULTURAL RAIN."

63 ROLAND BARTHES, *L'EMPIRE DES SIGNES* (PARIS: FLAMMARION), BACK COVER.

us a concrete image of that void, which is the condition of any encounter.

Creolization could be defined as a joyous practice of grafting, a productivity engine fueled by the cultural encounter that colonization enabled with its act of breaking and entering, in the postcolonial reflux, in those potential spaces that Gonzalez-Foerster frames and identifies in big cities, in the chinks opened up by migratory wandering. Beyond the Caribbean, creolization functions today as a conceptual model whose figures could constitute the basis of a globalized modernity, a weapon against cultural standardization. Let us remember that twentieth-century modern art was notable as a school of intellectual treachery. Stateless citizens, renegades, exiles, turncoats. In its day, the artistic avant-garde was called cosmopolitan and accompanied by countless criticisms that smacked of anti-Semitism and xenophobia; modernism was the art of the "stateless."

Where culture is concerned, let us hazard the claim that people have always taken pride in betraying their country and its conceptual traditions. Following in the footsteps of Victor Segalen, we will seek to shake figures and signs, to set them in motion, to *risk* them. Besides, by what right should a territory constrain us? Why should the fact of having been born in a place serve as a pretext for denying us the right to be merely temporary sojourners there? To betray one's origins by selling them in the market of signs, to crossbreed these signs with those of more or less distant neighbors, to renounce the value assigned to cultural materials in favor of their convertible, local use value: this is the program of creolization that is taking shape.

Walter Benjamin's formula resonates here: "But now the reflected image has become separable, transportable."[64] The global individual can no

64 BENJAMIN, "THE WORK OF ART IN THE AGE OF MECHANICAL REPRODUCTION" (NOTE 20), 231.

longer count on a stable environment; he is doomed to be exiled from himself and summoned to invent the nomad culture that the contemporary world requires. It is proving all the more important to crystallize this culture around readable concepts, given that the postmodern world—analytical, relativist, and identitarian—constitutes a natural ally, indeed an ideal terrain, for the development of religious sentiment, as can be observed pretty much all over the world. For the power of religion is that it gives meaning to everything; from roots and origins it derives directions and goals. Nothing escapes the semiotic influence of religion, which explains everything, justifies resistance to change, and delivers its marching orders. We have seen it before: in the past, nothing served to extricate us from such determinisms more effectively than the elaboration of modernity, whose power to uproot people from traditions was able to act as a counterweight to religious fundamentalisms and economic slogans, and to furnish an alternative direction, another prism through which to interpret the world that would be based on neither financial profit nor religious investment. How might this modernity be structurally defined? As a collective setting in motion. Far from aping the signs of yesterday's modernism, it is a matter today of negotiating and deliberating; rather than miming the gestures of radicality, it is a matter of inventing those that correspond to our own era.

The altermodernity emerging today is fueled by the flow of bodies, by our cultural wandering. It presents itself as a venture beyond the conceptual frames assigned to thought and art, a mental expedition outside identitarian norms. Ultimately, then, radicant thought amounts to the organization of an exodus.

RADICANT AESTHETICS

The major aesthetic phenomenon of our time is surely the intertwining of the properties of space and time, which turns the latter into a territory every bit as tangible as the hotel room where I am sitting right now or the noisy street that stretches beneath my window. By means of these new modes of spatializing time, contemporary art produces forms that are able to capture this experience of the world through practices that could be described as "time-specific"—analogous to the "site-specific" art of the 1960s—and by introducing figures from the realm of spatial displacement into the composition of its works. Thus, today's art seems to negotiate the creation of new types of space by resorting to a geometry of translation: topology. This branch of mathematics deals less with the quantity of spaces than with their quality, the protocol of their transition from one condition to another. Thus, it refers to movement, to the dynamism of forms, and characterizes reality as a conglomeration of transitory surfaces and forms that are potentially movable. In this sense, it goes hand in hand with translation as well as with precariousness.

AESTHETIC PRECARIOUSNESS AND WANDERING FORMS
Of all the sociological phenomena of these early years of the twenty-first century, the generalization of the disposable is no doubt the one that goes most unnoticed. It even tends to be regarded as a cliché, a legacy of the first ecological alarm bells sounded in the 1960s. Be that as it may, it is a fact that the lifespan of objects is becoming shorter and shorter, their turnover in the marketplace ceaselessly accelerated, their obsolescence carefully planned. Social life seems more fragile than ever, and the bonds that make it up seem increasingly tenuous. The contracts that govern the labor market merely reflect this general precariousness, which mirrors that of commodities whose rapid expiration now permeates our perception of the world. Originally, the term "precarious" referred to a right of use that could be revoked at any time. It must be admitted that each of us now intuitively perceives existence as a collection of ephemeral entities, far from the impression

of permanence that our ancestors, whether rightly or wrongly, formed of their environment. Paradoxically, however, the political order that governs this chaos has never seemed so solid: everything is constantly changing, but within an immutable and untouchable global framework to which there no longer seems to be any credible alternative. In an immediate environment that is constantly being updated and reformatted, in which the short-lived is overtaking the long-term and access is overtaking ownership, the stability of things, signs, and conditions is becoming the exception rather than the rule. Welcome to the disposable world: a world of customized destinies, governed by the inaccessible mechanism of an economy that, like science, is developing in a state of complete autonomy with respect to lived reality.

Until well into the 1980s, a fashion in clothing or music had time to develop before giving way to another that was equally distinct. By contrast, today's trends constitute a kind of continuous, low-amplitude motion, whose content no longer corresponds to behavioral or existential choices, as it did for the great pop culture movements of the last fifty years of the twentieth century. In the contemporary cultural tide, the waves no longer cover each other forcefully, forming hollows and crests. On the contrary, countless little wavelets wash up on the beach of a "now" in which all trends coexist without animosity or antagonism. The cultural choices are options that can be combined and superimposed. Nothing *counts*, since nothing really binds us or requires us to commit ourselves. Let us recall the great Nietzschean question of eternal return: are you willing to relive for all eternity the moments you are experiencing right now? Transposed to the realm of art, this question entails a commitment to values, a space traversed by conflicts, by wagers with consequences for the future. That question no longer arises. And yet it introduced tragedy into culture, for at that time artistic propositions, like the statements that accompanied them, bore the stamp of irreversibility; they had weight and a cutting edge [*tranchant*]. Now that the era of commitment is past, we find it

pathetically difficult to retain anything at all in a cultural environment that is marked by its volatility—except proper names, which increasingly function as brands.

Various authors have sought to delineate the contours of this precarious universe. The sociologist Zygmunt Bauman defines our industrial cult of the ephemeral as constituting a "liquid modern society" in which "the waste-disposal industry takes over the commanding positions in liquid life's economy."[65] In this society where everything is disposable, a society "nudged from behind by the horror of expiry," nothing is more frightening than "the steadfastness, stickiness, viscosity of things inanimate and animate alike." And the driving force of this "liquid life" is needless to say that globalized consumerism whose glorious face is the shopping malls and whose miserable underside is the flea markets and the slums, in a universe of global competition between disposable employees who are alternately consumers and consumed. As early as 1984, the German thinker Ulrich Beck described a "risk society" in which the individual—under the weight of "menacing possibilities," whether ecological or economic—becomes the object of an "invisible impoverishment" generated by universal precariousness.[66] Nor is private life far behind. Global capitalism, writes Slavoj Žižek, "clearly favor[s] [a] mode of subjectivity characterized by … multiple shifting identifications," a development that turns queer theory, MySpace culture, and the avatars of Second Life into the objective allies of a society governed by the quest for perpetual novelty.[67] Michel Maffesoli relativizes the emergence of this social changeability, regarding it as simply a polytheistic and pagan, eclectic and pluralistic "period," a

65 ZYGMUNT BAUMAN, *LIQUID LIFE* (CAMBRIDGE: POLITY PRESS, 2005), 3.

66 ULRICH BECK, *RISK SOCIETY: TOWARDS A NEW MODERNITY*, TRANS. MARK RITTER (LONDON AND NEW-BURY PARK, CA: SAGE PUBLICATIONS), 1992.

67 SLAVOJ ŽIŽEK, *THE SPECTRE IS STILL ROAMING AROUND!: AN INTRODUCTION TO THE 150TH ANNIVER-SARY EDITION OF THE "COMMUNIST MANIFESTO"* (ZAGREB: ARZKIN, 1998), 25.

"sign of vitality" that follows quite logically the totalizations of modernism. "The emblematic figure of this moment," he writes, "points to an identity in motion, a fragile identity, an identity that is no longer the only solid foundation of individual and social existence, as it was for modernity."[68]

This "liquid" modernism became a reality at the beginning of the 1990s, when the economic crisis relegated the themes of consumption and communication, which had dominated the 1980s, to the background. Using disparate sculptural means, Jeff Koons, Jenny Holzer, Cindy Sherman, and Haim Steinbach had all set the social play of shopping— whether it be that of identities (Sherman) or that of exchange value (Steinbach), ideology (Holzer), or the marketing of desire (Koons)— on durable supports. But as soon as the decade was over, the works of Cady Noland, which stood midway between the icy aesthetic that had prevailed until then (recognizable by its perfect finishes and sophisticated packaging) and the aesthetic of the flea market (which would soon become the formal structure most commonly employed by artists), formed a perfect transition to the 1990s, which would oppose the luxurious forms of the art of the preceding decade by exalting the precarious against the solid, the use of things against their exchange under the aegis of the language of advertising, the flea market against the shopping mall, ephemeral performance and fragile materials against stainless steel and resin.[69]

In these early years of the twenty-first century, it is clear that the oppositions are less marked. All forms coexist peacefully, and artistic production no longer even seems to be organized by that pendulum swing between the solid and the precarious that continued to echo

68 MICHEL MAFFESOLI, *DU NOMADISME* (LIVRE DE POCHE, 1997), 109.

69 FOR MORE ON THE MARKET AS HEGEMONIC FORM OF THE ART OF THE 1990S, SEE THE AUTHOR'S *POSTPRODUCTION* (NOTE 36).

the alternation of classical and baroque, a "fundamental principle of art history" according to the historian Heinrich Wölfflin.[70] For such "fundamental principles" can only fully operate in a radical world, or a world that retains a memory of that radicality. In a postmodern universe, everything is equivalent. But in a radicant universe, principles mingle and multiply by means of combinations. No more subtraction, but constant multiplication. That profusion, that absence of clear hierarchies, is in keeping with this precariousness, which can no longer be reduced to the use of fragile materials or short durations but now imbues all artistic production with its uncertain hues and constitutes an intellectual substrate, an ideological backdrop before which all forms pass in review. In short, precariousness now pervades the entirety of the contemporary aesthetic. Is this a paradox? Officially, if I may say so, precariousness is the sworn enemy of culture. Let us recall certain axioms of Western culture which hold that the cultural object is defined by its enduring character, or simply by its opposition to the world of consumption. Hannah Arendt's writings are a good example of this attempt to rank things according to their degree of solidity: "Culture is being threatened when all worldly objects and things, produced by the present or the past, are treated as mere functions for the life process of society, as though they are there only to fulfill some need."[71] In other words, art must absolutely resist the process of consumption: "An object is cultural to the extent that it can endure; its durability is the very opposite of functionality." Zygmunt Bauman makes the same argument, but he targets the enemy with greater precision: as the new purveyor of cultural criteria, the marketplace of consumption "propagates rapid circulation, a shorter distance from use to waste and waste disposal, and the immediate replacement of goods that are

70 HEINRICH WÖLFFLIN, *PRINCIPLES OF ART HISTORY: THE PROBLEM OF THE DEVELOPMENT OF STYLE IN LATER ART*, TRANS. M. D. HOTTINGER (NEW YORK: DOVER, 1950).

71 HANNAH ARENDT, *BETWEEN PAST AND FUTURE: EIGHT EXERCISES IN POLITICAL THOUGHT* (NEW YORK: VIKING, 1968), 208.

no longer profitable."[72] Operations that, according to Bauman, are radically opposed to "cultural creation." But is this dichotomy between the enduring and the functional still relevant today? Is it capable of establishing a distinction between what belongs to culture and what is hostile or alien to it? Is precariousness in itself a bad thing? Are there cutting edges [*du tranchant*] to be found in the precarious universe?

Paradoxically, precariousness is inscribed in the culture by the many mechanisms that seek to remedy it, and attest to it at the same time. We live in a "ctrl+S universe," a society with "automatic backup" in which the recording and archiving of cultural phenomena are widespread and systematic. If it is true that, as Bauman writes, "among consumer society's industries waste production is the most massive,"[73] the same might be said of the industry that reflects it, that of pres-ervation. Thus, a dense network of journals, museums, websites, and catalogues is turning the art world into a kind of hard disk that stores, recycles, and reuses the most precarious productions. Here too, the culture of precariousness privileges the replayable (which depends on access) over the durable (which involves the physical possession of things). Today, the function of the art museum has less to do with the storage of objects in a physical space than with the maintenance of a database of information. A performance by Vito Acconci from 1970, of which nothing survives but photographic doc-uments and eye-witness accounts, potentially represents the same value as a sculpture displayed in the rooms of a museum—specifically that of a replayable score, but also that of an artistic event whose shock wave cannot be reduced to its physical duration. Today, when Tino Sehgal recruits actors to interpret his interactive scenarios, he requests that no visible traces be left behind. This insistence on the

72 ZYGMUNT BAUMAN, *LIQUID LIFE* (NOTE 30), 59.

73 IBID., 9.

"here and now" of the artistic event and the refusal to record it are a challenge to the art world (whose institutional character is now becoming indistinguishable from archiving); they are also the assertion of a positive precariousness, or even an aesthetic of uncluttering, of wiping the hard disk.

If Hannah Arendt's criteria for the definition of culture—its enduring character, its distance from social processes, its rejection of function and commercialization—are applied to contemporary artworks, it is clear that nearly all of them fail to satisfy it, as does the system in which they are involved. Does this mean they are merely a parody of culture? Or on the contrary, that they are defining new territories in response to a new and unprecedented situation? For when we examine the phenomenon of artistic production today, we find that there seem to be new types of contracts being concluded between the physical duration of the artwork and its duration as information, contracts that shatter the foundation of certainties on which critical thought has hitherto been based. It is my contention that art has found a way not only to resist this new unstable environment but also to draw new strength from it, and that new forms of culture and new types of formal writing could very well develop in a mental and material universe whose backdrop is precariousness. For this is the situation in these early years of the twenty-first century, in which transience, speed, and fragility reign in all domains of thought and cultural production, giving rise to what might be described as a precarious aesthetic regime.

A modern moment took place at the end of the nineteenth century: the brushstroke became visible, expressing the painting's autonomy and magnifying the human hand in reaction to the industrialization of images and objects. It may be that, in these early years of the twenty-first century, our own modernity is developing on the basis of this collapse of the long term, at the very heart of the consumerist whirlwind

and cultural precariousness, countering the weakening of human territories under the impact of the globalized economic machine.

NO FIXED FORM (HOMELESS MATERIALS)

A history of the use of precarious materials in art since Kurt Schwitters's subtle compositions of found objects would fill multiple volumes. Here, however, we are interested in the contemporary meanings of the practice. It is certainly true that twentieth-century artists made abundant use of waste and everyday objects, but they did so for many different aesthetic reasons. Thus, Joseph Cornell's surrealistic boxes have nothing to do with Rauschenberg's "combine paintings," which sought to bridge the gap between art and life from a very Duchampian perspective. The industrial waste amassed, compressed, or packaged by the New Realists of 1960 sought to create an expressive lexicon of the new industrial nature, while the natural precarious materials manipulated by the Italian artists of Arte Povera in the latter half of the decade were a response to the consumerist optimism of American Pop Art. As for the precarious compositions produced by the various members of the Fluxus movement, they valorized everyday life against its capture by artistic means and introduced a poetics of the next-to-nothing that would later find its most forceful expression in the works of George Brecht and Robert Filliou. And today?

Here is a gigantic shambles without beginning or end... The most heterogeneous objects—some used, some not—accumulated, isolated, or connected by tubes or wires within a structure that has no symmetry or overarching form but abounds in little compositions that are partially or totally hidden beneath the mass of the materials. The first time I saw an installation by Jason Rhoades—in Cologne in 1993—I was puzzled. What was he getting at? And yet all of the elements of this precarious aesthetic were right before my eyes: clutter, indeed saturation; the use of "poor" materials; a failure to distin-guish between scraps and objects of consumption, between edible

and solid; and the rejection of any fixed compositional principle in favor of installations that seem nomadic and indeterminate. At the time, the allusions to homeless encampments seemed to be justified by a difficult economic situation. In New York in that same year, Rirkrit Tiravanija turned a gallery into a soup kitchen, inviting passersby to come in and eat in the guise of an exhibition. But what remains visible of Tiravanija's installations is not unrelated to those of Rhoades: kitchen utensils, minimal furnishings, and various objects in a state of apparent disorder unstructured by any discernible composition. As if in a world completely saturated with objects one could only compose negatively, by hollowing out: Rhoades, a Californian who died in 2006 at the age of forty-one, and Tiravanija, a Thai artist born in Argentina, are sculptors who bring figures to light by eliminating, by scraping away and eliding. For them there is no such thing as a blank page, a pristine canvas, or material to be worked. Chaos is preexisting, and they operate from the midst of it.

In 1991, an album by the group My Bloody Valentine, *Loveless*, expressed this new aesthetic tendency in the medium of sound. Within an undifferentiated aural chaos of electric guitars, the melody of each piece seemed to emerge by a series of subtractions, by emptying out, as if carved from some dense, preexisting magma. Reflections on a civilization of overproduction, in which the degree of spatial (and imaginary) clutter is such that the slightest gap in its uninterrupted chain—whether it be a disused urban area, a barren expanse (jungle, desert, or ocean), or an impoverished area—immediately becomes photogenic, even fascinating. The "few" or the "little" [*le peu*] is the ultimate icon, even in the midst of abundance. Here the artistic *laissez-faire* of a Jason Rhoades assumes the status of a moral act.

Fragile compositions, then. But that was not the final word of an aesthetic that insists on this fragility, not in an effort to highlight art's capacity to immortalize, but on the contrary, because it sees art as

the exaltation of instability. Born of the general excess, these compositions are in keeping with what the urban landscape has become, a precarious, cluttered, and shifting environment. Just as much of contemporary video deliberately models itself on the practices of amateurs, privileging raw documents and shaky images and restricting itself to the most rudimentary editing, in the same way, Jason Rhoades's installations assert that they only differ from life itself by a slight symbolic displacement. In a world that records as quickly as it produces, art no longer immortalizes but tinkers and arranges, throwing the products it consumes on the table pell-mell. Millions of people shoot, compile, and edit images with the help of software available to everyone. But they freeze memories, whereas the artist sets signs in motion.

Thus, Gabriel Orozco's photographs are merely stills from the great film of the precarious world. He frames ephemeral sculptures, collective, anonymous, and lowly compositions: a suspended plastic bag, water in a burst balloon, bunches of bicycles on a sidewalk. Orozco's subject is the collective as producer of forms, but at precisely the point where it cannot be distinguished from natural phenomena. Human agency or inclement weather—how can one tell them apart? Thus, as an artist he stands in the tradition of Jacques Villeglé, who collected the results of that "anonymous tearing" that provided the basic material for his project of unsticking posters, and Bernd and Hilla Becher, who created the visual yearbook of disused industrial structures. Human activities, sometimes indirectly, produce subtle compositions that the artist is content to simply frame, thus inscribing them within the register of duration, as with the series of *Monuments* conceived by Thomas Hirschhorn: "I wanted to show that monuments come 'from below,'" he explains. "I love anonymous altars, where people bring flowers and candles." One of these models was the improvised altar to Lady Di that came about after her accidental death in Paris, the reproduction of the flame of Bartoldi's Statue of

Liberty that her admirers spontaneously occupied because it was conveniently located above the tunnel where the media-friendly princess lost her life. Hirschhorn constructed a replica of it using his materials of choice (cardboard, aluminum foil, brown tape) before going on to realize more complex installations dedicated to authors such as Gilles Deleuze, Georges Bataille, Baruch Spinoza, and Michel Foucault. "It's a critique of the classical monument, in its choice of whom to memorialize and in its form. The monumental tradition celebrates warriors and men of power in the central squares of cities; I make monuments to thinkers in locations on the outskirts, where people live, precarious monuments that don't try to impress anyone and eschew the immortality of noble materials, marble or bronze."[74] The precarious aesthetic comes "from below" and cannot be distinguished from a gesture of solidarity.

Jennifer Allora and Guillermo Calzadilla make impressions in sand of signs etched on the soles of shoes (*Landmark—Footprints*) or encourage passersby to draw with white chalk on the asphalt of city streets (*Chalk Project*). One of their videos, *Amphibious* (*Login-Logout*), produced in 2005, shows a procession of seemingly trivial forms and events winding along a river and watched by turtles that have climbed up on a makeshift raft.

At the invitation of the Tate Gallery, Mark Dion recruited volunteers to collect the slightest artifacts trapped in the mud of the Thames at the foot of the British institution—pipes, plastic objects, old shoes, oyster shells… These archaeological excavations made it possible to raise the cultural and industrial history of London back up to the surface (*Tate Thames Dig*, 1999). While the horizon of Dion's work is the global environmental crisis and the sociopolitical relations between the rich

74 THOMAS HIRSCHHORN IN CONVERSATION WITH VALÉRIE SAINT-DO, AVAILABLE ONLINE AT
HTTP://WWW.HORSCHAMP.ORG/ARTICLE.PHP3?ID_ARTICLE=1300&VAR_RECHERCHE=HIRSCHHORN.

countries and the Third World—which he finds forms for in installations inspired by the museography of natural history and zoology—he too depicts our world as an enormous pile of assorted debris that the artwork then sets about collecting, classifying, and interpreting. This same perspective informs George Adeagbo's installations, constellations of trivial objects rescued from some abstract disaster, as well as the samples taken by Jeremy Deller from the folk culture of the United States.

While some artists seem to distance themselves from this precarious aesthetic, often they are only separated from it by their works' degree of material solidity. Take the trio of superstars consisting of Jeff Koons, Maurizio Cattelan, and Damien Hirst. What do they have in common besides the fact that their exhibitions are major events, unless it be their shared ambition to take an iconography born of contemporary precariousness and render it monumental? Thus, Jeff Koons takes children's toys and endows them with an enormous physical weight that contrasts with their frivolousness. His subject is heaviness: he turns the lightest of gadgets into untransportable monoliths, inflatable objects into lead, cheap junk into jewelry, as if he regarded aesthetic surplus value as a kind of gravity. For Koons, the density of matter becomes the quintessential code by which to organize the visible. An obsession with precariousness compels him to turn it into spectacle—that is, accumulated capital, gold value. As for Damien Hirst, the magnificent visual means he employs, the flawless finishes of his huge glass cages, and the luxurious formats of his paintings only serve to underscore the morbidity or fragility of the subjects he pins or imprisons there. Formaldehyde immortalizes, so he uses it to protect art against putrefaction. A butterfly catcher, the curator of a museum of cadavers, and the brilliant interior decorator of the hospital of the twenty-first century, Hirst is the great denier of precariousness, which he thus highlights as our actual horizon. Subodh Gupta's gleaming installations, realized using the most ordinary kitchen utensils to be found in the Indian state of Bakar; Nari Ward's heartbreaking

assemblages, produced by collecting used materials from New York City's African-American neighborhoods; Bertrand Lavier's chromium-plated African masks; and David Hammons's subtle arrangements of objects—even though they all belong to the category of sculpture, all of them contribute to the iconography of the precarious world.

It is equally clear that Cattelan works at the very heart of that universe. He derives the bulk of his material and the resources for his Chaplin-esque irony—the irony of the vagabond set loose in the universe of power—from the unstable status of the artist, the fragility of his position within the mechanism of the production of value. Thus, his life-size reproduction, above the municipal garbage dump of Palermo, of the letters that spell out "Hollywood" in the Los Angeles hills (*Hollywood*, 2001) may be seen as an emblem for his work, which is haunted by social precariousness and frequently orchestrates collisions between luxury and poverty. The emblem of this collision between two worlds is vanity, and it is coming back into fashion in these early years of the twenty-first century. Subodh Gupta's *Very Hungry God* (2006) repre-sents an enormous skull with the help of an assemblage of chromium-plated implements. Piotr Uklanski has done the "portrait" of a collector—specifically François Pinault—in the form of an X-ray image; earlier he produced a photograph in which intertwined nude bodies form a skull and crossbones. In the context of luxury, vanity acquires new meaning. When social cynicism reaches heights like these, the artist becomes a kind of pre-Socratic philosopher, the only one who can say to the emperor, "get out of the way, you're standing in my sun."

URBAN WANDERING

When future historians study our era, they will no doubt be struck by the number of works that depict life in the big cities. They will note the countless images of streets, stores, markets, buildings, vacant lots, crowds, and interiors that were exhibited in galleries in our day. From this they will infer that the artists of these early years of the twenty-first

century were fascinated by the transformation of their immediate environment and the "becoming-world" [*devenir-monde*] of their cities. They will compare this period to the second half of the nineteenth century, when Édouard Manet, Claude Monet, and Georges Seurat depicted the birth of industrial civilization, also by painting scenes of urban life from the immediate outskirts of the cities. The Impressionists' views of boulevards and Parisian cafés bear certain similarities to the post-industrial landscapes of Andreas Gursky, Thomas Struth, Beat Streuli, and Jeff Wall. And going beyond contemporary photography, one could define nearly all contemporary artists by reference to the Baudelairean maxim "to distill the eternal from the transitory." For the omnipresence of precariousness in contemporary art inevitably pushes it back toward the sources of modernity: the fleeting present moment, the shifting crowd, the street, and the ephemeral. In his most programmatic text, Baudelaire attempts to sketch the profile of this *artiste mutant*: "a man of the whole world, a man who understands the world and the mysterious and lawful reasons for all its uses," he is "interest[ed] … in things, be they apparently the most trivial." A flâneur who is able "to become one flesh with the crowd," that is, "the multitude, amid the ebb and flow of movement, in the midst of the fugitive and the infinite,"[75] this artist is "a kaleidoscope gifted with consciousness, responding to each one of its movements and reproducing the multiplicity of life and the flickering grace of all the elements of life."[76] From Gabriel Orozco to Thomas Hirschhorn and from Francis Alÿs to Jason Rhoades—all of them artists whose formal universes are nonetheless clearly dissimilar—many contemporary artists would embrace this definition of Baudelairean modernity, indexed to the urban, wandering, and precariousness. And the figure of the "kaleidoscope gifted with consciousness" might have been expressly

75 CHARLES BAUDELAIRE, *THE PAINTER OF MODERN LIFE AND OTHER ESSAYS*, TRANS. AND ED. JONATHAN MAYNE (LONDON: PHAIDON, 1964), 6–12.

76 IBID., 9.

invented to describe the viewer of a work by Rhoades or Tiravanija, who is able to break down and reconstruct the movements that unify the thousand and one elements of an installation that would seem, to a more stationary gaze, to be nothing but pure chaos.

"Perhaps you know what an *erre* is?"* asks Jacques Lacan. "It's something like momentum. The momentum something has when what was formerly propelling it stops."[77] At the end of the 1970s, when the modernist engine stopped, there were many who proclaimed the end of the movement itself. Thus, the postmodernists walked around the vehicle, deconstructed its mechanics, broke it down to spare parts, and formed theories regarding the nature of the breakdown before strolling off into the surrounding area and announcing that everyone was now free to walk however they liked, in whatever direction they chose. The artists under discussion here intend to remain the car, in the same direction as modernity, but while operating their vehicle according to the reliefs they encounter and with the aid of a different fuel. The *erre* would then be what remains of the forward motion initiated by modernism, the field that is open to our own modernity, our altermodernity. Thus, the work of Gabriel Orozco is riddled with allusions to the erratic movements of the urban pedestrian. *Yielding Stone* (1992) is a plasticine ball that is rolled across the asphalt surfaces of the city and collects the tiny debris that lies in its path. Consisting of a thin layer of minute materials, peelings, and dust, *Yielding Stone* is intended to reach the weight of the artist over the years, so that although it is not anthropomorphic it acquires the density of a portrait of the artist as flâneur. In a magnificent series of paintings begun in 2005 and entitled *The Samurai Tree*, Orozco uses gold leaf and tempera to paint a central circle, around which the compositions then develop by

* TRANSLATOR'S NOTE: THE WORD *ERRE* IS RELATED TO *ERRER*: TO WANDER, AND *ERRANCE*: WANDERING, BOTH OF WHICH ARE IMPORTANT WORDS IN BOURRIAUD'S TEXT.

77 JACQUES LACAN, "LES NON-DUPES ERRENT," SEMINAIRE XXI, NOVEMBER 13, 1973, UNPUBLISHED.

following the movements of the knight in chess, adding new circles of various sizes until the edges of the surface are reached. Each of the paintings describes a series of subtle spirals and undulating lines that evoke both Joan Miró's *Constellations* and Piet Mondrian's *Broadway Boogie-Woogie*. Utilized here as a compositional principle, the knight is a recurring figure in Orozco's work. *Knights Running Endlessly* (1995) consists of a chess set with 256 squares, all occupied by knights. The movement of this chess piece, which seems so fanciful and arbitrary but is actually strictly prescribed, functions as a metaphor for wandering, for sidling through the crowd of the big cities, for which the works of the series *The Samurai Tree* are icons.

If wandering practices are becoming so important today, even to the point of providing art with compositional models, it is in response to the evolution of the relations between the individual and the collective in the contemporary city. Walter Benjamin, who characterized the artwork's aura as "the unique phenomenon of a distance,"[78] describes its progressive disappearance in spatial terms: the space of human life is undergoing a metamorphosis; the distance between things and living beings is diminishing; the modern city, whose vital element is the crowd, introduced "perception in the form of shocks"[79] as a formal principle that found its aesthetic and technological expression in film. The immensity of the crowd, writes Benjamin, destroys the bond between the individual and the community, and it can only be recreated by an intentional, even artificial act. Thus, one might say that the contemporary megacity, as depicted or set in motion by the artists of today, is the effect of a political *erre*, of what remains of the movement of socialization when its own energy has vanished, giving way to an urban chaos. Moreover, each of these megacities displays the features of the world economy in concentrated form: the true borders are

78 BENJAMIN, "THE WORK OF ART IN THE AGE OF MECHANICAL REPRODUCTION" (NOTE 20), 222.

79 WALTER BENJAMIN, "ON SOME MOTIFS IN BAUDELAIRE," IN BENJAMIN, *ILLUMINATIONS*, 175.

now internal, and they bring about subtle forms of segregation between social or ethnic classes in the city itself.

For years, John Miller has been photographing scenes of daily life during the lunch break, wherever in the world he happens to be. The series *Middle of the Day*, which now numbers thousands of photographs, brings together images of this pause in the workday, this interstitial moment in which the employee—on parole, as it were—occupies the public space, eating lunch on a bench or strolling through the city. This period in which industrial production is suspended was also the subject of Georges Seurat's painting *A Sunday Afternoon on the Island of La Grande Jatte* (1884–86). A depiction of the weekly day off in the nearby Parisian suburbs, a pointillist allegory of the birth of the leisure society, the work of this French post-Impressionist was realized using pictorial means that themselves evoked the division of labor. With his punctual brushstrokes mechanically applied to the surface of the canvas, Seurat attempts to reproduce the movement of industry in painting. His dream was that it would be possible to reproduce his paintings ad infinitum, as if on an assembly line, by applying the dots of color to the canvas one by one. In a certain sense, Seurat anticipates the pixel. Today, when John Miller sets out to depict the midday lunch break, he too uses means that are perfectly homothetic to his subject: an amateur camera and framings that are sometimes approximate. And he displays these views of city centers and downtown areas by the hundreds in the most ordinary formats, in simple wooden frames. And where were they taken, these images of semi-occupied pedestrians with their sandwiches, against a backdrop of shopping malls or strolling around in the park? While a sign sometimes offers a vague clue, it is hard to tell if these are photographs of Amsterdam or Moscow, Hong Kong or Buenos Aires. John Miller depicts Seurat's Sunday enlarged to planetary dimensions and confined to the legal hours of flânerie.

Since 1991, Francis Alÿs has made his walks in Mexico the starting point for a body of work that is equally divided among painting, drawings, photographs, films, and actions. "Walking," says Alÿs, "is one of our last remaining intimate spaces." He sometimes records his strolls or collects found objects and images that he will later use in his paintings. Why is it that the contemporary equivalent of landscape painting is so often based on action and narrative at the expense of representation? Alÿs offers this explanation: "My paintings, my images, are only attempting to illustrate situations I confront, provoke or perform on a more public, usually urban, and ephemeral level. I'm trying to make a very clear distinction between what will be addressing the street and what will be directed to the gallery wall. I tried to create painted images that could become 'equivalents' to the action, 'souvenirs' without literally representing the act itself."[80] The artist of the precarious world regards the urban environment as a container from which to separate fragments. How many Florentine painters used terra sienna to depict the landscapes of Tuscany? Today, working *sur le motif*, or in nature, as the Impressionists did in their day, means entering the motif itself and moving according to its rhythms. The Slovenian artist Marjetica Potrč doesn't represent the slums of Caracas; she spends time there in order to study them from within, gathering or reconstructing fragments of them and then, in a second phase, proposing alternative solutions. The Danish group Superflex doesn't represent the power relations or commercial flows within countries of the Third World, but sets up structures for producing *soda de guarana* in Brazil and bioelectric power plants in Africa.[81] When speaking of these artistic interventions in urban reality, one is tempted to recall the famous formula of Karl Marx from his *Theses on Feuerbach*: "the philosophers have only *interpreted* the world in various ways; the point is to *change* it." Be that as it may, here we

80 FRANCIS ALŸS, "FRANCIS ALŸS: STREETS AND GALLERY WALLS," INTERVIEW BY GIANNI ROMANO, *FLASH ART* (INTERNATIONAL EDITION) 33, NO. 211 (MARCH / APRIL 2000): 72–73.

clearly find ourselves confronting another of the central figures of modernity.

To capture the city in an image really means following its movement. Remember Dominique Gonzalez-Foerster's long tracking shot along the river in *Riyo*. In a sequence from the series *The Needle Woman*, Kim Soo-Ja is filmed from behind as she impassively confronts the advancing wave of an Asian crowd. In his video installation *Electric Earth* (1999), Doug Aitken retraces the promenades of a solitary walker through a nocturnal urban landscape that is just as difficult to identify and from which all human presence seems to have been erased. What remains is the non-place (for example, the parking lot of a shopping mall) and machines (satellite dishes, laundromats) that little by little seem to take control of the flâneur, a contemporary zombie threatened and unsettled [*précarisé*] by the metaphysical indifference of his environment. Urban lighting seems to be Aitken's building material: harsh and cold, light is omnipresent here, and the pale streetlights leave streaks and smears on the sidewalk. Aitken's treatment of light is the opposite of that of Seurat, who sought to eliminate light's iridescence, its luminous halo, retaining only the definite color of the object under precise atmospheric conditions. The contemporary city, by contrast, must be represented in motion, and that goes for its light as well.

Like an insect colliding with a pane of glass, the wanderer quickly runs up against those territories in which the amount of (shared) public space is growing smaller every day. The South African artist Kendell Geers displays the flip side of the contemporary city in a number of

81 MANY FURTHER EXAMPLES COULD BE CITED—I WILL MENTION ONLY A FEW OF THEM HERE: THE TURKISH ARTIST CAN ALTAY TAKES PHOTOGRAPHS THAT DOCUMENT DERELICT AREAS AND OTHER SITES WHERE TEENAGERS CONGREGATE; THE JAPANESE ARTISTS OF ATELIER BOW WOW INVENTORY THE INTERSTITIAL SPACES PRESENT IN THE URBAN FABRIC; AND THE GROUP OF FILMMAKERS AND ARTISTS RAQS MEDIA COLLECTIVE, BASED IN NEW DELHI, CONSTRUCTS LONG-TERM PROJECTS INVOLVING VARIOUS COMMUNITIES.

his works of the 1990s: photographs of private security systems as well as works that are haunted by danger—such as *Mondo Kane* (2002), a minimalist cube covered with broken glass—or even literally dangerous, as with works that are made of razor blades or have an electric current running through them. Francis Alÿs's universe also exhibits the city's mechanisms of control and standardization, but it does so by gathering images of precariousness: homeless people, dropouts, stray dogs. His slide show *Sleepers II* (1997–2002) depicts eighty such figures dozing on sidewalks, photographed at ground level, surrounded by blurred asphalt that alters our perspective on the city.

The *erre*, an invisible line that cuts across city centers and downtown areas, groups together all those with nowhere to go—vagabonds, nomads, gypsies, marginalized individuals, and illegal immigrants. Thus, the wanderer very quickly finds him- or herself associated with the world of criminality. And if Baudelairean flânerie is a brief time out for the person of leisure, wandering quickly carries its practitioners beyond the pale of legality. Indeed, precarious artists often choose to define their work in terms borrowed from the world of criminal vagrancy: petty theft, poaching, robbery, and a refusal to seek paid employment. Kendell Geers confesses: "When I work with an existing image or object and shift it, I don't conceive it as sampling in a DJ sense, or even plagiarism as the Situationists did, but as pure theft. It is about stealing the images from Hollywood, from CNN, literally taking images and reworking them."[82] Bruno Serralongue works as a newspaper photographer, except that because he has no official credentials, he is forced to place his camera at the outskirts of the event, visually marking the line that separates the artist from the journalist whose methods he pretends to adopt, the professional from the mere citizen. Thus, he makes his way toward the margins of

82 CONVERSATION BETWEEN KENDELL GEERS, DANIEL BUREN, AND NICOLAS BOURRIAUD, IN *KENDELL GEERS*, EXH. CAT., MUSEO D'ARTE CONTEMPORANEA, ROME (MILAN: ELECTA, 2004).

information and assumes the role of witness, as when he produces portraits of illegal immigrants or striking workers. Serralongue photographs the line that separates information—the official *communiqué*—from the periphery of the event that serves as its pretext. He places himself outside the law.

Contemporary art commits its most serious act of breaking and entering against our perception of social reality. It essentially renders everything it touches precarious; such is its ontological foundation. By laying hold of the elements that make up our daily lives (corporate logos, media images, urban signs, and administrative procedures) and making them the materials from which they compose their works, artists underscore their arbitrary, conventional, and ideological dimension. We exchange objects for money, we live in this or that manner, but did you know that we could also do otherwise? By making the elements of the ordinary mechanisms of lived reality operate in different ways, art functions as an alternative editing bench for reality.[83] By formalizing behaviors, social interactions, spaces, and functions, contemporary art lends reality a provisional and precarious character. Unlike the ambient discourse, which comes down to Margaret Thatcher's famous formula—"There is no alternative"—art preserves intact an image of reality as a fragile construction and carries the torch for the notion of change, the hypothesis of a plan B. If contemporary art is the bearer of a coherent political project, it is surely this: to introduce precariousness into the very heart of the system of representations by means of which the powers that be manage behaviors, to weaken all systems, to endow the most well-established habits with the appearance of exotic rituals.

Art is thus a kind of primitive editing bench that apprehends social reality through its forms. In more general terms, these works produce

83 A THESIS I HAVE DEVELOPED IN GREATER LENGTH IN *POSTPRODUCTION* (NOTE 36).

the fiction of a universe that operates differently. This fiction might be said to introduce the dimension of the infinite into the continuous ribbon of social reality, just as language allows us to carve into tiny pieces this or that physical reality that for animals is a continuum, a one-dimensional space. Because we have been humanized by language, we know the element in which we move is not indivisible. The room in which I am writing these lines may be broken down into floor, table, drawer, handle, wood grain, mementos, and so on, ad infinitum. In the same way, the fictional dimension of art pierces the chain of reality, returning it to its precarious nature, to the unstable mixture of real, imaginary, and symbolic that it contains. This fiction augments reality, allowing us to keep it in perpetual motion and hence to introduce utopia and alternatives into it. For fiction is not just the imaginary, and the fictional cannot be reduced to the fictive. For example, the Duchampian readymade belongs to the order of fiction, but its nature is not different from that of the reality it presents, except with respect to the narrative by which Marcel Duchamp causes it to enter a fictional regime. The *fictive* is opposed to the reality that inspires it; the *fictional*—which is the regime of stories and narration—subtitles or dubs it, without erasing it.

Thus, wandering represents a political inquiry into the city. It is writing on the move and a critique of the urban, understood as the matrix of the scenarios in which we move. It creates an aesthetic of displacement. The term is admittedly well-worn today, a century after the Duchampian readymade, which was the act of displacing, or transplanting, an everyday object to the legitimating mechanism of the system of art. But if Duchamp used the museum as a kind of optical device that allows us to see a bottle rack differently, it is clear that the museum today is no longer a dominant apparatus, buried as it is beneath a mass of processes for capturing and legitimating that did not exist in Duchamp's day. We have seen that Walter Benjamin links the loss of the aura to the emergence of mechanical techniques for capturing

images, that is, to the emergence of the cinematographer as a model of control. Today, he continues, anyone can be filmed on the street, a surprisingly prescient anticipation of the systems of surveillance in use in most cities today. The mass-produced object inserted into the recording device of the museum (Duchamp) has its contemporary counterpart in the bodies of urban wanderers and the forms they carry with them as they move through the generalized telegenic space of the twenty-first century.

Hegel saw human history as a single path, evolving through an organized sequence of progressions and advances toward an eventual conclusion. The Hegelian vision of history, which is so persistent in twentieth-century art, may be represented by the image of a highway. As a formal compositional principle, wandering points to a conception of space-time that is opposed to both linearity and flatness. Both the linear time of history as well as the vision of a one-dimensional space of human life are rejected by works constructed on the model of progressions, itineraries, and a meandering navigation among different formats or circuits. The notion of the painting as a window, which dominated the classical age and which organizes the visible around the perceptual channel of monocular perspective, is to space what the Hegelian vision of history is to time: a tension modulated toward a single point. At the end of the nineteenth century, pictorial modernity begins to obstruct perspective, diverting the linearity of space toward time. Henceforth, it is flatness that will govern pictorial space, while the representation of history (time) will be oriented around a linear account. In an important text, Leo Steinberg dates the appearance of post-modern space to Robert Rauschenberg's first "combine paintings,"[84] in which painting becomes a network of information. Neither windows that reveal the world nor opaque surfaces, Rauschenberg's works

84 LEO STEINBERG, *OTHER CRITERIA: CONFRONTATIONS WITH TWENTIETH-CENTURY ART* (NEW YORK: OXFORD UNIVERSITY PRESS, 1972), 82–91.

effectively inaugurate a wandering of meaning, a stroll through a constellation of signs.

To describe this new figure of the artist, I have coined the term *semionaut*: a creator of paths in a landscape of signs. Inhabitants of a fragmented world in which objects and forms leave the beds of their original cultures and disperse across the planet, they wander in search of connections to establish. Natives of a territory with no a priori borders, they find themselves in the same position as the hunter-gatherers of old, those nomads who created their universe by tirelessly crisscrossing space. In her documentary *The Gleaners and I*, Agnès Varda tailors her method to her subject. Shooting a film on the ancient practice of gleaning and its contemporary forms, she wanders from one person to another, one place leading her naturally to the next, patiently constructing an analogy between her profession as filmmaker and the act of gleaning, the tolerated piracy of a system of production.

Seth Price, whose practice oscillates among seemingly incompatible forms, from writing theoretical essays to compiling mix tapes, conceptually associates wandering with the multiplicity of cultural forms available to works today. He writes: "Suppose an artist were to release the work directly into a system that depends on reproduction and distribution for its sustenance, a model that encourages contamination, borrowing, stealing, and horizontal blur? The art system usually corrals errant works, but how could it recoup thousands of freely circulating paperbacks?"[85] Price employs the term "dispersion" to describe his artistic practice, which involves disseminating information in various forms. Thus, the work *Title Variable* takes the form of albums, essays, and files, all of which are consultable online. Just like

85 SETH PRICE, *DISPERSION* (2002), AVAILABLE ONLINE AT HTTP://WWW.DISTRIBUTEDHISTORY.COM/DISPERSION2008.PDF.

an installation by Jason Rhoades, an exhibition by Rirkrit Tiravanija, or most of Pierre Huyghe's works, *Title Variable* cannot be confined within a unitary space-time.

In the works of Kelley Walker, Wade Guyton, and Seth Price, forms appear as copies, forever transitory. They seem to be suspended, poised between two translations, or as if they were permanently translated. Taken from magazines or websites, they seem ready to return there, unstable, ghostly. All formal origins are negated here, or more correctly rendered impossible. The mix tape is the symbol of this culture of postproduction. Seth Price has made a number of them, and Peter Coffin also puts together a lot of thematic compilations on CD. Navigating through a network of photocopies, printouts, screens, and photographic reproductions, the forms appear as so many transient incarnations. The visible appears here as essentially nomadic, as a collection of iconographic phantoms, and the work as a kind of jump key that can be connected to any support whatsoever and is capable of infinite transformations. The practice of these three artists, which discourages any attempt to assign their works to a precise and stable place in the chain of image production and processing, continues in more radical form the "rephotography" that Richard Prince has been practicing since the 1980s. But it is surely Kelley Walker who has taken Warhol's demonstration of the artist faced with the machine to its logical conclusion. Instead of identifying with it, as Warhol proclaimed, Walker presents himself as a minimal subjectivity, in motion, ceaselessly customized by the products it consumes, and operating within an entirely mechanized environment. Constructing chains of visual objects caught up in a never-ending process of reconfiguration, he depicts a deracinated reality through works that are merely freeze-frames of an emerging utterance.

CODA: REVOCABLE AESTHETICS

One might justifiably wonder if the true master narrative of our era—the presence of which is so blinding, we fail to perceive it—is actually this: that there is not, and can no longer be, any master narrative. The fragmentation of everything and everyone in a confused mass that forms an information bubble would then function as a totalizing ideology for our antitotalitarian world. Which is why we find it so difficult to conceive of history on the move. Who is recounting it? And for whom? And who could the hero of this narrative be, given that no people or proletariat can lay claim to that title any longer, and there is no longer any universal subject?

The general precariousness may be understood in connection with a culture in which there is no longer any master narrative—historical or mythical—around which forms can be organized, unless it be that of the *archipélisation* of iconographies, discourses, and narratives, isolated entities connected by filigree lines. We are confronted with images of a floating world, like the *Ukiyo-e* of Hokusai. Within these aesthetics, which are henceforth deprived of any grounding in a "master narrative of legitimation" (Lyotard) and partially or completely cut off from any local or national origin, every work must help to produce its own context, to signal its own coordinates—shifting meridians. In the order of aesthetics, this principle of deterritorialization points to that kaleidoscopic vision that Baudelaire describes as the very essence of the modern: positioning and value judgments take place in change-able, precarious, and revocable contexts. It is enough to make the sedentary residents' heads spin. But aren't they already experiencing it themselves, assuming they perceive something of this transformation?

In the early 1990s, mass marketing—supported by the Internet, which was still in its early days—embarked on a strategy of individualizing products while making the act of purchasing them as immaterial as possible. Thus, in luxury boutiques, the objects grew scarce in an

artificial attempt to place the consumer outside the world of mass production, which was embodied in the aisles of the supermarket. Thus, marketing's final ruse consists in denying the existence of quantity, creating the illusion of scarcity, and playing on the obscure nostalgia for privation. The diagnosis of these marketing experts seems entirely justified: the precariousness that affects the entire cultural landscape surely stems, at least in large part, from the process of cluttering that distinguishes our era. It is a function of mass production, and its antithesis—the impression of solidity—has more to do with an object's isolation than with the material from which it is made. A matchstick on a pedestal will always seem less precarious than a heap of marble.

Precarious: "that which only exists by virtue of an authorization that may be revoked at any time." Which is as much as to say that contemporary artworks do not have any absolute rights when it comes to obtaining "legal status." Is it art or not? This question, which delights the customs officers and border guards of culture and thrills its jurists to no end, is essentially the equivalent of a police investigation: what right do you have to enter art's soil? Do you have legal documents? But the question could be formulated differently: what constitutes a real presence as it traverses the space-time of art? Does this new object that has entered the artistic bubble generate thought and activity, or not? Does it have an influence on this space-time, and if so, what sort of productivity does it generate? These are the questions, it seems to me, that are more pertinent to ask of a work. Whether or not the object exists, whether or not it holds up and has a story to tell, coordinates, produces... Does something pass or come to pass? Let's set aside the reflexes of the policeman and the legislator and look at art through the eyes of a curious traveler, or those of a host receiving unfamiliar guests in his or her home.

Does the general context of clutter in which artworks appear to us today, which determines their modes of production and the manner in which we receive them, cause us to judge them differently? We'll come back to this question in the third part of this book. For now, however, consider the example of John Armleder's exhibition at MAMCO in Geneva in 2006. Organizing a retrospective of his work, the artist takes apart the entire corpus that can be identified as "the work of John Armleder" and puts it back together. By piling up and juxtaposing his work, by bringing some together and separating others, Armleder dramatizes the interchangeability of their positions and underscores a fundamental principle: the artwork is no longer a terminal object but merely one moment in a chain, the "quilting point" [*point de capiton*] that more or less solidly connects the various episodes of a trajectory. Armleder's rereading of his own work suggests that one of the surest criteria by which to judge any artwork is its capacity to insert itself into different narratives and translate its characteristics—in other words, its potential for displacement, which permits it to engage in productive dialogue with a variety of different contexts. Or in still other words, its radicantity.

JOURNEY-FORMS

THERE IS AN IMAGINARY CONCEPTION THAT JUST BARELY ACCOMMODATES THOSE INTENT ON NOT BEING DUPES OF THE STRUCTURE: THE IDEA THAT THEIR LIFE IS BUT A VOYAGE. LIFE, IN THIS VIEW, IS A NOMAD'S EXISTENCE, THE CONDITION OF THOSE WHO DWELL AS FOREIGNERS IN WHAT'S CALLED "THIS WORLD."
(JACQUES LACAN)

THE JOURNEY-FORM (1): EXPEDITIONS AND PARADES
On July 9, 1975, Bas Jan Ader's sailboat departed the east coast of the United States in an attempt to cross the Atlantic as part of his project *In Search of the Miraculous*. But three weeks after his departure, radio contact was lost. And on April 10, 1976, rescue teams found only the artist's half-submerged boat. The dramatic disappearance of an artist who was one of the most promising of his generation was

reminiscent of the helicopter accident in which another great pioneer, Robert Smithson, had perished three years earlier. They had in common that spirit of travel and adventure, that taste for great expanses, that was highlighted by the tragic circumstances of their deaths. Thirty years later, these two major bodies of work are unexpectedly being echoed in the works of those artists for whom the journey has become an art form in itself, or who find in the barren expanses or no-man's-lands of post-industrial society surfaces for inscription much more exciting than those offered by art galleries— an attitude already evinced in Smithson's colossal site-specific works of the 1960s, just as much as in the expeditions of Bas Jan Ader.

Today the journey is everywhere in contemporary works, whether artists borrow its forms (journeys, expeditions, maps), its iconography (virgin territories, jungles, deserts), or its methods (those of the anthropologist, the archaeologist, the explorer). If this imaginary universe is born of globalization, the democratization of tourism and commuting, let us underscore the paradox in the fact that this obsession with the journey coincides with the disappearance of any *terra incognita* from the surface of the earth. How can one become the explorer of a world now covered by satellites, a world whose every millimeter is now registered and surveyed? And more generally, how do artists take account of the space in which they live? Here the form of the expedition constitutes a matrix, in that it furnishes a motive (knowledge of the world), an imaginary universe (the history of exploration, subtly linked to modern times), and a structure (the collection of samples and information along a path).

Speaking of his film *A Journey that Wasn't* (2005), which retraces his expedition to the Antarctic, Pierre Huyghe insists that "fiction is a means of capturing the real."[86] It constitutes a means of locomotion that enables him to generate new knowledge of the contemporary

86 PIERRE HUYGHE, INTERVIEW BY GEORGE BAKER, *OCTOBER* 110 (FALL 2004): 86.

world, and the principal tool for constructing a body of work whose general form and metaphors are those of the journey. The set of works that was generated by this expedition and by the preparations for it constitutes a cognitive process that stretches across a period of several years. It is based on a narrative element, a rumor: an island was said to have appeared near the South Pole, and a strange creature was reported to have been born there—an albino penguin, an effect of the Earth's warming. The expedition carried out by Huyghe and his team aboard a laboratory ship weaving among the icebergs in a sea whipped by glacial winds uses fiction as a vehicle and the journey as a kind of drawing. Here we rediscover one of the principles invoked by Victor Segalen in his definition of the exote: "My journey," he writes from Beijing to Jules de Gaultier in 1914, "is decidedly taking on for me the quality of a sincere experience—a confrontation, in the *field*, between the imaginary and the real."[87] Another of his virtues, the writer recalls, consists in "*being free* with regards to the object that is felt or described."[88] Imagination and fiction enable Huyghe to open up free spaces in the real geography he traverses.

The work of Melik Ohanian involves, as he explains, "the experience of exploration more than the image of exploration." Ohanian's way of bringing adventure into play is perfectly expressed in his *Island of an Island* (1998–2001), an installation in several phases that opens with the narrative account of an event: in 1963, the island of Surtsey appeared off the coast of Iceland following a volcanic eruption. Around this geophysical event, Melik Ohanian constructed a unitary form linking heterogeneous levels of discourse and reality. Thus, *Island of an Island* brought together in a single space a film projected on three different screens showing aerial views of the volcanic island, and, on the floor, 900 light bulbs that traced the outline of a rare plant

87 SEGALEN, *ESSAY ON EXOTICISM* (NOTE 42), 58.

88 IBID., 34.

discovered on the island, whose image was reflected as a red dotted line in five convex mirrors attached to the ceiling. At the entrance to the room, books were suspended from wires, forming a curtain, and in this way made available to the installation's visitors. The *Island of an Island Handbook* is a compilation of excerpts from scientific studies and facsimiles of articles from the Icelandic press at the time of the eruption. History desynchronized: the anecdotes of the press stand side by side with the scientific analysis of a nascent, literally prehistoric universe. Ohanian continued his investigation into barren zones with *Welcome to Hanksville* (2003), in which the world appears as a vast movie set, an archipelago of *terrae incognitae* in which art can develop scenarios (which become forms) and protocols for the acquisition of knowledge.

The group Gelitin has adopted the form of displacement as a mode of production. The microcommunity of its four members might be compared to an exploratory probe equipped with multiple instruments for apprehending reality, which privileges the material dimension of culture in the choice of its thematics and employs the human body (insofar as it feels pleasure and lays itself open to experimentation) as its principal instrument of knowledge. Thus, in the video *Grand Marquis* (2002), various performances give emphasis to their discovery of Mexico. For *Nasser Klumpatsch (The Ride)*, which documents a project presented in Sofia in 2004, Gelitin set in motion the very process of mounting the exhibition, traveling the 700 kilometers between Vienna, where they live, and the Bulgarian capital, where they were invited to exhibit, on mopeds, and taking advantage of every leg of the journey to supply their final destination with new forms. The exhibition was the product of a trajectory that was punctuated by the works as if by notes on a geographic map.

The duo of Abraham Poincheval and Laurent Tixador is driven by a similar ambition, and they take this experimental logic to the point of

placing themselves in physical and mental danger. Each of their exhibitions brings together the tangible traces of an adventure conducted under extreme conditions. Thus, they spent one month on a desert island in a state of complete self-sufficiency (*Total Symbiosis I*, 2001), and they crossed France in a perfectly straight line (*L'Inconnu des grands horizons* [The Unknown of the Wide Horizons], 2002). Then they organized a speleological expedition in a tunnel they dug themselves, in which they were buried (*Horizon moins vingt* [Horizon Minus Twenty], 2008); spent time in prison; and pitched a tent on the roof of a skyscraper. Caught between the status of expedition souvenirs and that of scientific instruments, the objects displayed at their exhibitions suggest ballistic analysis and the calculation of trajectories as much as they do the art of surviving in a hostile environment.

In 2006, Mario Garcia Torres set out to find the mythical hotel where Alighiero e Boetti stayed on his travels to Kabul, the One Hotel: it was a way of plotting the passage of time. He also attempted to meet all the students whom Robert Barry—then a professor in Halifax—had told a particular secret, which thus took on the status of a conceptual artwork (*What Happens in Halifax Stays in Halifax*, 2005). Alfred Hitchcock used the term "McGuffin" to describe the elusive objects chased by the characters in his films. Artist-travelers often view history as a McGuffin, as the vanishing point or element of suspense that enables them to organize their parades of form. *Cucumber Journey* (2000) by Shimabuku is a typical work by the Japanese artist. It traces on the surface of the Earth the wandering lines of a journey that has its origins in an argument for departure very close to Hitchcock's McGuffins—pretexts for a setting in motion. For this boat trip from London to Birmingham on an eighteenth-century canal, Shimabuku takes the process of making pickles as a poetic incentive for drifting: "The vegetables and cucumbers that I bought fresh in London were pickled by the time I reached Birmingham. While traveling from London to Birmingham, I got recipes for pickles from

other people, and I watched the sheep and water birds and leaves floating in the water. And I watched the cucumbers slowly turning into pickles."[89] One might compare this project to another by Jason Rhoades, called *Meccatuna* (2003). Unlike Shimabuku, Rhoades did not actually travel with the objects he transported. His goal was to have a live tuna make a pilgrimage to Mecca; but given the difficulties he encountered, he lowered his sights from a live tuna to a tuna sushi roll, before finally making do with canned tuna.[90] Both of these projects bring into play the double meaning of the word *expédition*, which can refer to both expedition and shipping.

Sometimes, in contrast to these experiences of wandering, it is the path's coordinates that are important; its beginning and endpoints. On June 23, 2002, a peculiar procession departed from MoMA in New York City—which was closed for a period of time for renovation—heading for the museum's temporary address in Queens. The participants held reproductions of works from the museum's collection out in front of them: works by Picasso, Giacometti, and Duchamp. This work by Francis Alÿs, like the march he had recently organized in the Lima region of Peru, belongs to the genre of the parade, which—as Pierre Huyghe reminds us—"replays the idea of migration." Huyghe adds that in New York City, most annual parades are organized by immigrant communities as symbolic repetitions of their exodus.[91] A group march

89 PRESS RELEASE FOR THE EXHIBITION AT THE GALLERY AIR DE PARIS.

90 "THE *MECCATUNA* (2003) PIECE IN NEW YORK STARTED OUT AS A VERY SIMPLE IDEA TO TAKE A LIVE TUNA ON A PILGRIMAGE TO MECCA. I TRIED TO FIGURE OUT HOW TO DO IT, IF IT WAS POSSIBLE OR NOT, AND IT TURNED OUT IT WAS HARD. TO KEEP THE TUNA ALIVE, YOU HAVE TO KEEP IT SWIMMING. BUT I THOUGHT IT WOULD HAVE BEEN VERY BEAUTIFUL TO TAKE A TUNA TO MECCA. AND THEN IT WENT TO *SUSHI TUNA*, AND THAT WAS ALSO HARD. THEN IT TURNED INTO *CANNED TUNA*. THAT'S THE ONE I ACHIEVED FOR THE SHOW IN NEW YORK." (JASON RHOADES, IN CONVERSATION WITH MICHELE ROBECCHI, *CONTEMPORARY*, NO. 81 [2006]: 42.)

91 PIERRE HUYGHE, INTERVIEW BY GEORGE BAKER (NOTE 86).

is thus the temporal equivalent of a monument: it constitutes a replay, or rather a reenactment; the taking of a historical moment used by the actors as a kind of free musical score to create a moving image.

The form and iconography of the parade or demonstration, so often used since the early 1990s, refer to an event that the participants seek to celebrate or lay claim to in order to make it a foundation for the present. When Philippe Parreno recruits children to carry signs and chant the slogan "No more Reality," he is demanding that fiction and special effects be allowed to interfere with the protocols by which our shared reality is constituted (*No More Reality II*, 1991). Three years later, in collaboration with Carsten Höller, he uses the form of the demonstration again, this time to demand the liberation of an apparently monstrous "creature" whose identity remains mysterious (*Innocent et emprisonné: "Mais ce que vous avez à me reprocher c'est que j'ai abandonné mon premier amour"* [Innocent and imprisoned: "But what you're accusing me of is that I abandoned my first love"], 1994). Designed to express collective demands, here the demonstration becomes a projection of individual desires, the sign of an atomization of demands and narratives. Beneath the image of the marching crowd, the subtitles are now composed by individual authors. By contrast, during the modernist era, the individual might find himself carried by the message of a group. When this theme is used by Alÿs, Huyghe, Parreno, or Jeremy Deller (who organized a parade of minorities for the opening of Manifesta 2004 in San Sebastián), what counts is the setting in motion of a principle, the activation of an aesthetic. A group starts walking, becoming an image by detaching itself from the crowd and observed by the crowd itself.

What emerges from this proliferation of nomadic and expeditionary projects in contemporary art is an insistence on displacement. Faced with rigid and ossified representations of knowledge, artists activate that knowledge by constructing cognitive mechanisms that generate

gaps and prompt them to distance themselves from established fields and disciplines, setting knowledge in motion. Globalization offers a complex image of the world, fragmented by particularisms and political borders even as it forms a single economic zone. Today's artists travel this expanse and insert the forms they produce into networks or lines; in works that generate knowledge effects today, the space of contemporary life appears as a four-dimensional expanse in which time is one of the coordinates of space. This can be seen in works by artists like Rirkrit Tiravanija, who duplicates and summarily reconstructs the places he has stayed (*Apartment 21 [Tomorrow Can Shut Up and Go Away]*, 2002); it can also be seen in the work of Gregor Schneider, who has expanded his house to accommodate the past and the future, turning it into a permanent construction site. Here too, space is regarded as joining forces with time. This complication and the various figures it generates constitute the basis for this aesthetic of expeditions.

THE JOURNEY-FORM (2): TOPOLOGY

Thus, the journey is not just a fashionable theme but the sign of a deeper development, which affects the representations of the world in which we live and the way we inhabit it, concretely or symbolically. The artist has become the prototype of the contemporary traveler, *homo viator*, whose passage through signs and formats highlights a contemporary experience of mobility, displacement, crossing. The question is thus: what are the modalities and figures of this *viatorization* of art forms?

The journey has become a form in its own right, the bearer of a visual matrix that is gradually replacing the ad-like frontality of Pop Art and the documentary enumeration of Conceptual art, to cite two formats still widely used in the art of today. The emergence of the journey as a compositional principle has its source in a cluster of phenomena that form part of a sociology of our visual environment: globalization, the

transformation of tourism into an everyday phenomenon, and the advent of the computer screen as a feature of daily life, a phenomenon that began in the 1980s but has accelerated since the early 1990s with the explosion of the Internet. With the practice of web surfing and reading by following hypertext links, the web has produced specific practices that affect our modes of thought and representation. It is a mode of visuality distinguished by the simultaneous presence of heterogeneous surfaces, which the user links by charting a course or by random exploration. The type of mental progression brought about by the use of this instrument—amid a profusion of links, of files arranged on the surface of the screen or buried under banners, popups, and interfaces—has introduced a kinetic approach to elaborating objects that may very well become the basis for our era's brand of visual writing: composition by journey.

In more general terms, our globalized universe calls for new modes of notation and representation. Directly or indirectly, our daily lives now unfold against a vaster backdrop and depend on transnational entities. The representation of nonstatic spaces involves the construction of new codes that are capable of capturing the dominant figures of our imaginary universe (the expedition, wandering, and displacement), an operation that consists in doing more than merely adding a vector of speed to frozen landscapes. The cognitive trajectories imagined or experienced by the artists of these early years of the twenty-first century can be reconstructed by hypertextual forms, compositions whose unfolding enables them to make resonate the temporalities, spaces, and heterogeneous materials that constitute the procedures these artists use. In most of the works of Pierre Huyghe, Liam Gillick, Mike Kelley, Francis Alÿs, and Tacita Dean—to cite just a few of the artists who exemplify this development—the form of the work expresses a path, a journey, more than a fixed space or time. Here the finding of forms takes place through the composition of a line of flight, or even a program of translation, more

than the elaboration of a plane or volume: we are leaving the domain of Euclidean geometry and entering that of topology.

What is topology? It is a branch of geometry in which nothing is measured and no quantities are compared. Instead, one establishes the qualitative invariants of a figure, for example, by deforming it, as when one folds a sheet of paper or takes an object of one dimension and plunges it into another to see if the constants survive that change intact. One examines the edges of its surfaces: what is it that consti-tutes their structure? During the final years of his seminar—from 1972 to 1980—Jacques Lacan decided to reformulate his teaching in terms of topological figures, employing Möbius strips, Borromean knots, tori, and Klein bottles like so many "mathemes" useful to his enterprise of formalizing the unconscious. If the *objet petit a*, the void [*béance*] around which the formations of the unconscious "circle," constitutes the first term of the chain of desire that forms within each individual (the origin of his or her drive circuit [*circuit pulsionnel*]), the Lacanian unconscious could be schematized as a chain of signifiers (containers, symptoms) beneath which the signifieds glide into place through the intervention of mental objects that function like the "quilting points" used by the upholsterer. With topology, Lacan seeks to elaborate a map of the unconscious.

Although the works of Thomas Hirschhorn, Jason Rhoades, Rirkrit Tiravanija, and John Bock are very different, they nevertheless have one characteristic in common: the spatio-temporal dispersion of their elements. It is clear to the viewer that there is no immediately recognizable form (geometric or organic), no chromatic harmony, no apparent design to organize what seems to be a random collection of disparate elements. One must penetrate the installation and enter into the internal logic that structures the space of the work. Then one perceives the unfurling of a flow, within which one can organize forms according to one's path through the installation. This notion of

the exhibition as a "photogenic space" to be cut up into sequences by the viewer-actor was brilliantly introduced by the project *Ozone* (1989), a series of exhibitions produced by Dominique Gonzalez-Foerster, Bernard Joisten, Pierre Joseph, and Philippe Parreno around the image of the "hole in the ozone layer," which the artists regarded as an iconographic power cell capable of sustaining a collective and ongoing project. This figure of the active visitor then became widely established, but only implicitly—in an installation by Thomas Hirschhorn, visitors literally dig in, dipping into the pile themselves and creating their own assemblages from the fragments spread out in a saturated space.

Minimal art insisted on the phenomenological experience it sought to induce in the viewer. It called the space surrounding it into question, as well as the knowledge that enabled the viewer to identify an artwork. In an exhibition by Jason Rhoades or Thomas Hirschhorn, the viewers' attention is bombarded from every side; they can't possibly take in the whole installation in a single glance. Indeed, it is immediately clear that not everything can be seen. They find themselves in the presence of a chaotic current of signs that exceeds their capacity to master the space around them. They are caught up in a journey-form, swept along a spatio-temporal line that goes beyond the traditional notion of an environment. *24h Foucault* by Thomas Hirschhorn (2004) played with this excess: in this huge installation, which contained an impressive mass of information, one could watch or listen to all of Michel Foucault's appearances on TV and radio—an impressive mass of visual documents; and his complete works were laid out beside an army of copying machines. Finally, hour after hour, from noon on Saturday to noon on Sunday, speaker after speaker took the floor in the lecture hall located in the middle of this setup. The journey-form is above all defined by an excess of information, which forces the viewer to enter into a process and construct his or her own personal path. If the works of Jason Rhoades or Thomas Hirschhorn have met with

such a widespread and immediate response, it is also because their compositional principle plays with this saturation, which our epoch intuitively knows it embodies. Vast displays of heterogeneous elements—sometimes grouped by series, sometimes by affinities, and sometimes, as in Hirschhorn's case, around the proper name of an author—with no perceptible structural organization. Works like these inaugurate a specific regime of the sign. Beyond the Pop and Minimal serialism of the 1960s and the fragmentation of the 1980s, they stage an effect of visual critical mass by chaotically accumulating information and industrially manufactured forms. These signs rub shoulders, coalesce into clouds of data, subdivide in space, and spill out onto the street. All of which makes it abundantly clear that this type of agglomeration no longer has anything to do with Arman's groupings of objects in the 1960s, or with Jean Tinguely's mechanical compositions, which are never far from anthropomorphism. By contrast, the contemporary journey-form combines the forms of the ruin (culture after the modernist narrative) and that of the flea market (the eBay economy) in nonhierarchical and nonspecific spaces (globalized capitalism).

The journey-form encompasses the unity of a path; it takes account of or duplicates a progression. Through a compositional principle based on lines traced in time and space, the work (like the Lacanian unconscious) develops as a chain of linked elements—and no longer within the order of a static geometry that would guarantee its unity. This spontaneous conception of space-time, which we find in the works of the era's most innovative artists, has its sources in a nomadic imaginary universe that envisages forms in motion and in relation to other forms, one in which both geography and history are territories to be traveled. "Mobilis in mobili," moving within the moving element: such was the motto of Jules Verne's Captain Nemo. These journey-forms provide the iconography of global displacement with its anchor. But the emergence of this iconography also reflects the

character of an era in which multiplication has become the dominant mental operation. After the radical subtraction of early modernism, after the analytical divisions of a Conceptual art in search of the artwork's foundations, after a postmodern eclecticism whose central figure was addition, our era finds itself haunted by the multiple. Knowledge and forms are tormented by hybridization, which is supposed to generate beings and objects as products of multiplication. Simply by browsing the Internet in search of information, one gets a glimpse of this imaginary empire of the multiple. Every site explodes into myriad others; the network is a proliferating connection machine. And the art of the 2000s, which has its formal basis in connections and tightly stretched cords, tends less and less to represent space as a three-dimensional expanse: if time is not an attribute of space (Henri Bergson put an end to that notion), it nonetheless enables one to multiply it endlessly. Teeming is one of the dimensions of contemporary space-time: one must clear away, hollow out, eliminate, forge one's own path through a forest of signs.

The components of a journey-form are not necessarily united in a unified space-time. A journey-form may refer to one or more absent elements, which may be physically distant, past, or yet to come. It may be composed of an installation with connections to future events or other places. Conversely, it may bring together in a single space-time the dispersed coordinates of a path. In both cases, the artwork takes the form of an unfolding, an arrangement of sequences that place its objective presence in doubt and cause its "aura" to flicker. The work is transformed into the index of an itinerary. *Park—A Plan for Escape* (2002) by Dominique Gonzalez-Foerster fits this description. "It's not even clear where it all starts or stops," the artist comments. "Beyond this tree, after this cloud…?"[92] Tobias Rehberger creates

92 QUOTED IN DANIEL BIRNBAUM, "RUNNING ON EMPTY: THE ART OF DOMINIQUE GONZALEZ-FOERSTER," *ARTFORUM* 42, NO. 3 (NOVEMBER 2003).

sculptures that exploit geographic distance: *Treballant / Trabajando / Arbeitend* (2002) consists of an acrylic lamp exhibited in Barcelona, which goes out when the artist leaves his studio in Frankfurt. And at his exhibitions, Gregor Schneider, whose work is centered on the transformation of his house into a labyrinthine and obsessional construction site, shows items that document a work located elsewhere. In most of his works, Philippe Parreno plays with modulations of space-time. Thus, *The Boy from Mars* (2003) is presented as a disposable DVD that can be viewed only once and that documents an architectural project realized in Thailand, *Battery House*, which derives its energy from the driving force of buffalo and elephants. Then we meet the same project in the form of a glow-in-the-dark poster and as an illuminated sign. Where is the actual place of the work? It is multiple, formed by the articulated collection of its various modes of appearance.

Whenever he travels anywhere in the world, Franz Ackermann constructs a mental map of the place that goes beyond purely cartographic elements to integrate memories and personal notes. These forms and data are later incorporated into large-scale pictorial compositions, which sometimes grow in size to the point where they structure an exhibition. As an inheritor of the psychogeography invented by the Situationists, Ackermann depicts a contemporary experience of space. Inventing a type of painting that strives to become topography, applying GPS to color, he traces journey-forms in an effort to create an atlas of the transformation of urban spaces. His paintings are constructed around a mesh of more or less tightly overlapping colored planes, which are alternately fluid and angular and against which there stand out fragments of figures caught in a network of sinuous lines. In Ackermann's installations, a canvas will be connected to a metallic structure and extended by objects, photographs, drawings. Thus, an exhibition by Franz Ackermann makes one think of a three-dimensional computer screen on which multiple files are open, windows onto heterogeneous data regarding a place.

Contemporary painting seems tormented by this desire to represent the contemporary individual's lived experience of space through the intersection of spatial and temporal networks, figures of meshing, and superimposed planes. It is an ambition that is shared by the cartographer in the era of GPS, which takes satellite images and adds to them the transport routes and communicative flows which constitute the reality of the territory really traveled by the individual. In a human space now completely surveyed and saturated, all geography becomes psychogeography—or even a tool for *geocustomizing* the world.

This intuition informs the painting of artists as different as Michel Majerus (who died in an accident in 2002), Miltos Manetas, Matthew Ritchie, and Julie Mehretu. The subject of Majerus's work is urban space perceived at a certain speed. His enlargements of logos and details of industrial packaging, their surfaces swept by Expressionist brushstrokes, mixed to produce monumental compositions that rival the giant screens of Asian megacities, trace a kind of emotional map of consumerism. Manetas's painting almost seems to be a mechanical effect of the space of the Internet: it blends the landscape of technology with the affective reality of the individual, whose experience seems to be entirely filtered, as much as generated, by the screen. Matthew Ritchie takes as his point of departure an imaginary cosmogony based on a decomposition of the chemical reality of the world and uses an abstract pictorial vocabulary to compose a vast quantum fresco that reenchants science. As for Julie Mehretu, her canvases superimpose various different strata of the representation of the structured space in which we move. The result is the contemporary equivalent of the ambitious topographical projects of the nineteenth century, one of whose principal exponents in the United Kingdom was the young William Turner. The two-dimensional, pictorial journey-form displays the characteristics of a geographic map, its three-dimensional counterpart those of a ribbon or even a Möbius strip. In the former case, the painting produces its space by transposing

pieces of information onto the canvas; in the latter, the visitor moves along a flow that unwinds like a fragmented text.

"Aboriginals, it was true, could not imagine territory as a block of land hemmed in by frontiers: but rather as an interlocking network of 'lines' or 'ways through.' 'All our words for *country*,' he said, 'are the same as words for *line*.'"[93] This is how the writer Bruce Chatwin introduces his description of the "walkabouts" of the Australian aborigines, a practice whose adoption by the West might cause a true topographical revolution. The walkabout is a ritual journey in which the aborigines walk in the footsteps of their ancestors and "sing the country" as they travel through it. Each strophe recapitulates the creation of the world, since the ancestors created and named all things by singing. "What the whites used to call the 'Walkabout,'" Chatwin writes, "was, in practice, a kind of bush-telegraph-cum-stock-exchange, spreading messages between peoples who never saw each other, who might be unaware of the other's existence."[94] It is hard not to see the vision of space revealed in the walkabout as a wonderful meta-phor for the contemporary art exhibition and as the prototype of the journey-form. Topography, used so much by contemporary artists, defines a pictorial site that is geared to the viewer's real movements in everyday life. Walking constitutes a text in itself, which the artwork translates into the language of topology.

Although the radicant forms a line, it cannot be reduced to a one-dimensional linearity. If the function of the ego is to unify the various different perceptual and cognitive lines of an individual, we know that the latter—equipped with technologies that profoundly alter his or her experience of space-time—cannot be reduced to the classical def-inition of the subject, any more than to a linear monographic narrative.

93 BRUCE CHATWIN, *SONGLINES* (NEW YORK: PENGUIN, 1987), 56.

94 IBID., 56–57.

Contemporary art shows how lived experience can be reorganized using mechanisms of representation and production that correspond to the emergence of a new subjectivity that demands its own modes of representation. This is the question asked by Doug Aitken: "How can I break through this idea [that time is linear], which is reinforced constantly? How can I make time somehow collapse or expand, so it no longer unfolds in this one narrow form?"[95] Even though it expresses a path, the journey-form puts linearity in crisis by injecting time into space and space into time.

THE JOURNEY-FORM (3): TEMPORAL BIFURCATIONS

It may be that, in the imaginary representation that an individual of the beginning of the twenty-first century forms of the world, space and time have come to the point of merging and exchanging their properties. We know that time is spontaneously identified with succession, and space with simultaneity. Let us repeat, then, that we now live in times in which nothing disappears anymore but everything accumulates under the effect of a frenetic archiving, times in which fashions have ceased to follow one another and instead coexist as short-lived trends, in which styles are no longer temporal markers but ephemeral displacements that take place indiscriminately in time or space. Hype, or fashion miniaturized. For modernism, the past represented tradition, and it was destined to be supplanted by the new. For postmodernism, historical time took the form of a catalogue or repertoire. Today the past is defined in territorial terms: when one travels, it is often to change epochs. Conversely, to consult a book of art history today is to encounter a geography of contemporary styles and techniques. A science was once founded on the basis of this projection of time onto space: anthropology. To the various regions of the planet there correspond various temporal

95 DOUG AITKEN, "A THOUSAND WORDS: DOUG AITKEN TALKS ABOUT ELECTRIC EARTH," INTERVIEW BY SAUL ANTON, *ARTFORUM* 38, NO. 9 (MAY 2000): 160.

sequences, so that "over there" is spontaneously transformed into "back then."[96] Isn't it true that what tourists today are primarily seeking is a temporal change of scenery, achieved by means of geographic distance? And doesn't the fascination that the city of Berlin, for example, holds for artists today stem from the fact that two distinct lines of historical development coexist there—that of German popular democracy and that of the Federal Republic? According to Claude Lévi-Strauss, "a journey occurs simultaneously in space, in time and in the social hierarchy."[97]

A Borgesian aesthetic: the work of the Argentine writer contains numerous allusions to the spatialization of time, to its labyrinthine and nonlinear, bifurcating nature. Following Bishop Berkeley, Jorge Luis Borges regards the movement of time as flowing from the future into the past and thus as a ceaseless production of the past. In his short story *Tlön, Uqbar, Orbis Tertius*, he imagines a civilization whose inhabitants have developed a novel relationship with metaphysics: "For them, the world is not a concurrence of objects in space, but a heterogeneous series of independent acts. It is serial and temporal, but not spatial."[98] In this civilization, producing, discovering, and exhuming are one and the same, so that the archaeologists of Tlön can just as easily invent the objects they exhibit as unearth them. Don't we make discoveries in the past as well as the present? It seems that contemporary art resembles the thought of the philosophers of Tlön. In the context of the complex relations that many artists entertain with

96 JOHANNES FABIAN, *TIME AND THE OTHER: HOW ANTHROPOLOGY MAKES ITS OBJECTS* (NEW YORK: COLUMBIA UNIVERSITY PRESS, 1983), QUOTED IN HAL FOSTER, *THE RETURN OF THE REAL* (CAMBRIDGE, MA: MIT PRESS, 1996), 177.

97 CLAUDE LÉVI-STRAUSS, *TRISTES TROPIQUES*, TRANS. JOHN AND DOREEN WEIGHTMAN (NEW YORK: PENGUIN, 1992 [1973]), 71.

98 JORGE LUIS BORGES, "TLÖN, UQBAR, ORBIS TERTIUS," IN *FICCIONES*, ED. ANTHONY KERRIGAN (NEW YORK: GROVE PRESS, 1962), 23.

history today—and now that the end of the race for the "new" that structured the narrative of the artistic avant-gardes has been generally acknowledged—a formal discovery, the establishment of a relationship between the past and the present, is just as valorized today as an anticipation of the art of the future; for paradoxically, this kind of exercise also belongs to the past, and the idea of an art of the future to the elaboration of the present.

If time today has been spatialized, then the heavy presence of the journey and of nomadism in contemporary art is linked to our relationship with history: the universe is a territory, the entire dimensions of which can be traveled—the temporal as well as the spatial. Today, contemporary artists enact their relations with the history of art under the sign of travel, by using nomadic forms or adopting vocabularies that come from the interest in "elsewhere." The past is always present; one need only make up one's mind to go there. Consider the example of Pierre Huyghe's plans to lead an expedition to the Arctic in 2002. When we examine the forms it generated— from the preparatory photographs to the performance of the musical comedy *A Journey that Wasn't* in New York City three years later— we find that the iconographic backdrop of this cycle of works contains numerous historical references, from the Golden Age of Discovery to the circumstances surrounding the invention of the phonograph. The journey-form is a "switching form," a generator of connections between time and space. And for Pierre Huyghe, it is the combination of the two—the elaboration of exhibition structures articulated by a chain— that makes the object seem to be an event in progress, even as it produces spaces with the aid of temporal materials.

A journey in space or a journey in history? In 1998, Rirkrit Tiravanija organized a month-long expedition in a motor home. He traveled across the United States with five Thai art students who had never set foot there before. Their tour took them across the country from west

to east; it was punctuated by visits to mythical places, sites of American culture like the Grand Canyon, Disneyland, Las Vegas, Graceland (Elvis Presley's home), the birthplace of Abraham Lincoln, and Kent State University. During the trip, Tiravanija and the other members of his crew maintained a live website and made videos, before sending all the information and images they had collected back to Philadelphia.[99]

Thus, radicant artists construct their paths in history as well as geography. Modernist radicality (which sought to return to the origin in order to efface the past of tradition and rebuild it on new foundations) is succeeded by a radicant subjectivity, which might be defined as a new modality for representing the world: as a fragmentary space that blends the virtual and the real, in which time represents another dimension of space. This unification, however, is the spitting image of the ultimate objective of global capitalism: translated into economic terms, it is a question of a vast common market, a free-trade zone unsegmented by any border. For time and history, like borders, are producers of distinctions, factors of division, disruptive elements that the logic of globalization tends to weaken by diluting them in the smooth and unobstructed space of free trade. What is the only solution available to artists that does not involve contributing to the project of global cultural "sweetening"? It is that which consists in the activation of space by time and time by space, in the symbolic reconstruction of fault lines, divisions, fences, and paths in the very place where the fluidified space of merchandise is established. In short, in working on alternative maps of the contemporary world and processes of filtration.

Stories are Propaganda (2005), a film by Philippe Parreno and Rirkrit Tiravanija, was born of a trip spent wandering around Guangzhou,

99 THE EXHIBITION WAS REALIZED IN THE CONTEXT OF *MUSEUM STUDIES 4* AT THE MUSEUM OF PHILADELPHIA IN APRIL / MAY 1998.

China's most heavily urbanized area. "This is a journey through an infinite urban landscape," the artists explain. "A series of banners setting up fragments of a parallel world, a feeling of suburbia. Information that glows before fading away."[100] Thus, the film is composed of still images—a TV show, an albino rabbit, a snowman made of sand. As in *Fade to Black*, Philippe Parreno's series of phosphorescent posters, the time available for viewing the images is limited, since each one vanishes quickly, blinking off. The soundtrack consists of a child's voice reading a text that describes a bygone age, "the good old days before cappuccino and sushi and arugula went global, when every second person was not a hero, before we had an identity online, before music became our soundtrack." Here again, spatial displacement is coupled with a journey in time. As for the installation itself, it uses the antiquated codes of the neighborhood movie theater (a red velvet curtain that is opened by hand), but those codes are visually contradicted by the fact that the title is written directly on the surface of the curtain, like a graffiti tag. At the end of the film, the curtain is drawn again, and the viewing is over. Industrial products, like natural materials, are privileged vehicles for such journeys into the fourth dimension. Simon Starling, an archaeologist of the relations between nature and the world of modernism, is one of those artists who thematize the traceability of things, who analyze the social and economic components of our environment. Thus, for *Rescued Rhododendrons* (1999), he transported seven rhododendron plants from the north of Scotland to the south of Spain in a Swedish car (a Volvo), thus reconstructing the migration of this plant, which was introduced by a Swedish botanist in 1763, in reverse. For *Flaga, 1972–2000* (2002), Starling drove a Fiat 126—manufactured in 1974—the distance of 1,290 kilometers that separates Turin, the automaker's headquarters,

100 THESE LINES AND THE FOLLOWING ONES ARE EXCERPTED FROM THE VOICE-OVER SOUNDTRACK THAT ACCOMPANIES THE FILM. THE TEXT IS AVAILABLE ONLINE AT HTTP://WWW.AIRDEPARIS.COM/PARRENO/ STORIES/STORIES.HTM (ACCESSED BY THE AUTHOR FOR THE WRITING OF THIS BOOK ON AUGUST 17, 2008).

from the Polish city of Cieszyn, where some of that model's parts were manufactured at the time. Once back in Turin, Starling removed the car's engine, painted its body white and red—the colors of the Polish flag—and hung it on the wall, an object "informed" by the journey that it made. Having balsa wood shipped from Ecuador and using it to build a model of a French airplane in Australia, transporting a Spanish cactus to Frankfurt, Starling models exports and exchanges, mapping modes of production by executing drawings within reality itself. In praise of metamorphosis, of permanent transformation: he takes apart a shed and turns it into a boat, aboard which he then goes sailing on the Rhine (*Shedboatshed [Mobile Architecture No. 2]*, 2005); traveling around a Spanish desert on a moped whose engine leaks water, he uses the latter to produce a watercolor of a cactus (*Tabernas Desert Run*, 2004).

We also find the journey-form, which combines the dimensions of a geographic pathway and a journey in time, in the work of Joachim Koester, for whom "nothing is more instructive than a confusion of time frames." With this in mind, he follows the trail of historical figures and fictional characters and uses the materials he collects on these adventures to elaborate complex works that transcend the anecdotal through the complexity of their forms.[101] For *From the Travel of Jonathan Harker* (2003), he retraces the journey of the character imagined by Bram Stoker in *Dracula*; all that he finds in Transylvania by way of traces of the novel and of history is a vague "Hotel Castle Dracula." The ambitious installation *Message from Andrée* (2005) takes as its subject an expedition to the North Pole conducted in 1897 by the Swedish explorer Salomon Andrée and his team, whose hot-air balloon crashed on the ice, condemning the explorers to die of cold and hunger. The photographs taken by one of them, Nils Strindberg, were discovered

101 ALEXANDER KLUGE, *THE DEVIL'S BLIND SPOT*, QUOTED IN HAL FOSTER, "BLIND SPOTS: HAL FOSTER ON THE ART OF JOACHIM KOESTER," *ARTFORUM* 44, NO. 8 (APRIL 2006): 212.

thirty-two years later, and Koester transcoded them to produce a strange film, in which a blinding, monochromatic field of white is traversed by a hail of ghostly black and gray spots, stripes, and rays of light—all that remains of the images captured more than a century earlier. Not far away, an archival image shows the balloon taking off, an evocation of those dreams of exploration that recur throughout the century of Jules Verne and David Livingstone like a refrain, but also a genealogical work on our nostalgia for *terrae incognitae*.

The phenomenon of the expedition has two sides: the discovery of new territories (the colonial model, which goes hand in hand with appropriation) and the archaeological mission, which takes on a special importance today, since it represents a specific relationship to time: it is the present en route toward the past, in search of its history.

In a certain sense, the archaeological expedition seeks time in space, and this is why it represents a working metaphor for numerous contemporary artworks. In his book *The Shape of Time*, published in 1962, the art historian George Kubler defines this new field of investigation with prescient lucidity: "Instead of our occupying an expanding universe of forms, which is the contemporary artist's happy but premature assumption, we would be seen to inhabit a finite world of limited possibilities, still largely unexplored, yet still open to adventure and discovery, like the polar wastes long before their human settlement. Instead of regarding the past as a microscopic annex to a future of astronomical magnitudes, we would have to envisage a future with limited room for changes, and these of types to which the past already yields the key."[102] The artist-explorer is the pioneer of this spatialized relationship to history.

102 GEORGE KUBLER, *THE SHAPE OF TIME: REMARKS ON THE HISTORY OF THINGS* (NEW HAVEN, CT: YALE UNIVERSITY PRESS, 1962), 125–26.

Another twentieth-century writer is a key figure in this area: Winfried G. Sebald. His stories find him wandering through an ambiguous literary space that blends fiction and documentary, poetry and scholarly essay. Sebald's books, containing countless uncaptioned black and white photographs, is difficult not to relate to contemporary art. On long excursions through Europe, from Scotland to the Balkans, Sebald shows how the memory of the people and events of the past haunt our lives and shape the space around us. For him, the experience of traveling represents a privileged form of access to memory: thus, he finds history's traces in buildings, museums, and monuments as well as in hotel rooms and conversations with the individuals he meets. Liam Gillick's novel *Erasmus Is Late* (1996)—which presents Erasmus Darwin, Charles Darwin's libertarian brother, and moves among various prominent figures of Victorian England—constitutes a similar stroll through a London both past and present. Moreover, Gillick's entire oeuvre could be described as an echo chamber in which the aesthetic procedures of the avant-gardes and the history of the work world call to each other across a tightly woven network of forms and texts. In Sebald's books, as in Gillick's exhibitions, remembering can never be reduced to the act of telling: the past is reconstructed through a patient collection of visual and linguistic details.

If the videos of Jun Nguyen-Hatsushiba unfold in a subaquatic environment, it is for reasons linked to the very structure of memory. In an effort to build monuments commemorating various historical events—from the Vietnam War to the ecological disaster of Minamata—Hatsushiba constructs complex choreographies executed by divers. In *Happy New Year: Memorial Project Vietnam II* (2003), the under-water settings participate in the allegorical dimension of the work, assimilating the past to an unbreathable and vaguely dreamlike envi-ronment in which one immerses oneself. Above all, however, they represent a wilderness into which human beings must import their tools,

signs, and symbols: a void. W. G. Sebald, comparing our present with the rural societies of the past, when the preservation of the slightest object was vital to conserving the past and handing down memory, writes that "we have to keep throwing ballast overboard, forgetting everything that we might otherwise remember: youth, childhood, our origins, our forebears and ancestors."[103] Jun Nguyen-Hatsushiba's underwater spectaculars might be seen as a spontaneous application of this theory: evoking the past means stripping it to an extreme degree of the circumstances surrounding it, and reconstructing it with the help of highly formalized detail drawings, colorful and ephemeral ballets that unfold in a neutral element.

A work by Paul Chan, *My Birds... Trash... The Future* (2004), in which two videos are projected on either side of a single screen, constitutes a true historical epic, recounted with means that are just as banal, borrowed from the lexicon of computer graphics: a rudimentary animated film overlaid with popups and blinking banners in a lively color palette dominated by brown, electric blue, and orange. A flashing and eye-catching aesthetic: that of contemporary information. In it we meet Pier Paolo Pasolini and Goya, Samuel Beckett and the rapper Biggie Smalls, in an apocalyptic environment traversed by religion and suicide commandos, where trash flies in formation and huge, disturbing birds are killed. This work by Paul Chan might be compared to Brian de Palma's film *Redacted*, which three years later evoked the war in Iraq with the aid of soldiers' blogs and images from mobile phones and amateur cameras. In both works, we encounter a loss of faith in the notion of a single medium, as if history and current events could only be transcribed and transmitted by the multiple, by the organized proliferation of visual and narrative instruments. This formal mode reflects our civilization of overproduction, in which the degree of spatial (and imaginary) clutter is such that the

103 WINFRIED GEORG SEBALD, *CAMPO SANTO*, TRANS. ANTHEA BELL (NEW YORK: RANDOM HOUSE, 2005), 32.

slightest gap in its chain produces a visual effect; but it also points to the experience of *homo viator*, moving through formats and circuits, far from that monoculture of the medium to which certain critics would like to see contemporary art restricted.

TRANSFERS

As a manifestation of this culture of setting in motion (or viatorization), contemporary art identifies translation as a privileged operation. It must be said that modernism neglected the notion of translation, immersed as it was to its post-Babelian project of a (Western) universalism whose Esperanto was abstraction. By contrast, in our increasingly globalized world, all signs must be translated or translatable—if only into the new lingua franca of English—in order to really exist. But beyond this practical imperative, translation is at the center of an important ethical and aesthetic issue: it is a question of fighting for the indeterminacy of the code, of rejecting any source code that would seek to assign a single origin to works and texts. Translation, which collectivizes the meaning of a discourse and sets in motion an object of thought by inserting it into a chain, thus diluting its origin in multiplicity, constitutes a mode of resistance against the generalized imposition of formats and a kind of formal guerilla warfare. The basic principle of guerilla warfare is to keep one's fighting forces in constant motion; that way, they avoid detection and retain their ability to act. In the cultural field, such warfare is defined by the passage of signs through heterogeneous territories, and by the refusal to allow artistic practice to be assigned to a specific, identifiable, and definitive field. Since the end of the previous century, the act of translation has invaded the field of culture: transpositions, changes of dimension, ceaseless passages between different formats and levels of production, a diaspora of signs. Is this a new phenomenon? One might object that even the most insignificant drawing already translates an idea or sensation, that every work of art is the product of a series of transformations, normed displacements toward a form. Sigmund Freud showed how creative energy operates

as a transformer of libidinal energy, through the various stages of the process of sublimation. Thus, Jean-François Lyotard is able to define painting as "libido hooked up to color."[104] But what today's artists above all retain from psychoanalysis is a knowledge of connections: how do things link up? What happens when one passes from one system to another, when a sign appears in a variety of assumed forms? Unlike the regime of transformation of energy described by psychoanalysis, translation has its own laws and norms. And even more clearly, it brings distinct and autonomous realities face to face and organizes their displacement.

Thus, one might define contemporary art in terms of a criterion of translatability, that is, according to the nature of the contents it trans- codes, the manner in which it viatorizes them and inserts them into a signifying chain. Translation also appears today as the categorical imperative of an ethics of recognition of the other, a task it fulfills much more effectively than merely registering otherness. It may very well constitute the central figure of the modernity of the twenty-first century, a founding myth that would replace the myth of progress, which animated the modernity of the previous century. Andy Warhol encapsulated the mental landscape of the avant-garde artist of the 1960s when he declared that he "wanted to be a machine"—that is, in order to adapt to the standardized universe in which he moved, he sought to transform his human faculties into mechanical functions. No doubt, one could describe the ambition of the twenty-first-century artist as the desire to become a network. The modernity of the twentieth century was based on coupling the human to the industrial machine; ours confronts computing and reticulated lines.

104 JEAN-FRANÇOIS LYOTARD, *DES DISPOSITIFS PULSIONNELS* (PARIS: UNION GÉNÉRALE D'ÉDITIONS, 1980 [1973]) [NOT TRANSLATED INTO ENGLISH].

TRANSFORMATIONS, TRANSLATIONS, TRANSCODINGS

Since the 1980s, the planet has been dancing to the tune of the universal trend toward digitization. Images, texts, and sounds are passing from an analogue state to a digital one, which allows them to be read by new generations of machines and subjected to novel types of processing. This development is not without repercussions for contemporary art. On the one hand, this is because it affects the sources and materials artists use; on the other, because it ceaselessly creates obsolescence (where does one go to find a VCR to play an old VHS videocassette? and what about those old vinyl records?); but also because digitization is gradually destroying the old disciplinary divisions that held sway in the realm of technical equipment: on a computer today, one can listen to music, watch a movie, read a text, or look at reproductions of artworks. It's the end of the division of labor among household appliances; cultural post-Fordism for the family. A single system of codes—the binary language of computing—now makes it possible to pass from a sound to a graphic representation and to manipulate images in a thousand different ways. Images are now defined by their density, by the quantity of atoms they contain. How many pixels (picture elements)? Such is the new condition of the reading and transmission of images, centered on the capabilities of the computer, which today forms the basis of a new formal grammar developed by a new generation of artists. Artists, however, who do not necessarily utilize digital tools—for such tools are in any case part of the fabric of our manner of conceptualizing, representing, processing, and transmitting information.

Since it first took hold in the 1980s, home computing has gradually spread to all modes of thought and production. At the moment, however, its most innovative artistic applications stem from artists whose practice is quite distant from digital art of any kind—no doubt while waiting for something better to come along. But this is an area in which the computer as object is of very little importance compared

to the new forms it generates, foremost among them the mental operation at the very heart of the digital: transcoding. This passage from one code to another establishes, in contemporary artworks, a novel vision of space-time that undermines the notions of origin and originality: digitization weakens the presence of the source, since every generation of an image is merely one moment in a chain without beginning or end. One can only reencode what was already encoded to begin with, and every act of encoding dissolves the authenticity of the object in the very formula of its duplication. The work of Kelley Walker may be regarded as emblematic of this practice of transferring, of keeping signs in intermediate formats that permit their propagation, like those microbial agents stored at ultra-low temperatures to maintain their virulence. These signs without origins or stable identities represent the base materials of form in the radicant era. Instead of producing an object, the artist works to develop a ribbon of significations, to propagate a wavelength, to modulate the conceptual frequency on which his propositions will be deciphered by an audience. Thus, an idea can pass from solid to supple, from subject matter to concept, from material work to a multiplicity of extensions and declensions. The art of the transfer: one transports data or signs from one point to another, and this act is more expressive of our era than any other. Transformation, transcoding, passage, and normed displacement are the figures of this contemporary transferism.

To cite a few examples, when Pierre Huyghe transcribes his journey to Antarctica, he does so first in the form of an exhibition, then in that of a film, and then in that of an opera on ice. Liam Gillick transforms the story of a protest campaign by workers at a Volvo factory in Sweden into a series of Minimal sculptural sequences—as if an abstract film had been subtitled by striking workers (*A Short Text on the Possibility of Creating an Economy of Equivalence*, 2005). Saâdane Afif uses André Cadere's sculptures from the 1970s as a kind of color-coding system, which he then transforms into guitar chords played by automatons

(*Power Chords*, 2005). He also produced musical equivalents of his own works in the form of poems commissioned from writers, which he then set to music (*Lyrics*, 2005). In a video presented at the Whitney Biennial in 2006, Jordan Wolfson translates Charlie Chaplin's speech in *The Great Dictator* into sign language. Jonathan Monk engages in literal acts of translation when he takes a conceptual work by Robert Barry and translates its English-language content first into one language, then another, then that into a third, and so on until the original meaning is completely lost in a final, incomprehensible English sentence (*Translation Piece*, 2002). In Peter Coffin's work, a sound becomes an integral factor in the growth of a green plant; a thought becomes a winding thread that materializes in neon, evoking certain works by Keith Sonnier; modernist artworks become elements of a shadow theater; and a compilation of pieces of music becomes the tensor that will alter the configuration of a brain. Loris Gréaud records an encephalogram of the moment in which he mentally elaborates one of his exhibitions, thus producing a diagram that will be translated into luminous impacts intended for a series of lamps that will blink on and off at the exhibition. A logic of connections: in these works, every element used is valued for its ability to modify the form of another. One could cite countless examples of these *transformat* practices, all of which attest to the fact that the invention of modes of passage from one regime of expression to another is indeed a major concern for the art of the 2000s.

As we have seen, when the notion of translation is mentioned, that of topology is never far behind. Both of them have as their objective the transit of a form from one system of codes to another. Topology and translation are practices of displacement: what is it in an object that survives, and what is lost, when its properties and coordinates are reconfigured? Defining topology, Pierre Huyghe explains that it "refers to a process of translation. However, when you translate something, you always lose something that was in the original. In a

topological situation, by contrast, you lose nothing; it is a deformation of the same." He goes on to suggest that topology is "the fold of a situation. It's a way to translate an experience without representing it. The experience will be equivalent and still it will be different."[105] Using this processual model, it becomes possible to decipher a number of important contemporary artworks. It is a matter of taking a bundle of information and inventing a new mode of processing for it—in other words, of connecting to a flow of some kind and diverting it in a precise direction, that is, giving it a form.

THE "POST-MEDIUM CONDITION"
This valorization of instability against disciplinary stability, the choice of flows that cover lines and boundaries against the circumscribed territories offered by the various media, and the decision to shift among various formats instead of deferring to the historical and practical authority of a single one—all these shatter the aesthetic canons on which contemporary criticism is based. Seeking to describe this zone of turbulence, Rosalind Krauss speaks of a "post-medium condition." In a brilliant commentary on Marcel Broodthaers—specifically on the collection of works relating to the Belgian artist's fictional *Museum of Modern Art, Department of Eagles* (1968–72)—Krauss sees in Broodthaers's generic eagle an emblem that "announces not the end of art but the termination of the individual arts as medium-specific."[106] It is fiction, as it happens, that becomes the medium here, and comes to blur the boundaries between art and literature, narrative and form. More precisely, for Broodthaers the Museum becomes a medium in its own right, capable of endowing a heterogeneous collection of elements with a conceptual and aesthetic unity. But wouldn't any fictional framework be capable of replacing the traditional media in this way?

105 PIERRE HUYGHE, INTERVIEW BY GEORGE BAKER (NOTE 86): 90–92.

106 ROSALIND KRAUSS, *A VOYAGE ON THE NORTH SEA: ART IN THE AGE OF THE POST-MEDIUM CONDITION* (LONDON: THAMES, 2000), 12.

The *Department of Eagles* is only the harbinger of a long series of works from the 1990s and 2000s that aren't based on any specific disciplinary practice, but, on the contrary, borrow their modes of production and their formats from social reality.

This is the development that Rosalind Krauss denounces: "Twenty-five years later, all over the world, in every biennale and at every art fair, the eagle principle functions as the new academy. Whether it calls itself installation or institutional critique, the international spread of mixed media installation has become ubiquitous."[107] This new "academy," as she terms it, finds its material in that formal heterogeneity which constitutes the dominant experience of our time, an experience embodied by the channel-hopping TV-watcher: "Television and video seem Hydra-headed, existing in endlessly diverse forms, spaces and temporalities for which no single instance seems to provide a formal unity for the whole. This is what Sam Weber has called television's 'constitutive heterogeneity.'"[108] For Krauss, this "intermedia condition" ("in which not only language and image but high and low and any oppositional pairing one can think of freely mix") apparently represents a capitulation, and loss of interest in the medium; a sign of regression.[109] In Broodthaers's work itself, she notes, all the material supports are leveled by a homogenizing principle, the work of reification ("commod-ification"); thus, what was staged by the fiction of the *Museum of Modern Art, Department of Eagles* would today be the product of an accommodating attitude toward the entertainment industry.

The view that art must be rooted in some medium (painting, sculpture) is an extension of the Greenbergian theory of progress in art, progress that consists in essentializing art, in purifying the medium to the point

107 IBID., 20.

108 IBID., 31.

109 IBID.

where it is reduced to a practice of resistance. Resistance to what? The fear of the disintegration of the various traditional media springs, in the final analysis, from a pessimistic conception of culture that is very much present in Greenberg, for whom aesthetics was the arena of a struggle against a grave danger, the fall of art into kitsch. But let's turn the proposition around: what if the contemporary form of kitsch were actually none other than the confinement of artistic propositions within the gilt frames of tradition? And what if true art were defined precisely by its capacity to evade the implicit determinisms of the medium it employs? In other words, today one must struggle, not—as Greenberg did—for the preservation of an avant-garde that is self-sufficient and focused on the specificities of its means, but rather for the indeterminacy of art's source code, its dispersion and dis-semination, so that it remains impossible to pin down—in opposition to the hyperformatting that, paradoxically, distinguishes kitsch.

TRANSLATED FORMS

The transfer: a practice of displacement, which highlights as such the passage of signs from one format to another. Speaking of the collective project *Ann Lee*, which involved the participation of a dozen artists, Philippe Parreno insists on the notion of passage: "For me, it's a simple act of exhibition: the passage of a sign from hand to hand. *Ann Lee* was a flag without a cause (the cause was invented as it passed from hand to hand)."[110] As it happens, the medium used for this project was neither video nor any other specific discipline, but a character. A fictional character, the rights to which were acquired from a Japanese studio by Parreno and Pierre Huyghe, and which each artist—from Pierre Joseph and Doug Aitken to Dominique Gonzalez-Foerster and Richard Philips—was free to stage and interpret as he or she chose. The project *Ann Lee* thus made use of a system of formal

110 PHILIPPE PARRENO, "ANN LEE: VIE ET MORT D'UN SIGNE. ENTRETIEN AVEC FRÉDÉRIC CHAPON," *FROG* 3 (SPRING / SUMMER 2006).

translations based on a renewal of the idea of the medium, or rather on its original meaning as an "intermediary between the world of the living and that of ghosts." According to Walter Benjamin, a translation above all permits the original to survive, but it also entails its death. From the translation, there is no path leading back to the original text. Ann Lee, a manga character, ultimately died a legal death at the end of her artistic use; thus, she only existed in and through her passage from one format to another, through the intervention of artists who brought her to "life."

Sometimes it is history that the artist attempts to bring back to life by seeking modes of translation. In his video *Intervista* (1998), Anri Sala makes use of archival footage of his mother in Albania, where she is seen participating in a Communist Party meeting. Because there was no sound, Sala showed it at a school for deaf children and asked them to transcribe the dialogue. "They understood everything except for the only words that I could understand myself: Marxism/Leninism ... I feel a closeness to all meaningful/meaningless gaps."[111] What the act of translation produces is above all this remainder, this distance: here, this empty space that opens up between two generations separated by a historical event. Geography can also be translated. There is nothing more pathetic than those artists who merely import the signs of their visual culture and give them a vague face-lift, and thus help to reify them and reify themselves in an act of self-exploitation. There are others, however, who buckle down and viatorize their experience, without indulging in a little cottage industry of signs. Pascale Marthine Tayou may manipulate an iconography that largely comes from Africa—he composts its elements into a trenchant body of work that no longer has anything to do with folklore of any kind. His *Plastic Bags*, a formless mass of monochromatic plastic bags, delineate urban landscapes which are quite a bit more realistic than the tribal

111 ANRI SALA, IN *ART REVIEW* 18 (JANUARY 2008): 30.

motifs we are used to. And it is precisely because Tayou's work responds to the quintessential modernist question—"how can I bring my artistic work into line with the social modes of production that are currently in use?"—that it helps to define altermodernity. Piet Mondrian, Jackson Pollock, and Robert Smithson asked themselves the same question in their day. Tayou's answer is the practice of collecting and the decision to set up his forms in the midst of precariousness.

For his part, Barthélémy Toguo connects his giant watercolors, African motifs, and cardboard boxes to the economic flows linking Africa to multinational corporations. Kim Soo-Ja, a Korean artist, develops a vision inspired by the Tao in exhibitions that combine Minimal art with ancestral motifs, while Surasi Kusolwong constructs formal processes in which products of Thai folk and popular culture find themselves informed and deformed by Minimal and Conceptual art. Navin Rawanchaikul places the aesthetic of the Indian movie poster and Hollywood science fiction in the service of a narrative epic that stages the role of art and its definition in the style of Conceptual art. All these practices have in common a focus on translation: elements belonging to a local visual or philosophical culture are transferred from a traditional universe in which they were strictly codified and fixed to one in which they are set in motion and placed beneath the gaze of a critical reading.

UNDER THE CULTURAL RAIN (LOUIS ALTHUSSER, MARCEL DUCHAMP, AND THE USE OF ARTISTIC FORMS)

How exactly, in these early years of the twentieth century, do individuals perceive culture? As a form of merchandise, distributed by institutions and businesses. Thus, individuals move about within a veritable rain of forms, images, objects, and discourses, a rain around which are organized both (creative) activities and (consumption-oriented) traffic. Cultural production thus constitutes a continuous downpour of objects—visual, auditory, written, theatrical; of uneven quality and heterogeneous status—from which reader-spectators, using the means available to them and in accord with their education, intellectual baggage, and character, gather what they can. What is one to do when caught in this rain?

In his essay "The Underground Current of the Materialism of the Encounter," Louis Althusser uses the same metaphor to describe the atomic structure of reality as Democritus and Epicurus did before him. Here are the first lines of his description:

IT RAINS.

LET THIS BOOK THEREFORE BE, BEFORE ALL ELSE, A BOOK ABOUT ORDINARY RAIN.

MALEBRANCHE WONDERED "WHY IT RAINS UPON THE SANDS, UPON HIGHWAYS AND SEAS," SINCE THIS WATER FROM THE SKY WHICH, ELSEWHERE, WATERS CROPS (AND THAT IS VERY GOOD), ADDS NOTHING TO THE WATER OF THE SEA, OR GOES TO WASTE ON THE ROADS AND BEACHES.[112]

Let us regard cultural production the way Althusser does rain: as pre-cipitation, as an unfurling of parallel lines, only some of whose atoms will irrigate farmland and truly "serve" or be productive by bringing in an original element, but none of which is totally useless or absolutely without interest. Above and beyond judgments of taste, this rain of cultural objects hollows out crevices and modifies the contours and natural lines of human society. Its total mass is one thing; its individual atoms (that is, this or that particular work) are another. Ultimately,

each atom is capable of being useful, provided it is directed toward a suitable zone. From this user-centered perspective, the value of an object depends on its (always provisional) destination, but this value is never absolute: an aesthetic appraisal of an object must consider the context. The work of art is a locus with its particular *haecceity*, its specific and concrete situation, a landscape capable of being modified or disfigured by the action of *cultural rain*, which comes to disturb the system of relations that produces it as a work.

Drawing on Althusser's ideas, we will tentatively repeat the founding gesture of his philosophical approach by undertaking a return to the work of Marcel Duchamp, just as Althusser himself founded his work on a rereading of Karl Marx's writings, which he believed constituted a pure science whose inaccessible philosophy remained to be invented. The ideologues of state communism had read Marx through the lens of Hegel—that is, following a line of reasoning that preexisted Marx's work but was incompatible with its true nature, a line of reasoning, according to Althusser, that "didn't work"—Something like a diesel car

112 LOUIS ALTHUSSER, "THE UNDERGROUND CURRENT OF THE MATERIALISM OF THE ENCOUNTER," IN ALTHUSSER, *PHILOSOPHY OF THE ENCOUNTER: LATER WRITINGS, 1978–87*, ED. FRANÇOIS MATHERON AND OLIVER CORPET, TRANS. G. M. GOSHGARIAN (NEW YORK: VERSO, 2006), 167. THIS REMARK BY ALTHUSSER OPENS ONE OF HIS MAJOR WORKS, WRITTEN ABOUT 1984. IT WILL BE NECESSARY ONE DAY TO EXTRICATE THE WORK OF THE AUTHOR OF *FOR MARX* FROM THE CLICHÉS LINKED TO THE GENERATION OF MAY 1968 AND TO THE COLLAPSE OF "REAL COMMUNISM," THOUGH THIS IS NOT THE PLACE FOR SUCH AN UNDER-TAKING. AS HIS POSTHUMOUS WORKS REVEAL—AND AS WAS ALREADY ANNOUNCED BY HIS INCESSANT QUEST FOR A MATERIALIST PHILOSOPHY UNENCUMBERED BY HEGELIAN THEOLOGY AND RATIONALISM— ALTHUSSER WAS ABOVE ALL THE INSTIGATOR OF A RENEWAL OF NOMINALISM, AS ILLUSTRATED BY HIS CONCEPT OF ALEATORY MATERIALISM, WHILE HIS IDEAS ARE ARTICULATED AROUND SUCH KEY CONCEPTS AS MADNESS, PRACTICE, OCCASION, AND IDEOLOGY. FOR ANOTHER READING OF THE CONCEPT OF THE ENCOUNTER, SEE MY "RELATIONAL AESTHETICS AND ALEATORY MATERIALISM," IN *RELATIONAL AESTHETICS*, TRANS. SIMON PLEASANCE AND FRONZA WOODS WITH THE PARTICIPATION OF MATHIEU COPELAND (DIJON: LES PRESSES DU RÉEL, 2002).

that one insists on filling with super. Could it be that, in a similar manner, we have read Duchamp through the lens of a system of thought incompatible with his, and for this reason have been unable to deduce from his practice an aesthetics that remains as yet unknown?

APPROPRIATION AND NEOLIBERALISM

Louis Althusser defines ideology as the "imaginary representation that men make of their real conditions of existence."[113] And, by extension, the representation we make of others' activities. In the domain of art, the notion of ideology clearly permeates critical discourse, the interpretation of works, and the mode in which works are presented and classified, but it conditions artists' practices no less forcefully. An "imaginary representation" preexists their schemes, a representation that artists more or less fully escape and more or less successfully challenge. And in light of the emergence today of a culture of use, it is possible to identify certain founding notions of twentieth-century art, including one of its archetypes: appropriation; the term appropriation art having become, since the 1960s, a buzzword of Anglo-Saxon criticism.

The use of existing forms is not a particularly novel practice. Indeed, haven't all great artists copied, interpreted, and recycled masters of the past? This type of practice finds an exemplar in Pablo Picasso, so much so that he veritably embodies the strategy of recycling. An admirer of Velázquez's *Las Meninas*, of Ingres and Nicolas Poussin, Picasso in effect set the pattern for a modernist approach to using art history. For in Picasso's approach to recycling, this use of forms means, in effect, appealing to history, resurrecting it, and in so doing tracing a line from the resultant product to its historical model or models. And in his conversations with André Malraux,[114] Picasso

113 ALTHUSSER, "THE UNDERGROUND CURRENT" (NOTE 112), 280.

114 ANDRÉ MALRAUX, *LA TÊTE D'OBSIDIENNE* (PARIS: GALLIMARD, 1974).

indeed claimed that through his research into and use of elements of the past he sought to construct the countenance [*masque*] of his own epoch, that is, an equivalent for its "style," which is the word he likewise used to designate the production of civilizations without proper names, whether vanished or not. According to Picasso / Malraux, this notion of a countenance or mask is an exemplary approach to using forms. It is erudite (it never entirely conceals its source), it asserts the history of art as a transcendent entity, and above all it asserts, through peerless virtuosity, the primacy of style. Picasso's entire oeuvre—and the commentary accompanying his use of preexisting forms for personal ends—constitutes a salient juncture in the development of the dominant ideology of cultural use.

EXAMPLE 1: MARCEL DUCHAMP, *BICYCLE WHEEL* (1913)
The invention of the readymade represents a tipping point in the history of art, an innovation whose posterity has been prodigious. With this radical gesture, which consists of presenting an everyday object of consumption as a work of art, the entire lexical field of the visual arts found itself augmented by a new possibility: signifying not with the aid of a sign but with that of reality itself.[115] But does this incredible stroke of aesthetic and critical fortune, if detached from Duchamp's monumental and magisterial work, have nothing to do with the ideology of his time? Does it not ultimately run on ideological fuel? Marcel Duchamp himself never used the term "appropriation." To convey what's involved in the readymade, he made use of notions and terms that do not belong to the sphere of property or appropriation. The manner in which this last word appeared, and in what context, we will explain shortly.

115 ON THE LINKS BETWEEN THE READYMADE AND CINEMATIC LANGUAGE, SEE THE CHAPTER "TAYLOR ET LE CINÉMA" IN THE AUTHOR'S *FORMES DE VIE: L'ART MODERNE ET L'INVENTION DE SOI* (PARIS: ÉDITIONS DENOËL, 1999).

Within the framework of a questioning of production, a discourse that constantly invoked the pictorial process only to undercut it (in his remarks on the readymade he usually set it in relation to—in reaction against—traditional forms of art), Duchamp insisted first and foremost on the notion of choice, rather than that of production: "When you make an ordinary painting," he explains, "there is always a choice: you choose your colors, you choose your canvas, you choose the subject, you choose everything. There isn't any art; it is a choice, essentially. There [with the readymade], it's the same thing. It is a choice of object."[116] But the act of choosing is by no means equivalent to that of appropriating, even if Duchamp inaugurated the reign of the readymade at a time when painters were using pre-mixed colors from tubes.

Appropriation, with its aggressive connotations, implies competition, a dispute over a territory that could equally well belong to any one of the combatants. Insofar as the readymade implies "giving a new meaning" to an object, or more precisely removing it from its territory or place of origin, the notion of appropriation doesn't make any sense here; it doesn't really apply. Moreover, the readymade is in essence immaterial; it has no physical importance. If destroyed, it can be replaced, or not. No one owns it.

A second theoretical point, which hinges on the first, involves the notion of indifference. The beauty of indifference championed by Duchamp flies in the face of the purely retinal beauty of painting and sculpture: "Instead of choosing something you like or dislike, you choose something without any interest, visually, for an artist. In other words, you arrive at a state of indifference toward that object."[117] And

116 PHILIPPE COLLIN, MARCEL DUCHAMP PARLE DES READY-MADE À PHILIPPE COLLIN, ENVOIS (PARIS: L'ÉCHOPPE, 1999).

117 IBID.

indifference is precisely the opposite of avidity, which is the basis of the property deed. At best, indifference is shared; at worst, it bores and repulses. This idea of indifference is closer to certain concepts of Eastern philosophy: the Taoist principle of non-action (*Wu wei*), or, still more, that joyous form of indifference to the world, linked to the feeling of impermanence, that is the basis of Buddhism. An indifferent object is not something to be appropriated. On the contrary, in the readymade, Duchamp finds an aesthetic formula for dispossession.

The third point, an essential one, is the idea of displacement: the readymade achieves its maximum power only when displayed, that is, when registered by museum and camera, the museum system functioning as recording room and thereby ratifying, in Duchamp's terms, the "absolute contradiction" that is its very essence. This notion of displacement is also the basis of *Sculptures for Traveling*, *Boîte-en-Valise* (Box in a Suitcase) (1935–41), and almost all of Duchamp's oeuvre. Displacement is a way of using the world, a way of surreptitiously eroding established geographies. Thus, the readymade belongs to no particular domain. It exists between two zones and is anchored in none. In light of the three fundamental concepts that preoccupy the readymade, particularly strange is the critique of Duchamp's work that Joseph Beuys gave vent to fifty years later, a critique founded on that notion of appropriation that appears nowhere in the problematic developed by the readymade's inventor. Beuys sees in the readymade nothing but an act of appropriation, because the reigning ideology makes the latter hypervisible, like Edgar Allan Poe's purloined letter, which no one sees so long as it is prominently in view. On numerous occasions—notably on the subject of his performance *The Silence of Marcel Duchamp Is Overestimated* (1964)— the German artist makes fun of the bourgeois side of Duchamp, which according to Beuys was made manifest by the fact that Duchamp dared to put an individual signature on a urinal (*Fountain*, 1917), that is, on an object collectively produced by real workers in real kaolin

mines. Beuys implies that the signature expropriates the labor of these workers, thus reproducing the mechanism of capitalism, the social division between wage earners and owners of the means of production. Duchamp a small-time boss? Later, when Yves Klein calls the blue sky his work, he really does appropriate it. It is in details of this sort that one grasps the reasoning behind such a reading of the readymade, that is, the ideological context in which it is read by Beuys and Klein, not to mention Piero Manzoni and Ben [Vautier], who "sign" this or that aspect of reality in a gesture of appropriation.

This controversy brings to light the ideological nature of the notion of appropriation, which sets up categories of owners of property and those despoiled of it, and does so on the basis of the object's signature, in other words its means of production (its exhibition). Etymologically, to produce means "to bring forth before oneself": exhibition occurs when a signature (a proper name) legitimates the production in public of a collection of forms.

EXAMPLE 2: MARCEL DUCHAMP, *LHOOQ*
In putting a mustache on a reproduction of Leonardo da Vinci's *Mona Lisa*, Duchamp performs an operation that, once again, differs from appropriation in that neither the original object nor its author are in any way masked; on the contrary, they are emphasized, with the aim of desacralizing or trivializing a cultural icon. Here it is a question of the Dadaist use of forms, which is joyfully negating, iconoclastic, and deliberately shocking—what the bourgeois call "prankster wit." It is, in any case, a liberating use that aims to break the chain of what could be called cultural attachment, that is, the conditioned reflex of admiration—what Witold Gombrowicz portrays in his *Polish Memories* when he describes the "gaping mouths" and "vacant gazes" crowding around that very same *Mona Lisa*. These people are not appreciating or evaluating; they are obeying a cultural imperative.

This mode of intervention was later to be systematized by the Situationist International, which put it into practice for political ends. The term *détournement*,* which serves as shorthand for the formula "*détournement* of preexisting aesthetic elements," implies a radicality to which Debord and his friends laid claim in a tract against Surrealism, in particular André Breton: "The idea of citing without quotation marks, without stating the source, and with the aim of deliberately transforming it, in short, the idea that one would radically distort [*détourne*] it, this was too much for him."[118] Constant [Nieuwenhuys] and Gil Wolman intended to "pillage works of the past," but truly "in order to go forward." This first problematization of the use of culture can be found in the inaugural declaration of the Situationist International: "there can be no situationist painting or music, but only a situationist use of those means."[119] In particular, the signature is clearly returned to the status of property title and plainly situated in the general context of capitalist economy—even if that means pointing out the glaring contradictions between the declarations of avant-garde artists and their efforts to protect their patrimony by restricting access to it. As for the contemporary practice of *détournement*, it has tellingly moved toward the dominant code: the logo. We can no longer count the number of artists who hijack [*détournent*] acronyms or slogans that "belong" to existing businesses, from Daniel Pflumm's pirating of AT&T to Swetlana Heger and Plamen Dejanov's sale of their labor power to BMW (1999), not to mention Sylvie Fleury (the colors of Chanel), Philippe Parreno (in the video *Some Products*, he

* TRANSLATOR'S NOTE: THE TERM *DÉTOURNEMENT* IS DIFFICULT TO TRANSLATE; USED IN CONNECTION WITH THE SITUATIONIST MOVEMENT, THE WORD'S CLOSEST ENGLISH EQUIVALENTS INCLUDE "HIJACKING," "REROUTING," "MISAPPROPRIATION," "DISTORTION," AND "DERAILMENT."

118 JEAN-FRANÇOIS MARTOS, *HISTOIRE DE L'INTERNATIONALE SITUATIONNISTE* (PARIS: ÉDITIONS GÉRARD LEBOVICI, 1989), 27.

119 KEN KNABB, TRANS. AND ED., *SITUATIONIST INTERNATIONAL ANTHOLOGY* (BERKELEY, CA: BUREAU OF PUBLIC SECRETS, 1982), 52.

150

presents Picorette, a bygone brand of candies), and the logos appropriated by Michel Majerus in his three-dimensional paintings. Leisure activities are today subject to a specific form of engineering, as are relations among human beings. The capitalist system having colonized every aspect of daily life, the contemporary world appears to be a global assembly line composed of an infinite succession of jobs. All human production that does not conform to a logic of profit maximization thereby acquires the de facto status of an antiquated worker's practice known in France as the *perruque*, a practice that consists of using factory tools and machines outside of normal work hours in order to produce objects for personal use or for an undeclared job. When Pierre Joseph goes to Japan to station himself in front of a factory that produces telephone parts, soliciting workers to teach him how to manufacture various components, he introduces a clandestine element into the work process. Starting from a position of non-knowledge (ignorance is productive and establishes relations), he uses a factory as a turntable. Another form of use-misuse [*détournement*]: Philippe Parreno and Pierre Huyghe buy the rights to a manga character, Ann Lee, and use it as a heuristic device, asking: how does an image become a sign? And what does it mean to share ownership in a sign, since this character is brought to life across different works by different artists? What does this possibility of shared ownership reveal about the nature of a form?

EXAMPLE 3: MARCEL DUCHAMP, THE "RECIPROCAL READYMADE"
When he invented the principle of the reciprocal readymade, Marcel Duchamp indirectly celebrated the power of the *malentendu* or interpretive error. He described this unusual cultural object, which was never realized, as "the use of a Rembrandt painting as an ironing board." It is a perfect illustration of the idea of a cultural field in which incongruity rules unchallenged. What could be cruder than this plan? What could be less "cultivated," in Gombrowicz's sense of the word? Property madness. Viewed through the lens of the reciprocal readymade,

every act of appropriation attests to a misuse of the world, to a *malentendu* that has become the very nature of the economy. As soon as it depends on the ideology of property (the "right of access" theorized by Jeremy Rifkin), the right of use readily turns toward the tragicomic.

In 1991, Linus Torvalds launched Linux, a software program developed on the principle of open access to source code, which had until then been treated as a jealously guarded secret by those who sell software—notably Bill Gates and his Microsoft Corporation. This free software, paid for solely through customer support fees (a right of use), guarantees "the freedom to copy the program for yourself or your friends; the freedom to understand how it works if you wish to; the freedom to modify it and distribute your modifications."[120] Thus, the GNU / Linux system is defined in opposition to the logic of Taylorist economics, which is based on the suppression of know-how (since such knowledge incites the user to transform it) and on the inalienability of products, which are assumed to be mass-produced and delivered complete. Couldn't GNU / Linux be said to operate on the principle of the reciprocal readymade?

It runs up against a certain fear related to being a user of technology. This fear stems from our panic at the prospect of reaching our threshold of incompetence. Able to do nothing, or almost nothing, maintained as we are in a system that makes the division of labor seem a natural condition, we are evolving into a culture based on the famous "Peter Principle," which assigns each person a limit beyond which he or she becomes counterproductive, that is, blameworthy. We cannot conceive of manipulating objects beyond certain limits: the ideology of competence induces us unconsciously to refuse reading

120 [THIS IS AN EXCERPT FROM A COMMON FRENCH-LANGUAGE VERSION OF THE FREE SOFTWARE FOUNDATION'S DEFINITION OF FREE SOFTWARE; SEE FOR EXAMPLE WWW.LINUQ.ORG/INDEX.PHP?ID=5.—THE TRANSLATOR]

what we are not supposed to understand, operating machines without an instruction manual, making use of worlds that feel foreign to us; this is doubtless misguided. Resisting this trend, Brian Eno says that half of his ideas come to him in the studio, when using a machine whose instructions he only vaguely understands.

INTERFORM

The idea, then, is to use forms. But how? Althusser's aleatory materialism is a theory of the encounter: its primitive figure, the *clinamen* of Democritus, consists in "an infinitesimal *swerve*" that "causes an atom to 'swerve' from its vertical fall in the void, and, breaking the parallelism in an almost negligible way at one point, induce *an encounter* with the atom next to it, and, from encounter to encounter, a pile-up and the birth of a world."[121]

Thus, according to Althusser, the swerve or deviation appears as the principle of all reality. To assert in this way the primacy of the swerve (a change of path, a reorientation) is of course to attack idealism, which presupposes an origin and end for the universe and for history. But it is also, on an aesthetic level, to repudiate the concept of monstrosity. Conceived as an exception to the regular chain of being, the monster exists only by opposition to a nature, a normalcy supposedly inscribed as an absolute law for the human species as for its historical (as well as social and cultural) products. But the notion of rule of law functions only within the limits of a universe born of the void, of the aleatory grasp or staying power [*prise*] of a certain number of elements.

What did Marx say? asks Althusser. He said that "the capitalist mode of production arose from the 'encounter' between 'the owners of money' and the proletarian stripped of everything but his labor-power. 'It so happens' that this encounter took place, and 'took hold,' which

121 ALTHUSSER, "THE UNDERGROUND CURRENT" (NOTE 112), 169.

means that it did not come undone as soon as it came about, but lasted, and became an accomplished fact, the accomplished fact of this encounter, inducing stable relationships."[122] Capitalism (or art) has its rules, but they are like the rules of poker: meaningless when you move on to chess or the French card game *Belote*.

Thus, law is valid only in relation to the—aleatory—nature of its capacity to take hold [*prise*]. The world is nothing but a collection of spatiotemporal universes (societies, cultures, communities) that each represents an exception; there are only cases (the Latin word *casus* meaning both "instance" and "chance") produced by encounters. The monstrous has no distinct reality; it is merely a spectacular instance of the general rule: Edgar Allan Poe's *Angel of the Odd* with his Bavarian accent, Yves Klein's exhibition of empty space, the Residents' *Commercial Album*—ontologically, these constitute exceptions, but in the same way as does a garden gnome or Botero's most grotesque painting. Granted, some exceptions are more interesting than others, but only because they generate more thought, because they are full of thought, because they hack into the community system, into "taste," which is a rehearsal of habits, while others follow the collective inclination and plow well-furrowed ground. In any case, everything is replanted and grafted.

In *The Gay Science*, Nietzsche astutely described the opposition between the farmer who cultivates the field and the barbarian who ravages the harvest.[123] A productive use of culture implies a basic practice of uprooting objects from their native soil—that is, a practice of *deviation*. An element that ends up—on an artist's whim, say— thrust into a distant or incompatible cultural register is thereby diverted [*détourné*] from its intended use: displaced. It is thus the coupling of the industrial object with the museum system that produces the

122 IBID., 197.

123 NIETZSCHE, *THE GAY SCIENCE*, (NOTE 08), 32.

readymade. In the 1970s, rap was born of an alliance between the turntable and musicians' lack of means, and the idea spread that one could make do with the instrumental parts of a record, played one after another. But one could just as well trace its birth to the sudden emergence of the Jamaican sound system into African-American daily life. A matter of organizing an encounter between two or more objects, mixing is an art practiced under the "cultural rain," an art of deviation, of capturing flows and arranging them through singular structures. What is the elaboration of a plastic, musical, or literary work, if not the invention of a collection of collisions along with a mode of capture [*prise*] that enables them to endure? For these encounters must be made to take, or congeal, "in the sense in which ice 'crystal-lizes'" (Althusser). Ice is water that has entered into sympathy with the cold, water that finds a mode of coexistence, a state in which each of the two elements "rediscovers itself." Althusser and Deleuze find common ground here, when the latter defines his concept of assem-blage [*agencement*] as "a multiplicity which is made up of many heterogeneous terms and which establishes liaisons, relations between them, across ages, sexes and reigns—different natures. Thus, the assemblage's only unity is that of co-functioning: it is a symbiosis, a 'sympathy.'"[124] Mixing functions in a mode of coordination: it is the "and" rather than the "is,"[125] the nonviolent negation of the essence of each element for the sake of a mobile ontology, nomadic and circumstantial. "Conjectural," Althusser would say. Works of art create relations, and these relations are exterior to their objects; they possess aesthetic autonomy. "Relations are in the middle," writes Deleuze, "and exist as such."[126] A text by Jorge Luis Borges illustrates the relation to context in its pure form. In "Pierre Menard, Author of

124 GILLES DELEUZE AND CLAIRE PARNET, *DIALOGUES II*, TRANS. JANIS TOMLINSON, BARBARA HABBERJAM, AND ELIOT ALBERT (NEW YORK: COLUMBIA UNIVERSITY PRESS, 2002), 69.

125 IBID., 57.

126 IBID., 55.

the *Quixote*," he tells the story of a twentieth-century French author who rewrites Cervantes's classic word for word, and demonstrates that the meaning of the resulting work is entirely different from that of the original.[127] Borges's demonstration concerns the most basic form or zero degree of use: the copy. Yet recontextualization in "Pierre Menard" effects a temporal displacement of an object analogous to the spatial displacement produced by Duchamp. These two *coups* [moves, tricks, or strokes], precursors of mixing, designate an aesthetic sphere in which heterogeneous elements are effaced in favor of the form their encounter assumes in a new unity.

We should no longer speak here of forms but rather of interforms. The cultural object—larval, mutant, letting its origin appear under the more or less opaque layer of its new use or of the new combination in which it happens to be captured—no longer exists except between two contexts. It flickers, winks. Through hints—woven between the lines, diaphanous—the cultural object mingles its old attributes with those that it acquires through its presence in a foreign stage machinery. This is the case for a funk record from the 1970s when it ends up programmed, mixed, and filtered into a techno set. It is the case for César Baldaccini's *Expansions* when juxtaposed with Sylvie Fleury's recent *Rockets* in an exhibition curated by Eric Troncy.[128] It is also the case for the Minimalist motifs that Liam Gillick uses as part of the decor for his entrepreneurial installations, and for the cartoon fragments that Bertrand Lavier enlarges in his series *Walt Disney Productions*.

"There is no alternative," Margaret Thatcher once said in her effort

127 JORGE LUIS BORGES, *FICCIONES*, ED. ANTHONY KERRIGAN, TRANS. ANTHONY BONNER (NEW YORK: GROVE PRESS, 1962).

128 *DRAMATICALLY DIFFERENT*, AT THE CENTRE NATIONAL D'ART CONTEMPORAIN (CNAC) IN GRENOBLE FROM OCTOBER 26, 1997, TO FEBRUARY 1, 1998. FOR MORE INFORMATION, SEE ERIC TRONCY, *COOLLUSTRE*, (DIJON: LES PRESSES DU RÉEL, 2003).

to naturalize neoliberal ideology. It was a lie, of course; every society is born of aleatory circumstances, but after the fact a narrative is devised that finds a foundation for this chaos in natural order. In every situation, the mediocre demand stability and seek to extend this artificial clarity to history itself. Likewise, in art, there is an alternative to modernism that is not postmodernism as it has developed since the end of the 1970s, in the atomized form of an absolute relativism or of regressive fantasies. This aesthetic of aleatory materialism is of course opposed to modernist teleology, which asserted that the history of art had a direction and an origin. But it does not camouflage a return to an alleged natural order, as is the case with those philosophers of transcendence who would replace what they call "the failure of modernity" with a traditional morality. The latter may turn their back on the finality of history and on the idea of progress in art, but their gesture is scarcely more significant than shifting position in bed, since they merely give up the ends in favor of the origins: painting, classical style, meaning. And yet the ultimate reason and origin of things are only two sides of the same idealist coin: to believe that things were better before is fundamentally no different from the illusion that they will inevitably be better tomorrow.

If we are interested in the avant-gardes, it is by no means because of their historical novelty at a given moment. It is not because Duchamp was the first to introduce a manufactured object into a gallery that his work is exciting, but because of the singularity of his position in a particular historical situation that will never recur. Moreover, we have as much chance of rediscovering the configuration of a past epoch, Michel Foucault used to say, as of seeing the same hand dealt four times in a row in a game of poker.[129]

129 FOR MORE ON THE POSITIONS OF MICHEL FOUCAULT, AND MORE GENERALLY ON THE NOTIONS OF SITUATION OR CONTINGENCY (*CONJONCTURE*) AND THE CONTEMPORARY (*ACTUALITÉ*), SEE BOURRIAUD, *FORMES DE VIE* (NOTE 07), I,1.

Artists who are working today with an intuitive idea of culture as toolbox know that art has neither an origin nor a metaphysical destination, and that the work they exhibit is never a creation but an instance of postproduction. Like the materialist philosopher whose portrait Althusser sketches in his works on aleatory materialism, they know neither where the train is coming from nor where it is going, and they don't care: they get on.

ARTISTIC COLLECTIVISM AND THE PRODUCTION OF PATHWAYS

Playlist [130] is not a thematic exhibition—if one had to assign it a theme, it would be contemporary art itself. Of course, it is undeniable that the artists assembled by this exhibition have some traits in common, but this shared thread is not to be located in the form of a particular thematic, technique, or visual source, still less in the form of a shared identity. True artists invent their own identity papers—as for the others, they are at best able communicators of their "culture" or their sexual, national, or psychological particularisms. No, what makes it possible to bring together in one place artists pursuing such heterogeneous ends and using such heterogeneous methods is the fact that they are working from a similar intuition of the contemporary mental space— the fact that they perceive the culture of the beginning of the twenty-first century as an infinite, chaotic field of which artists are the ideal navigators. They survey the crumbling landscape of the last century's

130 *PLAYLIST* IS AN EXHIBITION THAT TOOK PLACE AT THE PALAIS DE TOKYO IN PARIS IN FEBRUARY 2004. ARTISTS: JACQUES ANDRÉ, SAÂDANE AFIF, JOHN ARMLEDER, CAROL BOVE, ANGELA BULLOCH, CERCLE RAMO NASH (COLLECTION DEVAUTOUR), CLEGG & GUTTMANN, SAM DURANT, PAULINE FONDEVILA, BERTRAND LAVIER, RÉMY MARKOWITSCH, BJARNE MELGAARD, JONATHAN MONK, DAVE MULLER, BRUNO PEINADO, RICHARD PRINCE, ALLEN RUPPERSBERG. VIDEO PROGRAMMING (IN COLLABORATION WITH VINCENT HONORÉ): JOHN BALDESSARI, SLATER BRADLEY, SUSANNE BÜRNER, BRICE DELLSPERGER, CHRISTOPH DRAEGER, KENDELL GEERS (RED PILOT), CHRISTOPH GIRARDET, DOUGLAS GORDON, GUSZTÁV HÁMOS, PIERRE HUYGHE, MIKE KELLEY AND PAUL MCCARTHY, MARK LEWIS, CHRISTIAN MARCLAY, MATTHIAS MÜLLER, STEFAN NIKOLAEV, JOÃO ONOFRE, CATHERINE SULLIVAN, VIBEKE TANDBERG, SALLA TIKKÄ.

modernism, observe the easing of the tensions that once stabilized its architecture, and acknowledge the disappearance of ancient figures of knowledge. Using heterogeneous means, they endeavor to produce works that fit this new environment while at the same time highlighting those aspects of our environment that still bear the imprint of yesterday's order. Though we can only sketch the topology of this new mental landscape, which appears vaporous to the myopic, we know the nature of the ruins on which it rests. Since the sixteenth century and the advent of the modern era, the propagation and accumulation of knowledge had been transmitting form and movement to culture. Horizons were expanded by voyages of discovery, while library towers were stormed with the invention of the humanities and of the conventions of gentility (of the "*honnête homme*"). The invention of the printing press in the fifteenth century goes along with the emergence of a new figure of knowledge, the scholar, incarnated by Pico della Mirandola, Leonardo da Vinci, and the "abyss of knowledge" that was to become Rabelais's giant. Today, though, it has become impossible for an individual to master the totality of a field of knowledge, even someone who formerly passed for a specialist. Now we are submerged by information whose relative importance is no longer readily apparent to us, bombarded by data arriving from multiple sources and accumulating at an exponential pace; in an unprecedented experience in human history, the sum of cultural products exceeds both an individual's capacity for assimilation and the duration of a normal life.

The globalization of art and literature, the proliferation of cultural products, and the ready availability of information on the Internet, not to mention the erosion of the values and hierarchies born of modernism, are creating new and unprecedented conditions that artists are exploring in their works, which chart this new terrain for us like roadmaps. The Internet, where almost all available information resides, suggests a method (navigation, whether reasoned, intuitive, or

aleatory) and provides an ideal metaphor for the state of global culture: a liquid ribbon on whose surface we are learning to pilot thought. A principle or method seems to be emerging: this capacity to navigate information is in the process of becoming the dominant faculty for the intellectual or artist. Linking signs, producing itineraries in the sociocultural space or in the history of art, the twenty-first-century artist is a semionaut.

The (conceptual) roadmap could thus be the emblem of *Playlist*, just as the geographical map was that of my prior exhibition, *GNS— Global Navigation System*. It concerns an object with the same characteristics as the Geological Survey Map, both arising from a preliminary data collection, both enabling movement around and navigation of a given space. Moreover, the list of artists could have been more or less identical, except that those who figured in *GNS*, from John Menick to Pia Rönicke, practice a topocritique that aims to describe and analyze the spaces in which our daily lives unfold, while *Playlist* brings together navigators of culture, who take the universe of formal or imaginary production as their field of reference. It's a matter of degree. Beyond its field of application, this method (the production of forms through the collection of information)—a method used more or less consciously by many artists today—attests to a dominant preoccupation: the affirmation of art as an activity that enables people to navigate and orient themselves in an increasingly digitized world. Making use of the world by using works of the past and cultural products in general could also be the master plan for the works presented in this exhibition.

For the preparation of *Playlist*, my essay *Postproduction* functioned as a screenplay or rather libretto, in the operatic sense. I can do no better than reiterate what I said there concerning the notion of a culture involving the use of forms: "In generating behaviors and potential reuses, art challenges passive culture, composed of merchandise and

consumers. It makes the forms and cultural objects of our daily lives *function*. What if artistic creation today could be compared to a collective sport, far from the classical mythology of the solitary effort? 'It is the viewers who make the paintings,' Duchamp once said, an incomprehensible remark unless we connect it to his keen sense of an emerging culture of use, in which meaning is born of collaboration and negotiation between the artist and the one who comes to view the work. Why wouldn't the meaning of a work have as much to do with the use one makes of it as with the artist's intentions for it?"[131] Such is the meaning of what one might venture to call a formal collectivism.

Another hypothesis: could it be that what has been called "art of appropriation" operates not to seize but to abolish ownership of forms? The DJ is the concrete popular embodiment of this collectivism, a practitioner for whom the work-with-its-signature-affixed is merely one point in a long and winding line of retreatments, bootlegs, and improvised variations. Borrowed from the vocabulary of the DJ or pro- grammer, "playlist" generally designates the list of pieces "to be played." It is a cartography of cultural data but also an open order, a path that can be borrowed (and infinitely modified) by others.

GLOBAL ART OR ART OF CAPITALISM
"Culture is the rule; art is the exception," recalled Jean-Luc Godard. Along the same lines, one could designate as artistic any activity involving the formation and transformation of culture. Formation and transformation: though the abuse of the term "critical" can be irritating, contemporary artists do not maintain polite relations with their national (or regional) cultures. Yet within the global art world there is a fracture, for the most part unmentioned, that stems less from cultural difference than from degrees of economic development. The gap that still exists between the center and the periphery does not separate

131 BOURRIAUD, *POSTPRODUCTION* (NOTE 36), 20.

traditional cultures from cultures reformed by modernism, but economic systems at different stages of evolution toward global capitalism. Not all countries have emerged from "industrialism" to reach the phase that sociologist Manuel Castells calls "informationalism," that is, an economy in which what is most valued is information, "generated, stored, retrieved, processed, and transmitted" in digital language,[132] a society in which "what has changed is not the kinds of activities humankind is engaged in, but its technological ability to use as a direct productive force what distinguishes our species as a biological oddity: its superior capacity to process symbols."[133] If we accept the idea that the Western economy is post-industrial—that is, centered on service industries, the reprocessing of raw materials coming from the periphery, and the management of interpersonal relations and information—we can imagine that this has transformed artistic practice. But what is the situation for artists living in industrial or indeed pre-industrial societies? Can we really believe that all imaginations are today born free and equal?

Rare are the artists from countries of the periphery who have succeeded in penetrating the central system of contemporary art while continuing to reside in their countries of origin: removing themselves from all cultural determinism by successive acts of *re-enrooting*, brilliant individuals like Rirkrit Tiravanija, Kim Soo-Ja, and Pascale Marthine Tayou succeed in processing their respective cultures' local signs only from the economic center. This is no coincidence, nor is it a simple opportunistic decision on their part. There are, of course, exceptions, comings and goings. But for the most part, the import and export of forms seems genuinely to function only at the very heart of the global circuit.

132 MANUEL CASTELLS, *THE RISE OF THE NETWORK SOCIETY* (OXFORD: BLACKWELL PUBLISHERS, 1996), 29.

133 IBID., 100.

For what is a global economy? An economy capable of functioning in real time on a planetary scale.

In a process that has accelerated and broadened since the fall of the Berlin Wall in 1989, the unification of the world economy has automatically led to a striking standardization of cultures. Presented as the advent of a condition of multiculturalism, this phenomenon has proved to be principally political: contemporary art is more and more in harmony with the movement of globalization, which is standardizing economic and financial structures while turning the diversity of forms into the inverted, but precise, reflection of this uniformity. Like an Arcimboldo painting or an installation by Jason Rhoades or Thomas Hirschhorn, the contemporary world is structured in a manner that feels all the more implacable because we can decipher its image only as an anamorphosis, an apparently abstract design unrecognizable to the naked eye—for which it is the role of art to unfurl and display.

Globalization is above all economic in character. Art merely follows its contours, for it is the more or less distant echo of processes of production—and thus of symbolic forms of property, as we shall see. It would be easy to make baseless accusations here, so let us clarify that, far from constituting a simple mirror in which our epoch would recognize itself, art does not proceed by imitating contemporary practices and methods, but according to a complex play of resonance and resistance that sometimes brings it closer to concrete reality and sometimes pushes it further away, toward abstract or archaic forms. If it is clear that there is more to being contemporary than using machines, the vocabulary of advertising, or binary language, let us also admit that the act of painting does not have the same meaning today that it had in the period when that artistic discipline fit the work world like a cog in a clockwork mechanism. That does not prevent painting from continuing to exist; to deny it, however, is to render painting null

and void. Art gives an account of the evolution of productive processes in their global nature, of the contradictions among practices, of the tensions between the image that an epoch has of itself and the image it actually projects. And in an era in which representations interpose themselves between people and their daily lives and between human beings themselves, it is not surprising that art sometimes moves away from representation to become a part of reality itself. Karl Marx explained that, because history is a movement of interaction and growing interdependence among the individuals and groups that constitute humanity, its logical destiny is to become universal. "Global" art and multiculturalism reflect this new stage of the historical process that we reached with the fall of the Berlin Wall, without, however, always providing an adequate and pertinent response to this condition.

For the art world today is dominated by a vague ideology of sorts—multiculturalism—that claims somehow to resolve the problem of the end of modernism in a quantitative manner: since more and more cultural specificities are gaining visibility and attention, that is supposed to signify that we are on the right path. Since a new version of inter-nationalism is thought to be taking over from modernist universalism, the gains of modernity will supposedly be preserved. That, at any rate, is the argument of Charles Taylor, theorist of the "politics of recogni-tion,"[134] who asserts that the "dignity" accorded to cultural minorities in a national community is a "vital human need." But what is valid in the United States is not necessarily equally valid elsewhere: are we certain that Chinese or Indian cultures constitute minorities that will be swiftly satisfied if recognized politely? How are we to reconcile the valorization of "peripheral" cultures with the codes (or values) of contemporary art? Does the fact that the latter actually represents a Western historical construction—a fact that no one would dream of challenging—mean that it is necessary to rehabilitate the tradition?

134 CHARLES TAYLOR, *MULTICULTURALISM* (PRINCETON, NJ: PRINCETON UNIVERSITY PRESS, 1992).

Multiculturalism thus appears as an ideology involving the naturalization of the culture of the other. It is also the other as putative "nature," as a reservoir of exotic differences, in opposition to an American culture perceived as "global," a synonym for universal. Yet the artist reflects less his or her culture than the mode of production of the economic (and thus political) sphere within which he or she moves. The appearance of a contemporary art in South Korea, China, or South Africa reflects the respective nation's degree of cooperation with the process of economic globalization, and the emergence of its citizens onto the international artistic scene is a direct function of the political upheavals that have occurred there. To take an inverse example, the importance that performances and happenings have assumed in former Soviet bloc countries since the 1960s not only reflects the impossibility of circulating objects and the political virtues of cathartic action; it also attests to the necessity to not leave tracks in a hostile ideological context. How can we avoid the conclusion that contemporary art is above all contemporary with the economy surrounding it?

Moreover, one would have to be rather naïve to believe in a contemporary work of art that would be the natural expression of the culture from which its author comes, as if culture were a self-contained, closed, and independent universe—or on the contrary sufficiently cynical to promote the idea of the artist as the noble savage of his or her native language, the bearer of a difference that is spontaneous because not yet contaminated by the white colonist. That is, by modernism. There is, however, an alternative to this globalized vision of contemporary art. This alternative affirms that there are no pure cultural habitats, but rather cultural traditions and specificities cut across by this globalization of the economy. To paraphrase Nietzsche, there are no cultural facts, but interpretations of these facts. What one might call "interculturalism" is based on a double dialogue: one that the artist maintains with his or her tradition, and a second dialogue between that artist's tradition and the corpus of aesthetic values inherited

from modern art, which are the foundation of the international artistic debate. Interculturalist artists who are important today—from Rirkrit Tiravanija to Navin Rawanchaikul, from Pascale Marthine Tayou to Subodh Gupta, from Heri Dono to Kim Soo-Ja—brace their vocabulary on the modernist matrix and reread the history of the avant-gardes in the light of their specific visual and intellectual environment. The quality of an artist's work depends on the richness of his or her relations with the world, and these are determined by the economic structure that more or less powerfully shapes them—even if, fortunately, every artist theoretically has the means to evade or escape that structure.

APPROPRIATION ART OR FORMAL COMMUNISM

In 2003, Bertrand Lavier redoes a Frank Stella painting using neon tubes, while Bruno Peinado tackles three of César's expansions in giant hats; John Armleder produces a painting in the style of Larry Poons, Jonathan Monk a cinematic version of one of Sol LeWitt's books. Although they refer to previous works, the works I have just listed are not based on an art of citation. To practice citation is to appeal to an authority: in measuring him- or herself against the master, the artist claims a place in a historical lineage and thereby legitimates first of all his or her own position, but also, tacitly, a vision of culture in which signs unequivocally "belong" to an author (artist x or y), to whom the present work refers, ironically, aggressively, or admiringly. In Julian Schnabel's paintings of the 1980s, moreover, citation is sometimes reduced to the writing of a proper name. By leading to the borrowing, theft, or restitution of signs from / to their "author," citation naturalizes the ideology of private property of forms simply because it forges an indissoluble link between those forms and the authority of an individual or collective signature.

There is nothing of this in the attitude of the previously cited artists, from John Armleder to Jonathan Monk. Their relation to the history of art

does not imply an ideology of signs as property, but rather a culture of using and sharing forms, a culture for which the history of art constitutes a repertoire of forms, postures, and images, a toolbox that every artist has the right to draw upon, a shared resource that each is free to use according to his or her personal needs.

It is notable that this collectivist vision of art should appear at the moment of global triumph for the liberal economic model, as if the repressed of this system were concentrated in the universe of forms, finding there a space in which to preserve threatened elements and develop antibodies. Both the underground development of a collectivist culture on the Internet—from computer freeware (the Linux system) to the unauthorized downloading of film and music—as well as the strategic importance assumed by the debate on artistic copyright and reproduction rights together indicate the formation of an interstitial territory that isn't governed by the dominant law.

For a historian of art cut off from contemporary practices, what seems most difficult to understand is that this culture of using forms dissolves imaginary relations that formerly linked borrowings to their sources, copies to originals. On the contrary, it attests to an at once chaotic and collective imaginary register in which the paths between signs and the protocol for their use matter more than the signs themselves. If everyone can see that the imaginary universe of postindustrial societies is haunted by the figures of reprocessing, recycling, and use, this imaginary universe is translated in the discourse of contemporary art by the term "appropriation art." Since the beginning of the 1980s, appropriation art is most often used, in English at least, to describe artistic practices based on the staging of a preexisting work or product. Of course, these practices have been around for awhile, and the notion of appropriation art extends beyond the use of artworks to encompass the larger set of practices derived from Marcel Duchamp's readymade.

In 1913, when Duchamp developed a work entitled *Bicycle Wheel*, which consisted of a bicycle wheel perched on a stool, he simply transferred the capitalist process of production to the sphere of art. First of all, he abandoned the traditional tools of art (brush, canvas), which represented in artistic production the equivalent of pre-industrial labor conditions. With Duchamp, art adopted the general principle of modern capitalism: it ceased to work by manually transforming an inert material. The artist becomes the first consumer of collective production, a labor power connecting up to this or that pool of forms. He is, of course, subject to the general regime, but at the same time, he is free to arrange his space and time, unlike the worker who is obliged to plug his labor power into an existing production system that is independent of him and over which he has no influence.

In *The German Ideology*, Karl Marx describes the rupture produced at the birth of capitalism by a shift from "natural means of production" (in working the land, for example) to "means of production created by civilization." Capitalism could thus be described as an initial stage in the devaluation of raw materials. In art, capital is a mix of accumulated labor (works of art and products of consumption) and means of production (the set of tools available at a given moment to produce forms). Duchamp's indifference conveys a certain contempt for all ownership, even symbolic, that is confirmed by his work as a whole and by his reiterated disdain for the material form of his readymades. A note Duchamp wrote for a work that was never executed further underscores his collectivist vision of artistic activity and the very temporary role he granted the signature: "to buy or take known or unknown paintings and sign them with the name of a known or unknown painter—*the difference* between the 'style' and the unexpected name for the 'experts'—*is the authentic work* of Rrose Sélavy, and defies forgeries."[135] Here Duchamp outlines an argument about the gap (the "difference") between style and name, the object and its cultural and social context. Nothing is more foreign to the fetishism

of the signature that is inherent in the concept of appropriation than this aesthetic of relations between things and signs that the readymades evince. In Duchamp's thought, art begins in this infrathin [*inframince*],* the margin by which the sign differs from what it is supposed to signify, in the space for play between the artist's name and the object that displays it. By contrast, the object that is possessed or appropriated becomes the pure and simple expression of its owner, the owner's double in the legal and economic order.

The anti-copyright movement (Copyleft), for which the Internet represents both the model and the privileged tool, is struggling to abolish property rights for intellectual work, a logical culmination of the end of modern times. As has been written by the group of activists known as the Critical Art Ensemble, "prior to the Enlightenment, plagiarism was useful in aiding the distribution of ideas. An English poet could appropriate and translate a sonnet from Petrarch and call it his own. In accordance with the classical aesthetic of art as imitation, this was a perfectly acceptable practice. The real value of this activity rested less in the reinforcement of classical aesthetics than in the distribution of work to areas where otherwise it probably would not have appeared."[136] In *For a Critique of the Political Economy of the Sign*, Jean Baudrillard explains that "in a world that is the reflection of an order," artistic creation "proposes only to describe." The work of art,

135 MARCEL DUCHAMP, *NOTES*, ARRANGED AND TRANS. PAUL MATISSE (PARIS: CENTRE NATIONAL D'ART ET DE CULTURE GEORGES POMPIDOU, 1980), FACSIMILE 169.

* TRANSLATOR'S NOTE: MARJORIE PERLOFF DEFINES DUCHAMP'S NEOLOGISM "INFRATHIN" [*INFRAMINCE*] AS "THE ALL BUT IMPERCEPTIBLE *DIFFERENCE* BETWEEN TWO SEEMINGLY IDENTICAL ITEMS" (PERLOFF, "'BUT ISN'T THE SAME AT LEAST THE SAME?': TRANSLATABILITY IN WITTGENSTEIN, DUCHAMP, AND JACQUES ROUBAUD," *JACKET MAGAZINE* 14 [JULY 2001]).

136 CRITICAL ART ENSEMBLE, "UTOPIAN PLAGIARISM, HYPERTEXTUALITY, AND ELECTRONIC CULTURAL PRODUCTION," IN CRITICAL ART ENSEMBLE, *THE ELECTRONIC DISTURBANCE* (BROOKLYN, NY: AUTONOMEDIA, 1994), 83–84. AVAILABLE ONLINE AT WWW.CRITICAL-ART.NET/BOOKS/TED/TED5.PDF.

he continues, "wishes to be the perpetual commentary of a given text, and all copies that take their inspiration from it are justified as the multiplied reflection of an order whose original is in any case transcendent. In other words, the question of authenticity does not arise, and the *work of art is not menaced by its double.*"[137] Later the conditions of signification for the work of art changed radically, for it became a question of "preserving the authenticity of the sign,"[138] a struggle in which the signature assumes the familiar role. The trend toward organizing the domain of art around the signature of the artist, taken as guarantee of the contents and authenticity of his or her speech, fully took off only at the end of the eighteenth century, with the spread of the system of industrial capitalism. Artists themselves were to become the key marketable value of the art world, to adapt their principles of work to the sphere of exchange, to assume a role akin to that of the wholesale merchant, whose job is to move a product from a place of manufacture to a place of sale. What does Duchamp do with his readymades? He moves the bottle rack from one place to another on the economic map—from the sphere of industrial production to that very specialized sphere of consumption, art.

In using the entirety of human industry as his "means of production," Duchamp bases his work on the accumulated work of others. But the globalization of culture has considerably extended the field of usable products. Artistic capital has never been so substantial; artists have never been in contact with such an abundance of accumulated work. Art in these early years of the twenty-first century bears the mark of this radical change. Since artists have become consumers of collective production, the material for their work can henceforth come from outside, from objects that do not belong to the artist's personal mental

137 JEAN BAUDRILLARD, *FOR A CRITIQUE OF THE POLITICAL ECONOMY OF THE SIGN*, TRANS. CHARLES LEVIN (ST. LOUIS, MO: TELOS, 1981), 103. EMPHASIS IN ORIGINAL.

138 IBID., 105.

universe but to cultures other than his or her own. The contemporary imagination is deterritorialized, in the image of global production.

THE AESTHETIC OF THE "RÉPLIQUE": THE DEFETISHIZATION OF ART*

As the Critical Art Ensemble emphasizes, "if the industry is unable to differentiate its product through the spectacle of originality and uniqueness, its profitability collapses."[139] It is this pillar of the capitalist economy that is being attacked by the artists in question here. Their works are less the expression of a recognizable style than that of a particular wavelength whose modulations the observer will endeavor to follow. The artistic practice of a Richard Prince, a Bertrand Lavier, a John Armleder, or an Allen Ruppersberg—to cite only some of the artists heralding this evolution—consists not in manufacturing objects but in inventing modes of coding and protocols for using signs.

These hypercapitalist practices rest on the idea of an art without raw material, an art that depends on the already-produced, the "already socialized elements," to use Franck Scurti's expression. Sometimes the act of re-displaying is indistinguishable from that of re-making—the difference is insignificant, as in the work of Jacques André, who displays in a personal exhibition works of other artists (for example, a piece by Jacques Lizène), a frieze presenting recently acquired books or discs, and a stack of copies of Jerry Rubin's *Do It*, the artist having acquired all of the copies of the book that were available in Brussels. Manufacturing, conceiving, consuming: these are just so many facets of a single activity for which the exhibition is the temporary receptacle. When Dave Muller organizes one of his "three-day

* TRANSLATOR'S NOTE: THE FRENCH WORD *RÉPLIQUE* MEANS BOTH "REPLICA" AND "REPLY"; IT CAN ALSO MEAN "AFTERSHOCK."

139 CRITICAL ART ENSEMBLE, *THE ELECTRONIC DISTURBANCE* (NOTE 136), 97–98.

weekends," exhibition-events to which he invites different artists, he doesn't trade the status of artist for that of curator: working with signs produced by others constitutes the very form of his artistic work. The iconography of his drawings derives, moreover, from para-artistic materials (invitation cards, promotional materials, exhibition spaces) staging heterogeneous aesthetics unified by the realism of his drawing. The drawings of Sam Durant combine Neil Young and Robert Smithson, the Rolling Stones and Conceptual art, in the framework of a critical archaeology of the avant-garde. Carol Bove's installations explore the same historical period, 1965–75, when artistic experiments and experiments in daily life went hand in hand and attenuated the difference between high culture and popular culture through hippie utopias.

Today, music continues to provide a procedural model. When a musician uses a sample, when a DJ mixes discs, they know that their own work may in turn be taken up and serve as material for new operations. In the digital era, the piece, the work, the film, and the book are points on a moving line, elements of a chain of signs whose meaning depends on the position that they occupy. Thus, the work of contemporary art is no longer defined as the endpoint of the creative process but rather as an interface, a generator of activities. The artist tinkers and improvises on the basis of general production and moves around the network of signs, inserting his or her own forms into existing channels. A long text by Allen Ginsberg, *Howl*, thus forms the basis of *Singing Posters* (2003), a work in which Allen Ruppersberg, through a process of transcoding, transforms the writing of the beat generation poet into a complex installation. The wavelength of a work, whatever it is, can be transferred from one medium to another, from one format to another: the formal thought of a digital era.

What is the basis for these practices of rewriting, of using existing works? What is the principle, the set of notions, the vision of culture on which they are founded? Is it simply an art of the copy, of appro-

priation? Not quite, for as we have seen, the era evinces the need for a cultural collectivism, for a pooling of resources, and this need manifests itself beyond the sphere of art, in every practice born of Internet culture. Is it a question of a cynical aesthetic whose operative word is plagiarism? Or is it rather the symptom of a generalized amnesia that extends to the history of art? Yet when Sam Durant makes a dozen copies of an image of an ephemeral work by Robert Smithson (*Upside Down: Pastoral Scene*, 2003), the source is clear. And when Jonathan Monk adapts Robert Barry or Sol LeWitt, the referent is no less clearly identified. Citation is no longer an issue—no more than the novelty so dear to people nostalgic for modernism.

This aesthetic is incomprehensible if one does not relate it to a general evolution of artistic preoccupations, which have shifted from space toward time as artists increasingly contemplate their work from a temporal rather than a strictly spatial perspective.[140] Once again, the evolution of the global economy provides a model for understanding this phenomenon: the dematerialization of the economy, which Jeremy Rifkin has characterized by the phrase "the Age of Access," amounts to a progressive devaluation of property.[141] When a buyer acquires an item, he explains, his or her relationship with the seller is short-lived. With a rental, by contrast, the relationship with the provider is ongoing. Incorporated into all sorts of commercial networks and financial agreements (rentals, leasing, admission fees, membership dues, subscriptions), consumers are seeing the entirety of their lives become

[140] FOR A DISCUSSION OF THIS PROBLEMATIC AND ITS DEVELOPMENTS IN RECENT ART, SEE THE AUTHOR'S BOOK *FORMES DE VIE: L'ART MODERNE ET L'INVENTION DE SOI* (PARIS: ÉDITIONS DENOËL, 1999), IN PARTICULAR CHAPTER II, SECTION 3, "L'ŒUVRE COMME ÉVÉNEMENT," AND ALSO *RELATIONAL AESTHETICS*, TRANS. SIMON PLEASANCE AND FRONZA WOODS WITH THE PARTICIPATION OF MATHIEU COPELAND (DIJON: LES PRESSES DU RÉEL, 2002).

[141] JEREMY RIFKIN, *THE AGE OF ACCESS: THE NEW CULTURE OF HYPERCAPITALISM, WHERE ALL OF LIFE IS A PAID-FOR EXPERIENCE* (NEW YORK: TARCHER/PUTNAM, 2000).

merchandise. According to Rifkin, "the exchange of property between sellers and buyers—the most important feature of the modern market system—gives way to short-term access between servers and clients operating in a network relationship."[142] In aesthetic terms, what is dying is the mode of acquisition, replaced by a generalized practice of access to experience, whose object has become merely a means. This is a logical evolution of the capitalist system: power, in the past based on landed property (space), has slowly shifted toward pure capital (time, during which money "works").

What is a copy, a rerun, a remake, in a culture that values time over space? Repetition in time is called a rerun or *réplique*—a replica, a reply. And the term *réplique*, "aftershock," is also used to refer to the tremor(s) following a major earthquake. These aftershocks, more or less attenuated, distanced, and similar to the first, belong to the original, but they neither repeat it nor constitute entirely separate events. The art of postproduction is a product of this notion of *réplique* (replication, reply): the work of art is an event that constitutes the replication of and reply to another work or a preexisting object; distant in time from the original to which it is linked, this work nonetheless belongs to the same chain of events. It is located on the precise wavelength of the original earthquake, putting us back in touch with the energy from which it sprang while at the same time diluting it in time, that is, ridding it of its character as historical fetish. To use works from the past the way Bertrand Lavier, Bruno Peinado, or Sam Durant do is to reactivate a source of energy, to affirm the power of the materials being reprocessed. To do so also means participating in the defetishization of the work of art. The intentionally transitory character of the artwork is not asserted by its form, which may be durable and solid, and forty years after Conceptual art it is no longer a matter of asserting the immateriality of the work of art. The defetishization of art in no way

142 IBID., 4–5.

concerns its status as object; the star products of our time are no longer objects anyway, as Jeremy Rifkin points out. No, this transitory, unstable character is represented in contemporary works by the status they claim in the cultural chain: the status of event, or of response to past events.

POST-POST, OR ALTERMODERN TIMES

In a formulation as terse as it is illuminating, Peter Sloterdijk defines the modern era as governed by the worship of rapid combustion— as an age of abundant energy, permanent growth, and "the epic of motors."[143] Have we really left that world behind? Modern, postmodern, altermodern. So many terms that above all serve to periodize—terms, in the final analysis, by which we take sides within history by stating our adherence to this or that narrative of contemporaneity. According to Sloterdijk, however, we are still "fanatical adherents of explosions, worshipers of that rapid release of a large quantity of energy. I think today's adventure films, the action movies," he continues, "are all grouped around this second primal scene of modernity—the explosion of a car or an airplane. Or better still a big gas tank, the archetype of the divine impetus of our age."[144] The first of these "primal scenes" took place in Pennsylvania in 1859, on the day the first oil well was built near Titusville. "Since then, the image of an oil well erupting, which specialists call a gusher, has become one of the archetypes not only of the American dream but of the modern way of life in general, which is made possible by easily available energy."[145] As a matter of interest, 1859 was the year that Édouard Manet painted his *Absinthe Drinker*, and that Baudelaire wrote of Eugène Boudin that he saw a molten universe in his paintings: "These ferments of gloom; these immensities of green and pink, suspended and added one upon another; these gaping furnaces; these firmaments of black or purple satin, crumpled, rolled or torn; these horizons in mourning, or streaming with molten metal ... rose to my brain like a heady drink or like the eloquence of opium."[146] In the same Salon review in which

143 PETER SLOTERDIJK, *IM WELTINNENRAUM DES KAPITALS* (FRANKFURT AM MAIN: SUHRKAMP, 2005), 351.

144 PETER SLOTERDIJK, CONVERSATION WITH FABRICE BOUSTEAU AND JONATHAN CHAUVEAU, IN "VIES MODE D'EMPLOI," SPECIAL ISSUE, *BEAUX ARTS MAGAZINE* (2004): 192.

145 SLOTERDIJK, *IM WELTINNENRAUM DES KAPITALS*, 354.

146 CHARLES BAUDELAIRE, *ART IN PARIS, 1845–1862: SALONS AND OTHER EXHIBITIONS REVIEWED BY CHARLES BAUDELAIRE*, ED. AND TRANS. JONATHAN MAYNE (LONDON: PHAIDON, 1965), 200.

he vigorously opposes "the industrial horror" as the worst enemy of art, he also glimpses in the calm Impressionist landscapes of Boudin that world "streaming with molten metal" that will go on to become the explosive and pulverized universe of productivist modernity.

This explosive form is explicitly present throughout the twentieth century: in the Futurist painters' celebration of war, in the Cubist vision that Fernand Léger discovered in the trenches of World War I, in the jagged forms of Dadaism. Modernist painting sought to channel or materialize energy: Jackson Pollock's drippings constitute a pure form of this iconography of the explosion, which we meet again in the imagery of Pop Art, for which—even more than Roy Lichtenstein's literal references to comic strip explosions—enlargements ("blow ups") and multiplication represent pictorial equivalents of detonation. The seriality of Pop is not a translation of mass production alone, but also of the chain reactions of atomic explosions; it is the image of a world that is infinitely decomposable by nuclear fission. But modernist energetics is not just represented; it is conceived as a plan of action. Venice must be razed (the Futurists), musical instruments smashed (Fluxus), color unleashed. The modernist program consists in exploding, shattering, and decomposing the visible, in form or in fact. Thus, we find a "rapid release of a large quantity of energy" in the happenings of the group Gutaï and the Viennese Actionists, in Jean Tinguely's self-destructive machines, in Joseph Beuys's cathartic performances, and in Yves Klein's "fire paintings." Beauty? "Convulsive," André Breton will say, or even better, "fixed-explosive": like a drilling installation, Surrealist automatism seeks to release the unconscious energies buried in the subsoil of our psyches, preparing our minds for the revolution to come. Isn't revolution the political equivalent of an explosion?

According to Walter Benjamin, one of the defining features of twentieth-century modernism was its aesthetic of shock. Another—as we have seen—was its passion for radicality; it was a mode of thought that

pruned and severed. Who, then, was modern man if not the barbarian of the twentieth century, eager to "topple the old barriers" and throw yesterday's culture—in Vladimir Mayakovsky's phrase—"overboard from the steamship of modernity"? Barbarous, the Futurist dream of razing Venice. Barbarous too, the Dadaists. Savages, those painters who were content to paint monochromatic surfaces. The barbarous is always defined from within the town walls by the defenders of the city. It describes the roving hordes that lay siege to the static fortress. The shock principle that permeates the modernity of the twentieth century is a watchword of unsubscription, a tool that makes it possible to unstick the calcified certainties from their pedestals, to dislodge the traditional icons from their niches. Making art with hammer blows— such was the program of the modernist avant-gardes. Dadaism, which was emblematic in this respect, left behind an iconography of shattering, explosion, and the spontaneous exploitation of human material. "Everything an artist spits out is art," said Kurt Schwitters.

At the same time that Stéphane Mallarmé set out to dynamite the space of poetry, he was also associating with anarchist militants who were widely viewed as dangerous, some of whom were still planting very real bombs in the city of Paris. Is it merely a coincidence that Marcel Duchamp—who took his artistic credo from the author of "Un coup de dés jamais n'abolira le hasard" ("A Throw of the Dice Will Never Abolish Chance")—was also an assiduous reader of Max Stirner, the great libertarian and individualistic thinker of his day and the author of *The Ego and Its Own*?[147] A parallel under the sign of radicality has yet to be drawn between anarchism and the birth of the avant-gardes in the nineteenth century, but even now one can already note their disquieting points of convergence and point to numerous analogies—for example, between the shattered typography of Dada

[147] MAX STIRNER, *THE EGO AND ITS OWN*, ED. DAVID LEOPOLD (NEW YORK AND CAMBRIDGE: CAMBRIDGE UNIVERSITY PRESS, 1995).

and the movement of an explosion, or, more generally, between the thought of Proudhon or Bakunin and the individualization of artistic criteria that took place throughout the twentieth century, as the age of those "individual mythologies" celebrated by the curator Harald Szeemann. Radical anarchism remains a kind of "unthought" in the analysis of the modernist avant-gardes, a phenomenon that would have to be seen in the context of an energetic theory of art.

It is always interesting to discover an element that swims against the current of a general trend. Right in the midst of the mechanical and electrical fury devoted to the "worship of rapid combustion," Marcel Duchamp privileges "timid energies," delicate ores that art has the power to extract. Thus, he imagines an "apparatus to / record / collect and / transform all the little external manifestations / of … energy (in excess or lost) / like / for example: the excess pressure / on an electric switch, the exhalation / of tobacco smoke, the growth / of hair and nails, the / fall of urine and shit / the impulsive movements of fear / of astonishment," etc.[148] In 1913, Duchamp's work has already left the orbit of Western productivism and begun to anticipate the world of renewable energy: his work encourages decluttering, taking the same objects and reusing them in different ways, moving things from place to place instead of producing new ones. Jean-François Lyotard, who went on to popularize the term "postmodern" in 1979, describes the artistic process as a transformation of energy, a well-ordered system for recycling matter. In a gesture entirely consistent with this vision of art, he pulverizes the subject of classical philosophy, replacing it with the notions of libidinal flows, drive mechanisms, connections, and energy exchangers.[149] Indexed to progress and abundance, modernism is thus structured around the image of a derrick planted in the depths of the individual and society, a violent explosion of

148 MARCEL DUCHAMP, *NOTES*, ARR. AND TRANS. PAUL MATISSE (PARIS: CENTRE NATIONAL D'ART ET DE CULTURE GEORGES POMPIDOU, 1980), FACSIMILE 176.

the visible. If one had to sum it up in an image, it might well be the slow-motion explosion at the end of Michelangelo Antonioni's film *Zabriskie Point* (1970): a movement of decomposition and analysis as well as a detonation.

The appearance of the term "postmodern" is contemporaneous with the oil crisis of 1973, the moment the world became concretely aware of the limits of its reserves of fossil energy. In other words, with the abrupt economic and symbolic break that occurred in 1973, it was the future itself that suddenly found itself called into question in the Western imagination. Is it merely a coincidence that "postmodernism" came into widespread use in the second half of the 1970s, when society was assimilating the fact of the end of abundance? Twentieth-century modernism was the historical moment when the production of goods and signs was based on limitless trust in available energy and an infinite projection of the present into the future. It is this ideology that is compromised by the oil crisis. Postmodern ideology is born in the wake of the energy crisis, just as a depression often follows a sudden loss—in this case the loss of a carefree faith in the world's intrinsic vitality, the death of progress as an ideological foundation. Even worse than a loss—because it foreshadowed and staged an extinction that was situated in a vague, uncertain future, the oil crisis of 1973 is the "primal scene" of postmodernism. Since then, the global economy has sought to end its dependence on the exploitation of raw materials—the transition from industrial production to an economy of postproduction. In the hyper-industrialized countries, capitalism at this time disconnected from natural resources, orienting itself instead around technological innovation (the option chosen by Japan), financialization (the choice of the United States), and the service

149 JEAN-FRANÇOIS LYOTARD, *DES DISPOSITIFS PULSIONNELS* (PARIS: UNION GÉNÉRALE D'ÉDITIONS, 1980 [1973]) [NOT TRANSLATED INTO ENGLISH]; *LIBIDINAL ECONOMY*, TRANS. IAIN HAMILTON GRANT (BLOOMINGTON, IN: INDIANA UNIVERSITY PRESS, 1993 [FRENCH ORIGINAL PUBLISHED 1974]).

industries in general. The economy disconnects from concrete geography as much as it can, leaving the exploitation of raw materials to so-called emerging countries, which are henceforth regarded as open-air mines and pools of cheap labor.

Thus, at least in its first phase, postmodernism resembles a mode of thought based on mourning, a long depressive episode of cultural life. Since history had lost its direction, there was nothing left to do but confront a static and motionless space-time in which mutilated fragments of the past loomed up like vague recollections, those "museum's ruins" that Douglas Crimp described in 1980 as the defining characteristic of postmodern art.[150] This melancholy posture constitutes the first period of postmodernism: it is characterized by an intensive citing of identifiable forms from the history of art as well as by the theme of the "simulacrum," in which the image replaces reality in reality itself. The theme of the simulacrum is the symbolic counterpart of the progressive "derealization" of the economy, which is less and less linked to any geological or geographic reality. Because a possible direction for history cannot be determined, history is simply declared to have ended. The eternal recurrence of modernist forms in the 1980s—the decade of all things "neo" ("neo-geo," neo-Romanticism, neo-Surrealism, etc.)—is followed by the relativization of the very notion of history through the medium of postcolonial thought.

The second period of postmodernism, in which melancholy gives way to multiculturalism, is born of the end of the Cold War. 1989, the year of the fall of the Berlin Wall, is also the year of the exhibition that—however controversial it may have been—symbolically inaugurated artistic globalization, *The Magicians of the Earth*. At this point, history seems to emerge from the glaciation generated by the silent

150 DOUGLAS CRIMP, *ON THE MUSEUM'S RUINS*, WITH PHOTOGRAPHS BY LOUISE LAWLER (CAMBRIDGE, MA: MIT PRESS, 1993).

confrontation of the two great political blocs. The modernist master narrative now gives way to that of globalization: by opening to cultures and artistic traditions other than those of the Western world, post-colonial postmodernism followed the path opened up by the world economy and ushered in a global reexamination of the conceptions of space and time that will remain its historical legacy. Henceforth, the historical clock is synchronous; that is, it is no longer based exclusively on the Greenwich meridian of progress but includes the many different cultural time zones.

At this dawn of the twenty-first century, we are about to emerge from this era that was defined by the prefix "post-" which united the most disparate domains of thought within the experience of a single, undifferentiated "afterward." Postmodern, postcolonial, postfeminist, post-human, post-historical... To situate oneself within the space of an eternal afterward of things—in other words, in a kind of suburb of history—immediately implies a mode of thought in the form of foot-notes. It is this prefix, "post-" that will ultimately turn out to have been the great myth of the end of the twentieth century. It points to the nostalgia for a golden age at once admired and hated. It refers to a past event that supposedly cannot be surpassed, an event on which the present depends and whose effects it is a question of managing. This is the sense in which postmodernism is a mode of thought that is inherently reliant on, even captive to, the origin. To move within the space of the "post-" one had first to declare where one came from, to situate oneself in relation to an earlier historical situation. What is more characteristic of the postmodern period than the mythification of the origin? The meaning of a work—for this second, postcolonial postmodernism—ultimately depends on its locus of enunciation. "Where do you come from?" is its fundamental question, essentialism its critical paradigm. Membership in a gender, ethnicity, sexual community, or nation thus determines, in the final analysis, the signi-fication of the works; all signs are "stamped": as a critical methodology,

multiculturalism resembles a system for distributing meaning that assigns individuals to their social demands, reduces their being to their identity, and repatriates all meaning toward an origin regarded as a political revealer. It is this critical model that is in crisis today, this multi-culturalist version of cultural diversity that must be placed in question, not in favor of a systematic universalism or a new modernist Esperanto, but rather in the context of a new modern moment based on gener-alized translation, the form of wandering, an ethics of precariousness, and a heterochronic vision of history.

Since the end of the twentieth century, our spatial imagination has undergone spectacular transformations due to the instantaneous nature of communication and of telepresence in its various forms, increased movement from place to place, and the globalization of goods and cultural signs: space has shrunk. It is now little more, writes Sloterdijk, "than the nothingness between two electronic workstations."[151] Michel Serres regards the highway interchange as the fundamental unit of space today, a view that raises the question of the habitability of the world: "If interchanges are now the basic units of a space through which we henceforth merely pass, how can one dwell there? Answer: we no longer dwell. Is it possible to conceive of, to draw a garden of wandering?"[152] Today's art meets this challenge by exploring this new space-time of conductivity, in which supports and surfaces have given way to journeys. Artists become semionauts, the surveyors of a hypertext world that is no longer the classical flat space but a network infinite in time as well as space; and not so much the producers of forms as the agents of their viatorization, of the regulation of their historical and geographic displacement.

151 SLOTERDIJK, *IM WELTINNENRAUM DES KAPITALS* (NOTE 143), 399.

152 MICHEL SERRES, *ATLAS* (PARIS: CHAMPS-FLAMMARION, 1997), 61.

The problematization of translation in contemporary art goes hand in hand with an aesthetic of displacement and an ethics of exile. Within this intellectual framework, topology itself—which is a geometry of spatial translations—constitutes a privileged mode of representation: forms exiled from one space to another. The mode of wandering—the visual model and monitoring force of these displacements—determines *a fortiori* an ethics of resistance to the vulgar form of globalization: in a world that is structured by consumption, it implies that what one finds is above all what one *isn't* looking for, an event that is increasingly rare in this era of universal marketing and consumer profiling.

The random comes together here with precariousness, understood as a principle of non-membership: that which is constantly moving from place to place, which weakens origins or destroys them, which viatorizes itself and proceeds by performing successive translations, does not belong to the continental world but to this new altermodern archipelago, this garden of wandering

The universalist and progressive dream that governed modern times is in tatters, and this disintegration is today giving rise to a new configuration of thought that no longer proceeds by building great totalizing theoretical systems but by constructing archipelagoes. A voluntary grouping of islands networked together to create an autonomous entity, the archipelago is the dominant figure of contemporary culture. As a continental mode of thought, modernism had no use for mental insularities. As the notion of progress implies, it was a matter of forming a continent, an international, an avant-garde intent on conquering a territory. In political terms, the *altermondialisation* (or alterglobalization) movement groups together all the local oppositions to the economic standardization imposed by globalization; it expresses the struggle for diversity, without, however, constituting a totalization itself. The altermodern is to culture what altermondialisation is to geopolitics, an

archipelago of local insurrections against the official representations of the world.

The prefix "alter-" which may be regarded as pointing to the end of the culture of the "post-" is thus linked both to the notion of an alternative as well as to the notion of multiplicity. More precisely, it designates a different relationship with time: no longer the aftermath of a historical moment, but the infinite extension of the kaleidoscopic play of temporal loops in the service of a vision of history as a spiral, which advances while turning back upon itself. Altermodernity, which represents a change of position *vis-à-vis* the phenomenon of modernity, does not regard the latter as an event to be depicted but as one phenomenon among others, to be explored and envisaged in a space finally divested of hierarchy, that of a globalized culture busy with new syntheses. Marcel Duchamp, in his own day, sensed the danger of "progress" in art; for example, he developed a passion for perspective at the very moment that it was being relegated to the antique shop by modernist painting. Even more explicitly, he asserted that art was "a game between all people of all times" rather than a direct and univocal relationship with the present. Duchamp was never radical: this nomad hated roots, as well as the principles and cultural determinations that accompany them. In quiet opposition to his time—and even as he explored as yet uncharted aesthetic pathways—he thus embodies a nonlinear modernity which in no way corresponds to the modernity that postmodernism claimed to surpass, but which may find an echo in the modernity now taking shape.

The postmodern myth would thus describe a people delivered from the tyranny of an illusion, that of Western progressive modernism, which finds itself alternately galvanized and made helpless by the latter's retreat. The parallel with the myth of Babel, a universalist and Promethean construction, is inescapable. From the fall of the Tower of Babel were born the multiple languages of humanity,

inaugurating an era of confusion that followed the dream of a unified world bent on taking the future by storm.

Then came a new idea: translation.

In addition to the postmodern myth of Babel, the prefix "alter-" also points to another Biblical episode, that of the Exodus. If we consider the flight from Egypt—that turning point in the history of the Jewish people—we will find that it contains, in gripping abbreviation, the critical question that culture is asking itself today. The Exodus is the moment when the Jews take to the road, leaving behind them the Egyptian machinery of state with its heavy and strictly coded gods, its pyramids, and its obsession with immortality. The Exodus, writes Peter Sloterdijk, represents the moment when "all things must be reevaluated in terms of their transportability—even if it means running the risk of leaving behind everything that is too heavy for human beings to carry." The challenge was to "transcode God, to transfer Him from the medium of stone to that of parchment."[153] In a word, to pass from cultural sedentariness to a nomadic universe, from a polytheistic bureaucracy of the invisible to a single God, from the monument to the document. What the Jewish people realized at that time in the realm of theology is not unrelated to the latent content of the modern mind, whose fundamental character is to oppose territorialization, the pull of a soil that has become an origin and an end in itself, and the ossification of the spirit under the authority of the monument. The modern is ultimately none other than an exodus, the reconstruction, in motion, of the structures of the community, the act of moving the community to another space. There is a diaspora of forms; in it, twentieth-century modernism might be defined as the historical moment when the artistic traditions of the entire world, from African statuary to the masks of the New Hebrides, were discovered and reevaluated in light of the

153 PETER SLOTERDIJK, *DERRIDA, UN ÉGYPTIEN* (PARIS: MAREN SELL ÉDITEURS, 2006), 53.

issues and challenges of the present. Today, the perspective is reversed, and the question is how art can finally define and inhabit a globalized culture, against the standardization presupposed by globalization.

At the collective level, it is ultimately a question of inventing a common world, of realizing, practically and theoretically, a global space of exchange. This shared world (shared within the space of translation) would implement that relativist relativism that Bruno Latour opposes to postmodern relativism, a space of horizontal negotiations without an arbiter. Thus, we move among representations of the world; we practice translation and organize the discussions that will give rise to a new common intelligibility. This is all the more important today—amid the constant unrest caused by economic globalization—since reification has never wielded its power so completely nor with such diversity. Faced with the challenge it poses to culture and art, we must therefore set things in motion again—start a counter-movement—by beginning a new exodus.